Carol Mann

...aduated from the Courtauld Institute
...d lectured in art history and fashion stu...
...olleges in London before moving to Pari...
...nized exhibitions on contemporary art an...
...e d'Art Moderne de la Ville de Paris
...on behalf of the French Ministère d...
...ures. She is the author of several novels
...aturing Modigliani in a prominent role, including
Dorothea von A (Paris, 1992)

WORLD OF ART

This famous series
provides the widest available
range of illustrated books on art in all its aspects.
If you would like to receive a complete list
of titles in print please write to:
THAMES AND HUDSON
30 Bloomsbury Street, London WC1B 3QP
In the United States please write to:
THAMES AND HUDSON INC.
500 Fifth Avenue, New York, New York 10...

Printed in Singapore

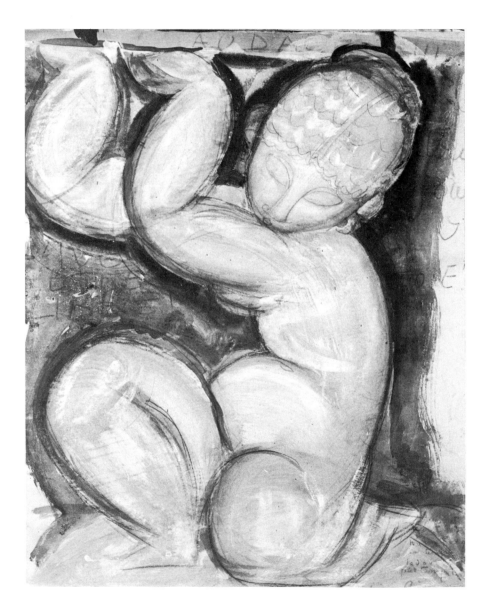

CAROL MANN

modigliani

with 150 illustrations, 20 in colour

THAMES AND HUDSON

Frontispiece: *Rose Caryatid (L'Audace)*, c. 1913

Unless otherwise indicated, all translations from the French and Italian are by the author.

© 1980 Thames and Hudson Ltd, London
Reprinted 1995

ISBN 0-500-20176-5

Printed and bound in Singapore by C.S. Graphics

Contents

Acknowledgments

Thanks for help and moral support to Ronald Alley, Dana Belmont, Christine Bernard, Chrissie Lindey, Lila Mann, Achim Moeller, Marevna Vorobëv, the infinitely patient staff at the Victoria and Albert Museum Library . . . and of course Isabelle and Sylvie in Paris.

Special thanks to Lord Alastair Gordon.

Carol Mann

Italy: the early years

There used to be a law in Italy which prohibited the seizure of possessions from the bed of a woman in labour; this was most fortunate, because on 12 July 1884, when the bailiff called on 4 via delle Ville in Livorno, Signora Eugenia Modigliani was giving birth, under a mound of family heirlooms, to her fourth and last child, a son who was to be called Amedeo Clemente.

The family had certainly come down in the world, probably because of the neglect in business matters by the paterfamilias, Flaminio Modigliani. In later years, Amedeo was to claim that he came from a family of bankers – only partially true, but like everything he was to claim, not entirely untrue. The actual nature of Flaminio's business is not quite clear; it seems that initially he had a *cambio*, that is a money exchange; this was normally an extremely lucrative occupation in Italy's second largest port, but one that demanded a commercially orientated mind which he did not have – although his cousins in Rome certainly did. The Modigliani were Sephardic Jews, that is Jews whose culture had remained Mediterranean. They had originally come from Spain, fleeing the Inquisition, to a far more liberal Italy, where they had become extremely prosperous tradesmen; one ancestor, Abramvita, had been a councillor to Napoleon. In the middle of the nineteenth century, Flaminio's father had been sent to expand the exchange business in Livorno, a freeport where Jews were respected and encouraged. After the ruin, Flaminio engaged in the less hazardous commerce of wood and coal, but the family continued to live in a comfortable, unostentatious manner. Money and material possessions were despised, especially by his wife Eugenia's side of the family; as she had populated the house with her own tribe, the Garsin, it was their way of thinking that prevailed. Amedeo, affectionately called Dedo, was named after two of them: Eugenia's extravagant brother Amedeo, a playboy of sorts who made and lost three fortunes and was to finance Dedo's studies in Venice, and her sister Clementine, who was the only one who had stayed in Marseilles where Eugenia herself was born.

The Garsin were Sephardic Jews too; they had originated in Tunis and settled in Livorno in the eighteenth century. Part of the family had moved to Marseilles, so that there was always a connection between the two countries,

7

and the Garsin were as a result bilingual. They valued education and liberal thinking and venerated Baruch Spinoza (who may have been an ancestor), Moses Mendelssohn, Uriel da Costa and anyone who was associated with the great tradition of Jewish free thinking; philosophers, poets and writers who had been persecuted for their beliefs, *artistes maudits* condemned by society were seen as heroes.

While never denying their Jewishness in any way (in any case, persecution of Jews comparable to that which went on in Northern Europe had not been experienced since the sixteenth century), the Garsin, unlike the Modigliani, were not observant in their religion; so when Eugenia arrived in Livorno, aged seventeen, on the arm of her new spouse, his family of successful tradespeople seemed very strait-laced, and their material interests were quite alien to her. Between 1872 and 1884, she bore Flaminio four children: Emanuele, the socialist militant, Margherita, who never married and who was to bring up Modigliani's daughter Jeanne, Umberto, an eccentric engineer, and Dedo.

Eugenia then proceeded to import her own family to Livorno: her father, the temperamental Isaac Garsin (her mother had died from tuberculosis), and her sister Laure whose sense of reality sometimes wavered. Both in fact suffered from acute paranoia, but they were Dedo's favourite relations. A strong current of mental instability runs through the Garsin family, and it is important to understand this in relation to Dedo's subsequent behaviour in Paris. His debonair uncle Amedeo appears to have been extremely unbalanced, and many similarities had already been seen by Eugenia herself between uncle and nephew; his aunt Gabriella committed suicide in 1915, and his own brother Umberto was given to temperamental excesses. But the family tolerated and helped its more unconventional members, who actively contributed to Dedo's education.

The household was divided in two: Flaminio, alone on one side, everyone else on the other; they all depended on the formidable character of Eugenia. It is not so much that she blamed her husband for their financial ruin, but for the fact that he did not appear to have any redeeming intellectual qualities; even if he had, it would have been hard to confront the scholarly Garsin barrage with any kind of independent argument; so Flaminio preferred to retire to his own world: it was probably safer for him to appear self-effacing in order to achieve any kind of domestic tranquillity. It is possible that Dedo came to understand this years later, when he in turn shied away from dogmatic artists, who were otherwise his equals in every way.

In 1886, Eugenia decided to supplement the family income by working; probably the aim was partly to cast herself in the role of the self-righteous mother sacrificing all to bring up her children (a rather characteristic Jewish

matriarchal ideal). And she revelled at the idea of doing something so actively nonconformist in the face of her husband's conservative family. She translated Gabriele D'Annunzio, ghost-wrote articles on Italian literature for an American writer and then, with the help of her sister Laure, herself a literary critic, opened an experimental school for children from middle-class families with intellectual pretensions – quite an achievement in this sleepy provincial city. She was helped in her efforts by Rodolfo Mondolfi, perhaps the most erudite scholar in Livorno and also a spiritualist; he brought Dante and Nostradamus to the Garsin programme, and these were two sources that Dedo was to refer to all his life: in Paris he would recite Dante at length, and a number of portrait drawings bear quotations from Nostradamus's predictions.

Laure represented the avant-garde in an already progressive household: her particular interests were Friedrich Nietzsche, Henri Bergson and Piotr Alekseïevitch Kropotkin, all of whom she made Dedo study. So from the very beginning, he was taught to question established values and to be self-critical, in order to aim at continuously surpassing himself. These ideals are to be found in most of late nineteenth-century thinking, but above all in that of Nietzsche, whose doctrines provided Modigliani with a philosophical framework for his own ideas.

What he learned from this mixed intellectual background was chiefly tolerance, and from his eccentric relations a certain degree of psychological perception. This enabled him to understand and befriend a wide range of people in Paris. His respect for genius, again based on Nietzsche, enabled him to see, before anyone else, beyond Maurice Utrillo's alcoholism and Chaïm Soutine's frankly repellent appearance.

The Modigliani household was seen by the locals as an eccentric but patrician one. Eugenia dressed in rather extraordinary clothes, and presided over tea-parties where the tone was distinctly Anglophile. A friend of Dedo's remembers going there and drinking tea for the first time – something Livornese society did not (and still does not) indulge in; the effect on the poor boy was soporific. Dedo in turn would go to this friend's house to enjoy the *torta di cecei*, a typically northern Italian working-class dish made of chick-peas, which was his favourite. At home, all aspects of English culture were admired, especially those linked to its traditional liberalism; Oscar Wilde was something of a family hero, and the last gift Eugenia made to her son before he left for Paris was a beautifully bound copy of *The Ballad of Reading Gaol*. Although Dedo was bilingual in Italian and French, it is not entirely clear as to how fluent he was in English at this time.

As the youngest child and a strikingly beautiful one at that, Dedo grew up rather capricious and undisciplined, all the more indulged since he was sick

1

with various pulmonary complaints. Summer 1895: 'Dedo has been seriously ill with pleurisy and I haven't quite recovered from the terrible scare he has given me. The child's character is not quite formed for me to give here an opinion of it. His manners are those of a spoilt child who is not lacking in intelligence. We shall see what lies inside this chrysalis. Maybe an artist?' It is generally presumed that it was during childhood that he contracted tuberculosis, but this is hard to determine because his mother never mentions it in her diaries. Certainly, in the photographs, he looks healthy enough and during his adolescence even portly. But it is certain that his childhood illnesses weakened his lungs; he may also have already contracted the dormant variety of tuberculosis, which was to declare itself when he was in his thirties, but then it was not to be of the pulmonary kind anyway.

From her notes made in her diary, Eugenia was picking up signals from her child that indicated a visual imagination rather than a studious frame of mind. He may have enjoyed drawing more than his brothers and sister, but Eugenia gave credence to these inclinations only later when, in a delirious attack of typhoid, he revealed his wish to paint. Her first priority however, as she saw it, was to give her son an adequate education and to leave decisions about his career until he had finished his studies. This attitude is not unreasonable, although some biographers have seen in it a desire on the part of his family to repress his talents. His mother had no point of reference as far as her son's aspirations were concerned. The Jewish religion forbids the practice of figurative art (as being an imitation of the divine faculty of creation), so without necessarily being religious, Eugenia did not have a spiritual ancestor to look back on: there was no artistic equivalent of Spinoza or Mendelssohn; and then Livorno is no artistic centre, although a late Medici creation; it has no important historic monuments and, until recently, had no museums either.

At thirteen, he underwent his barmitzvah, the Jewish ritual whereby the adolescent is admitted into the male community as an adult. His religious education was otherwise kept to a minimum, and the only prayer he knew was the Kaddish, the prayer for the dead which he was to sing (for Jewish liturgy is always sung) one evening at a friend's house, when he knew the end was near.

In 1898, when Modigliani was fourteen, his brother Emanuele, aged twenty-six, was sentenced to six months' imprisonment in Livorno for his activities as an anarchist and a socialist. His family – his mother rather than his father – gave him moral support and approved his ideals. In the same way, Eugenia was to contribute as much money as she could to her youngest son's survival when he was struggling to become an artist in Paris. She wrote

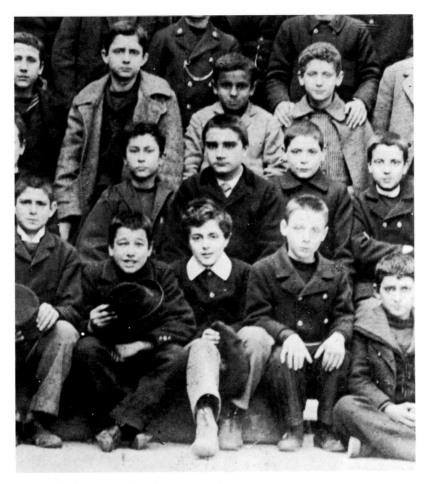

1 Modigliani as a schoolboy (front row, third from right)

to him there every month, enclosing prepaid postcards. The few surviving letters show that what united them was not the stipend, which both thought normal, but a passionate understanding of each other's motivations; the same emerges from the correspondence between Emanuele and his mother. Her domineering manner, although well meaning, could have utterly crushed and emasculated either of them, but it was her inherent respect for her children shown by her continuous support that maintained the balance of their relationship.

2 *Country Road, c.* 1899

Meantime, Dedo's studies at school had become particularly slack, much to his mother's dismay. 17 July 1898: 'Dedo has not done well at his exams, but that does not surprise me in the least because he has studied very badly all year. On the first of August, he begins drawing lessons, which he has wanted to for a long time. He thinks he's already a painter; as for me, I don't really want to encourage him, in case he completely neglects his studies to pursue this shadow.' Yet in the face of her son's determination, Eugenia felt she had to submit, whatever her misgivings.

Modigliani was enrolled in 1898 at the art academy in Livorno run by Guglielmo Micheli, a pupil of Giovanni Fattori, the famous Macchiaioli painter. The Macchiaioli were a group of painters interested in naturalism and who used techniques loosely derived from Impressionism; as *macchiare* means to stain, the term was initially a derogatory one, just as it had been for the Impressionists, although by now their style had become recognized, even academic.

Under Micheli, he was given a sound traditional training in portraiture, landscape, still-life and the nude, which as his fellow students recall he was best at. His interest in the nude was not purely academic, as, parallel with his studies, he was busy seducing the household maid; at fifteen, he may have

3 *Portrait of a Young Boy* (Guglielmo
Micheli's son?), *c.* 1900

blushed easily in conversation at art school, but he made up for it with
considerable precocity in other fields. A landscape and a couple of portraits *2, 3*
have been ascribed to him. They are painted with a certain amount of skill,
but, in their relative banality and lack of distinction, could be the work of
any of Micheli's students, and it is for this reason that they are not often
included in the biographies. Most writers prefer to say that all the early work
has disappeared, maybe to save themselves the embarrassment of having to
admit into the Modigliani *œuvre* such unassuming work. If they are not by
Modigliani, the pictures he did paint must have been very similar; anything
out of the ordinary would have been noted by at least one of his fellow
students, most of whom have left testimonials of their acquaintance with

Modigliani. The interest of these works is historic and although they display some talent, it is hard to say in which direction it will go.

It is interesting to compare his early achievements to those of his contemporary Pablo Picasso (born in 1881), when they were both the same age. Significant parallels can be drawn at certain stages of their development. Picasso's earliest work in Barcelona is, if anything, more conventional and academic than Modigliani's, and he appears to concentrate more on technical virtuosity than on self-expression.

There is one rather remarkable charcoal sketch very different in style from the previous examples and the later pictures painted in Paris: it is prominently signed 'A. Modigliani', and could be a self-portrait. It certainly resembles his physical appearance, and the forceful elegance of the drawing reveals great talent and promise.

His work met with the approval of both his teacher and Fattori, who would always stop at Micheli's studio on his visits to Livorno. Modigliani one day coloured a still-life with smoke and this met with Fattori's admiration; his innovations were always very acceptable. He seems to have been very proud of himself, and this caused Micheli to nickname him

4 Pablo Picasso, *Holy Communion*, 1896

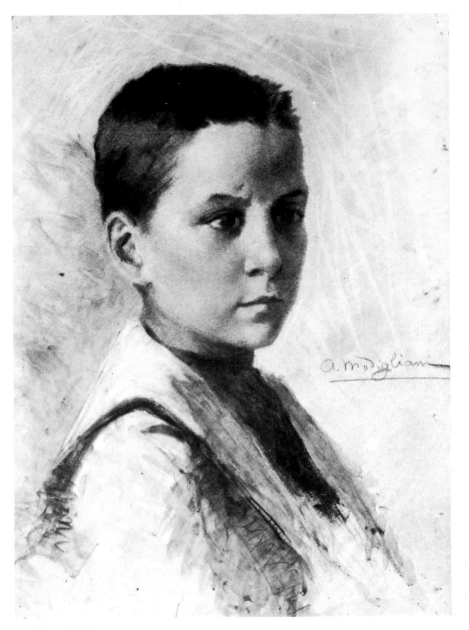

5 *Self-portrait* (?), *c.* 1900

'Superman', especially as he quoted from Nietzsche's *Thus Spake Zarathustra* at every available opportunity. His father ironically referred to him as 'Botticelli'.

Micheli also gave the students lectures in art history, which more than anything were to influence Modigliani's artistic thinking. He got them to write long essays on subjects they chose themselves. Modigliani wrote on the Pre-Raphaelites, a fashionably decadent subject bound to impress the other students. His early artistic tastes were naturally influenced by his family in that they were so literary. Early witnesses at Micheli's academy say that he read Charles Baudelaire and also D'Annunzio, whose cult of corrupt beauty expressed through Symbolist imagery influenced the whole of Modigliani's generation. And then there was the rèlatively unheard-of – in Livorno, at any rate – Lautréamont.

The comte de Lautréamont (born Isidore Ducasse, in Montevideo, in 1846) died in Paris at the age of twenty-four, ridden by anxiety, after having written *Les Chants de Maldoror*, extraordinary for their poetical intensity, fantastical juxtapositions and corrosive sadistic imagery. Considered insane by early critics, he became the pivotal poetic source for the Surrealists in Paris (led by André Breton). *Maldoror* became Modigliani's favourite book, and he learnt it by heart; the significance of this choice will become clear in later chapters. The fact that he knew and appreciated this book so early on is

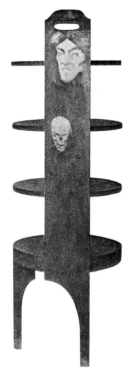

6 *Shelving-stand*, 1898 (and details opposite)

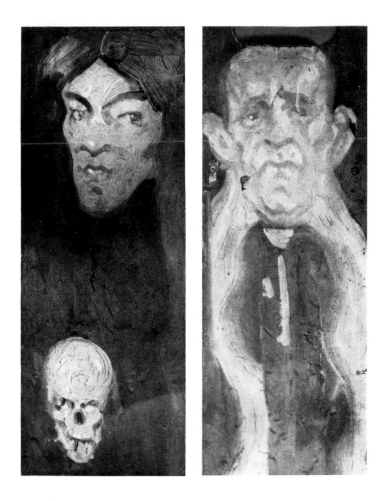

an indication of the extent of his somewhat unsystematic erudition and also an important pointer as to the nature of his tastes.

Lautréamont, Nietzsche, Bergson, even D'Annunzio and Wilde, all advocated in their different ways the cult of the individual creative mind excluded from society by the independence of his intuitive beliefs and will to self-realization. Modigliani upheld this ideology all his life by assuming the role of the decadent *artiste maudit*.

This outlook influenced some aspects of his imagery both in Livorno and Paris. In 1898, the year he started art school (and according to his mother, already convinced he was an artist), he painted a shelving-stand with his *6*

friend Uberto Mondolfi, the son of Roberto who had helped Eugenia Modigliani with her school. Uberto had thought up the iconography: a woman with a skull on one side, a man on the other – a rather Symbolist-cum-*Jugendstil* image, not very skilfully painted. Romiti, a fellow student, says that a little later Modigliani was thinking about a picture to be entitled *The Song of the Swan* which recalls the Pre-Raphaelites or D'Annunzio in concept, but unfortunately no trace remains.

It was at the Caffè Bardi rather than at Micheli's that he learnt about the latest trends. There the local established and also aspiring artists would congregate – Modigliani, Natali, Sommati, Romiti, Martinelli and many others – and compare standpoints. The importance of cafés for Mediterranean artists must not be underestimated. It is part of the intimate fabric of their lives; the route from the Caffè Bardi (or the Quatre Gats in Barcelona) to La Rotonde in Paris is a direct one. Indeed it was for the Caffè Bardi that Modigliani headed when he was to return briefly to Livorno in the summer of 1912, looking for his old friends who were all, by then, leading undistinguished careers, not all of them in art. Modigliani was unrecognizable; instead of the quiet nonchalant young man, here was a haggard wild-eyed sculptor, dressed like a tramp, who ordered absinthe in irascible tones. When he proudly showed his friends photographs of his sculptures, they looked at him aghast and said he was mad. This certainly reinforces the idea that his early work must have been extremely conventional, if not totally undistinguished. Modigliani was never to return to Livorno again.

Like many precocious adolescents, Modigliani felt unable to communicate with his exact contemporaries and he chose friends older than himself, among them Uberto Mondolfi and Oscar Ghiglia, both seven or eight years older than he was. We shall see how this trend was later to be reversed, and Modigliani was to look for the admiration of younger companions. Oscar was eight years older than Modigliani, a jack-of-all-trades, self-taught but extremely talented, and he was to lead a successful career as an artist. He may have shown Modigliani how limited his life in Livorno was, especially if he had aspirations to fame and self-realization. Their correspondence, of which Modigliani's letters survive, shows the importance of this friendship.

In 1901, when Modigliani was seventeen, Eugenia decided to take him on a trip to Capri because of his health and because she realized that her son was getting restless at home. During this trip, he wrote a number of revealing letters to Oscar, which are our only documents on his intimate thoughts and feelings at the time. The vocabulary at times is rather mannered, and the

sentences convoluted; he uses writing as a means of working out ideas, and not of stating his conclusions, hence the occasional verbose confusion, with shades of Baudelaire and D'Annunzio; but underneath it all runs a current of warmth and enthusiasm that infuses these letters with unique poetry. The translation has been kept as literal as possible, complete with original underlining, paragraphs and lack of capitals.

Dearest Ghiglia

. . . and this time answer unless your honours have weighed your pen down. I have just read in the 'Tribune' the announcement of your acceptance in Venice: Oscar Ghiglia, self-portrait. I suppose that it is the self-portrait you spoke to me about and that you were already planning in Livorno. I rejoice for you very much and most sincerely. You can believe that this news has really moved me. I am here in Capri, a delightful place, by the way to look after my health. It is now four months that I have not brought anything to conclusion, just accumulated material. I shall soon be going to Rome and then Venice for the Exhibition . . . I'm behaving like an English tourist. But the time will soon come when I probably will have to settle in Florence and work – in the best sense of the word, that is to dedicate myself with faith (head and body) to organizing and developing all the impressions, all the seeds of ideas that I have accumulated in this peaceful place as in a mystic garden. But let's talk about you: we left each other at the most critical point of our intellectual development and we have gone our separate ways. I should like to meet you now and talk to you.
Do not take this letter as one of vulgar congratulations but as a testimony to the sincere interest in you from your friend
<div align="center">Modigliani</div>

Hotel Pagano, Capri.

Villa Bitter Anacapri The Island of Capri

Dearest Oscar

still in Capri. I wanted to wait to write to you from Rome: I shall go there in two or three days, but the wish to talk to you a little has made me take up my pen. I do believe that you've changed under the influence of Florence. Would you believe that I have as well, travelling in these places? Capri whose name alone would evoke in my mind a tumult of images of beauty and antique sensuality appears to me essentially a symbol of springtime. In the classical beauty of this landscape there is (for me at any rate) an omnipresent and indefinable feeling of voluptuousness. And even (despite the English invading with their Baedekers) a glittering and venomous flower emerging from the sea.
So much for poetry. Imagine besides (these things only happen in Capri) in the countryside by *moonlight* with a Norwegian girl, alone . . . in truth rather

erotic but also very pretty. I don't exactly know when I shall be in Venice; besides, I shall let you know. I should like to visit it with you. Micheli? Good God, how many there are in Capri . . . whole regiments.

How's Vinzio? He's made a good start with that little picture of his. Is he progressing or is he staying put? Answer me. And that is really why I am writing, to know what is going on with you and with the others.

Greetings to Vinzio Ciao Dedo

April 1st. Write Rome, Poste Restante.

Dear friend

i write to pour myself out to you and to affirm myself to myself.

I am the prey of great powers that surge forth and then disintegrate.

But I should like my life to be as an opulently abundant river flowing over the land with joy. You are now the one I can henceforth tell everything to : well – I am rich and fecund with germination and I have need of the *work*.

I have the excitation [*orgasmo* in the original Italian], but the excitation which precedes joy, which will be followed by the dizzying uninterrupted activity of the intelligence. Already after having written this, I think that such a state of excitation is a good thing. And I shall free myself from this excitation by throwing myself into the great fight, hazard, war with a kind of energy and lucidity hitherto unknown.

I would like to tell you what are the new weapons with which I take up more the joys of battle.

A bourgeois told me today – insulted me – that I or at least my brain was lazy. It did me good. I should like such a warning every morning upon awakening: but they cannot understand us nor can they understand life.

I shall not speak of Rome. As I speak to you Rome is not outside but *inside* me, like a terrible jewel set upon its seven hills, as upon seven imperious ideas.

Rome is the orchestration which girds me, I isolate myself within her limits and place there my thoughts. Her feverish sweetness, her tragic countryside, her own beauty and harmony, all these are mine, for my thought and for my work.

But I cannot tell you all the impressions that I have found in her, nor all the truths.

I am going to start on a new work and since having defined and formulated it, a thousand new ideas surge forth from everyday life. You can see the necessity of method and application.

I am also trying to formulate with the greatest lucidity the truth about art and life gained scattered amidst the beauties of Rome and as I have understood their intimate link, I shall seek to reveal and to recompose their construction, I could nearly say their metaphysical architecture, in order to create my truth of life beauty and art. Goodbye. Speak to me about you as I speak to you. Isn't this the aim of friendship: to shape and exalt the will

according to its bent, to reveal oneself to the other and then to both ourselves.
Goodbye your Dedo

Dearest Oscar

you had promised me a daily account of your life from the time we separated until now . . . I await it impatiently.

As for me not keeping my promise, I cannot do so because I'm incapable of keeping a diary. Not only because no exterior event has penetrated my life, but also because those that take place in one's innermost soul cannot be expressed whilst we are still under their domination.

Why write when you are still in the process of feeling? These are all stages of evolution through which we have to pass and that have no importance other than the goal they lead us to. Believe me, the only work which is worthy of being translated into style is that which has arrived at the end of its gestation, fully mature and freed from all the cumbersome incidents that have contributed to fecund and produce it. The efficacity and necessity of a style is in that it separates the idea from its creator leaving room for all that cannot and should not be expressed, and style is the only vocabulary that can bring out this idea.

Every great work of art should be considered like any work of nature. First of all from the point of view of its aesthetic reality and then not just from its development and the mastery of its creation but from the standpoint of what has moved and agitated its creator. These are purely dogmatic questions anyway.

But rather, why haven't you written to me? What about your paintings? I have read the description of one of them in an article in the 'Corriere'. I cannot bring forth a picture yet; I have to stay at a local hotel; you realize the impossibility of dedicating myself to a painting; however, mentally and in the contemplation of nature *I am working very much*. I think I shall end up changing residence: the savagery of tourists and holiday-makers renders concentration, especially that I now most need it, completely impossible. I'll finish by going to the Austrian Tyrol. Don't speak about it at home yet. Keep on writing Hotel Misurina, Misurina. Goodbye. Write to me, send me what you have promised. The habit of contemplating the countryside and alpine nature will mark, I think, one of the greatest changes in my spirit. I should like to speak to you of the difference between the artists who have most communicated and lived with nature and those who today seek their inspiration in their studies and want to educate themselves in art cities.

Does one amuse oneself in Livorno

[no signature]

Dearest Oscar

I have received your letter and regret tremendously the loss of the first one you sent to me. I understand your distress and your discouragement and this alas more from the tone of your letter than from its actual contents. I can guess the reason and believe me, I too have suffered and

feel for you, sincerely. I don't exactly know yet the events that have caused this, but knowing you are a noble soul, I know that this situation must have produced a sad reduction of yourself, of the right you have to joy and life, as well as bringing you to this state of dispiritedness. Again I do not know what the reasons are, I repeat, but I believe that the best remedy would be to send you a breath of life from my sturdy heart because you are created, believe me, for intense life and joy. We (forgive the 'we') have different rights from other people which place us above − one has to say and believe it − their morality. Your duty is not to consume yourself in the sacrifice. Your *real* duty is to save your dream. Beauty has some painful duties yet they bring about the most beautiful exertions of the soul. Each obstacle that we overcome indicates an increase in our will-power, and produces the necessary and progressive renewal of our ambition. You must have the sacred belief (and I say this for you . . . and for me) in everything that can exalt and excite your intelligence to its maximum creative power. For this we must fight. Can we confine this research within the narrow limits of their morality? Affirm and surpass yourself always. The man who cannot spring continuously from his energy new desires and almost fresh creations destined to affirm himself and crush everything is not a man but a bourgeois, a freak, call him what you will. You are suffering, you are right, but couldn't your suffering spur you on to a further renewal and to elevate your dream still higher, even stronger than desire? You could have come this month to Venice, but take your time to decide, don't exhaust yourself, get used to putting your aesthetic needs above your duties towards men. If you wish to flee Livorno, I can help you as much as I am able to, but I don't know if it is necessary. It would be a joy for me, Answer me in any case. From Venice, I have received the most precious teachings of my life; from Venice, I seem to go forth with a feeling of fulfilment just like after completing a work. Venice, head of Medusa with countless blue serpents, sea green immense eye in which the soul is lost and exalted to the infini . . . [infinite is what he meant, the word is incomplete.]

[no signature]

With Oscar, as with no one else, he could fill his overflowing need for self-expression; communication for the youthful Modigliani was more a question of clarifying his ideas to a receptive listener than a real discussion of ideals; his passion for Oscar was based on what united them as idealists, on their solidarity as exceptional beings who spurned conventional society and bourgeois morality. We do not know to what extent Oscar actively supported these ideas, but they are fairly typical of their generation, as Modigliani was to discover later in Venice where he met the young men of his generation who were to invent Futurism.

From his letters, we get occasional glimpses of his daily life. In Capri, he has a brief affair with a Norwegian girl (he was frequently to choose Nordic

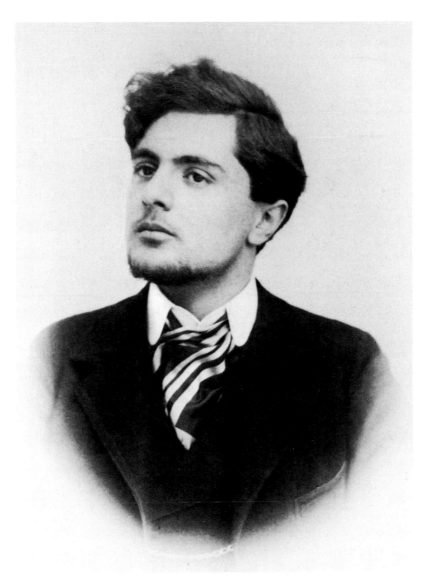

7 Modigliani as an adolescent

lovers): the romantic aspect of the situation strikes him more than the actual girl. He is annoyed by English tourists who scuttle all over the country on their Grand Tour. A bourgeois taunts him, accuses him of wasting his time and being lazy: Modigliani is delighted and even proud of this bourgeois affront, which only reinforces his belief in how exceptional his mission is: the bourgeoisie 'cannot understand us nor can they understand life'. Modigliani is, at this stage, sensitive about nature, which, considering his career as a portraitist and his essentially urban life in Paris, is unexpected.

From Capri then, he travelled to Rome, Misurina and Venice without his mother. We cannot be certain if he reached the Austrian Tyrol as he had planned. In Rome, it is likely that he called on his relations and there would have discovered that he had two cousins on his father's side who were also artists: Olga and Corinna Modigliani; Corinna had become a popular portraitist. He would have found them in no way inferior to the Garsin, and this would have made him even more proud of his ancestry.

It may be asked why Modigliani did not paint anything during his travels. At one point, he writes that it is impossible to get down to work in a hotel room, although later in Paris he was to live and paint mostly in such environments; then, he writes that it is hard to concentrate with so many tourists around him. The real problem was that he must have been at a loss as to what to paint. Having discovered that Capri was teeming with Michelis, he was no longer interested in painting naturalist Macchiaioli pictures, especially as his own ideology was quite opposed to their naturalist creed. One imagines that, had he had the opportunity or the technical experience, he would have painted involved Symbolist pictures. Furthermore, his intellectual background had been mainly a literary one: he had learnt, in his own estimation, far more from books and philosophical discussions than from art school training, so that he basically still lacked visual experience. He was to compensate for this when he lived in Florence and Venice. Modigliani's letters give the impression that he had a need primarily to situate himself within a higher order of things, to understand what the moral function of a creator was – within the terms of reference he had chosen – before actually creating anything. He wanted to construct his 'metaphysical architecture' in which he could create his 'truth of life, beauty and art'. His philosophy has very little direct connection with painting altogether – his letters could equally well have been written by a young writer in the wake of his own creative forces. The process of artistic creation is explained with marvellous perspicuity; Modigliani repeatedly refers to fecundation and gestation, implying that his role as a creator is a female one. His honesty would have been admired by later psychoanalysts, especially as his letters reveal with remarkable clarity the flow of his unconscious mind.

24

When he actually started painting seriously in Paris, he no longer cared to make verbal statements of intent, and deeply despised theories like Cubism that imprisoned artists within a stylistic strait-jacket.

On 7 May 1902, we find Modigliani registered at the Scuola Libera di Nudo in Florence, an art academy where he could draw nudes. Henceforth and until his death, he regularly attended life classes.

Nothing survives from his stay in Florence; it is possible that much time was spent in discussion with Oscar, with whom he shared lodgings; this was the first time that Modigliani had actually lived away from home and he probably enjoyed his new-found freedom. He had now ample opportunity to look at Tuscan art, but it is only from his later work in Paris that we can see what has struck him the most. The artists who left an indelible mark on his unconscious mind all came from these regions: the sculptor Tino di Camaino, Duccio, Sandro Botticelli, Francesco Parmigianino. He made a documented trip to Pietrasanta and Carrara, to Michelangelo's quarries, and that may have determined his desire to become a sculptor; it was indeed as a sculptor that he was to introduce himself when he arrived in Paris. But nothing is known of any practical forays in the field; it may well have remained a carefully nurtured dream until Paris.

Oscar married in 1903; this may have been one of the reasons which made Modigliani leave for Venice. In constant need of attention as he always was, he probably realized that Oscar now had less time for him and that he could no longer be the focus of every discussion.

In March 1903, he arrived in Venice, registered at a similar academy and was probably financed by his uncle Amedeo Garsin whose favourite he was. Two years earlier, he had declared to Oscar that it was in Venice that he had 'received the most precious teachings' in his life. It was probably then that he had made plans to return one day to the city. Venice exerted enormous fascination on most young artists of his generation, not least the anarchic Futurists, some of whom he met often at the Caffè Florian in the Piazza San Marco.

. . . O Venice, old procuress, who under your heavy mosaic mantilla, still eagerly prepare exhausting romantic nights, querulous serenades and frightful ambushes! Nevertheless, O Venice, I used to love the sumptuous shade of your Grand Canal steeped in exotic lewdness, the hectic pallor of your women who slip from their balconies down ladders woven of lightning, slanting rain, and moonrays to the twinkle of crosses . . .
And yet once you were the invincible warriors and gifted artists, audacious navigators, ingenious industrialists and tireless merchants . . . And

you have become waiters in hotels, ciceroni, pimps, antiquarians, imposters, fakers of old pictures, plagiarists and copyists. . . . Free Torcello, Burano and the Isle of the Dead from all the diseased literature and all the endless romantic embroidery draped over them by poets poisoned with Venetian fever . . .

<div align="right">(R. W. Flint, ed., Marinetti: Selected Writings.)</div>

Modigliani, like Filippo Marinetti, suffered from Venetian fever, the fateful lure of the now decadent city. In this his Futurist Speech to the Venetians, Marinetti unwittingly explains with poetic fervour what made the city so attractive to young artists steeped in Symbolism at the turn of the century. Modigliani had found a city whose whole atmosphere echoed exactly his own feelings and he gave in to it completely, whereas Marinetti was combating its fatal attraction by evoking grandiose visions of a mechanized universe.

In Venice, Modigliani met Giovanni Papini and two young artists who were to become greatly involved in Futurism: Ardengo Sofficci and Umberto Boccioni. At that time, the three still had a great deal in common, and their mutual ideals were based on a passionate understanding of Nietzsche. They saw their artistic mission as a great battle against bourgeois morality and prejudice; Modigliani's warlike ardour in his third letter to Oscar was shared by all his companions. Later, the Futurists took Nietzschean principles further by insisting on the destruction of conventional art culture because they felt that it imprisoned people in the virtues it incarnated; this was the only aspect of their philosophy Modigliani was to disagree with. How surprised Modigliani would have been to know that only a few years later (in 1910) Boccioni was to be involved with a group of Futurist artists in the launching of 800,000 copies of Marinetti's 'Against Passéist Venice' manifesto, which contained suggestions like 'Let us burn the gondolas, rocking chairs for cretins and raise to the heavens the imposing geometry of metal bridges and howitzers plumed with smoke to abolish the falling curves of the old architecture' (R. W. Flint, ed., *Marinetti: Selected Writings*).

When collecting signatures for the Futurist manifesto in Paris in 1909, Gino Severini thought it quite natural to approach his compatriot and friend Modigliani and was quite startled at his refusal to sign it. The great difference was that the exaltation Modigliani had felt in Venice was not based on a desire to create a new civilization, but on a feeling of communion and integration within a culture whose principles he was to renew for the twentieth century within the framework of a tradition.

At first, Modigliani lived in the elegant San Marco area, within walking distance of the Caffè Florian and all the fashionable meeting-places; then,

when the money ran out, he moved to the artists' quarter of San Barnaba, across the bridge from the Accademia, and finally to the Rialto, a more working-class area; between these addresses, he shifted across Venice, staying with new-found friends or chance acquaintances, much as he was to do in Paris. Venice lent itself to adventure and experiment, and Modigliani, exalted by the perspective of endless possibilities, pursued pleasure and hazard like the youthful Casanova.

It was at this time that a mysterious Baron who organized orgies for his young companions introduced him to *paradis artificiels* (artificial paradises), namely hashish taken orally, as Baudelaire recommended. In the last surviving letter to Oscar, Modigliani had put forward the idea that intelligence and creativity had to be stimulated by any means; he probably did not know about drugs at the time, but inferred that he was willing to try anything that would exalt his imagination.

'He who looks to a poison in order to think will soon be unable to think without it. Picture if you will the appalling fate of a man whose paralysed imagination would be unable to function without the help of hashish.' Baudelaire, in *Les Paradis artificiels* (first published in 1860) had understood that this drug, without being necessarily physically addictive, could create a state of mental dependence. Modigliani was to build up this mental reliance on external stimuli, especially as drugs, and later alcohol, were also to provide a refuge from what was to become an increasingly hostile world.

Venice was also the most cosmopolitan city of Italy in that it attracted a floating population of artists, musicians and writers from all over the world, drawn by its history, its myth and now by the exhibition at the Biennale that had recently been created in 1895. So Modigliani's world now opened up: for the first time, he had the opportunity of experiencing as well as discussing modern European art, and this was to be a revelation for him. During the years he lived there, the Biennale showed Impressionism and Rodin rather than the more fashionable Symbolist and Art Nouveau tendencies – Klimt was given a show there only in 1910. Modigliani's early work in Paris shows that he was interested in the descriptive art of the Pre-Raphaelites, Henri de Toulouse-Lautrec, James Abbot McNeill Whistler and Edvard Munch; he was familiar with their work before his arrival in France. If he did not see their work in the original, he may have seen that of their imitators who thronged Venice, and also most European art magazines which were now available to him, like *The Studio* or *The Yellow Book* or perhaps even the satirical *Assiette au Beurre* to which many avant-garde artists in France contributed illustrations.

Modigliani's own taste at that time inclined towards Art Nouveau, called in Italy *Stile Liberty*, which appears to have been somewhat less popular in

Venice than in other Italian cities. It was the style adopted by a more literary avant-garde, youthful and introspective, and characterized by a self-indulgent, *fin-de-siècle* morbidity. These were the circles where the Baron recruited participants for his orgies, and this is where Modigliani met Guido Cadorin, who was to become an extremely talented painter. They immediately became friends although Guido was only thirteen.

Baudelaire says that the use of hashish makes one feel extremely protective towards lesser beings, but in a rather patronizing way. But with Modigliani this feeling went deeper. With the exception of the occasional father figure, he henceforth needed the unquestioning admiration of younger friends, who did not echo his self-doubts or put his beliefs to the test. In the face of the diversity of opinions he was encountering daily, he may have felt disconcerted, disorientated even; his own beliefs had sprung naturally from his creative impulse, guided by the study of Nietzsche and D'Annunzio; they did not rest on a reasoned structure and could not be questioned without the fundamental rationale collapsing. Passionate enthusiasm is not to be argued with as it gushes forth tumultuously, in one direction only, so no reasonable discussion could be possible with Modigliani; he was bound to take any disagreement as a personal insult. This was certainly to be the case in Paris, where he isolated himself progressively from the literati and artists of equivalent intellect and culture, in order to avoid confrontation. His passionate character, linked to his chronic inability to distance himself emotionally from the problems under discussion, made him terribly vulnerable, and he overcompensated from the start by behaving in a haughty, often aggressive way if ever he felt in the least bit threatened. Two more contributory factors must be taken into consideration when attempting to understand his aggressiveness: his height and his shyness. Although extremely good-looking, he was rather short by contemporary standards, measuring 5ft 5in.; moreover, since childhood, he had been extremely shy; his frequently pugnacious behaviour must be seen as an effort to conceal and compensate for what he considered personal failings. Modigliani, it must be remembered, was extremely ambitious and expected prompt recognition.

In her diary, his mother indicates that his main painting activity was portraiture. The only known work from this period is the portrait of Fabio Mauroner. It was shown at the Biennale of 1930, but until very recently its whereabouts have remained unknown. The most striking feature of the portrait is the directness of the sitter's gaze and the intensity of the expression. Is this one surviving work prophetic of what was to follow? The style changes, but the uncompromising directness of approach remains the same.

8

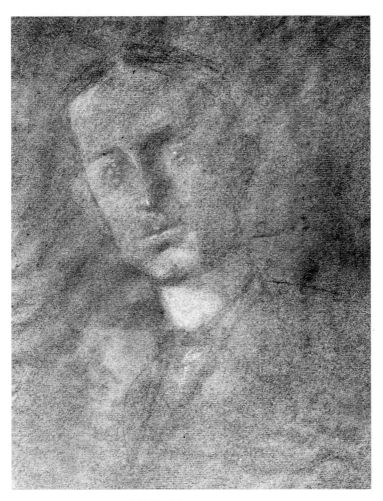

8 *Fabio Mauroner, c.* 1905

In 1905, his uncle Amedeo Garsin died, and this meant the end of his
subsidy. By now, Modigliani probably felt that Venice no longer provided
the challenge and stimulation he needed. He had outgrown the possibilities
the city offered, and, like all artists of his generation, felt attracted to that
Mecca of modern art, Paris. So in the winter of 1906, he set off.

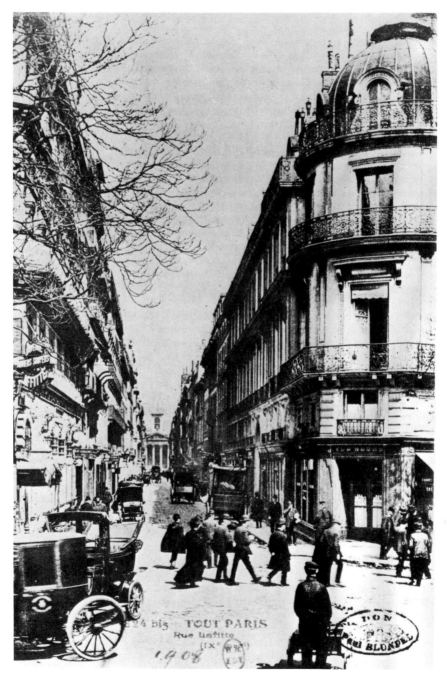

9 The rue Lafitte, 1908

Montmartre 1906–09

'*O Paris*
Gare centrale débarcadère des volontés carrefour des inquiétudes'
(O Paris/Central railway station landing-stage of destinies cross-roads of anxieties)
(Cendrars, *Prose du Transsibérien et de la petite Jeanne de France*, 1913)

Modigliani arrived in France in the cold winter months of 1906. As in Venice, he allowed himself a few days of luxury in a hotel centrally situated in the place de la Madeleine, taking the city in at a gentle pace like any bourgeois traveller. It was too early to consider seriously plans to survive as an artist. Unlike many of the artists who arrived in Paris early in the twentieth century, he had two great advantages: he spoke French fluently, and he could depend on a regular income from home, even if it was minimal; this gave him a comforting sense of self-sufficiency and confidence. Modigliani had come to Paris to further his career as an artist, not as a student or a refugee, and his sense of propriety forbade him all his life to consider any other kind of work as an aid to financial survival, even when he encountered real poverty.

The hotel where he was staying was ideally located within walking distance of the new artistic centre round the rue Lafitte. Since the early 1890s, the area had become an important information centre for artists and public alike, and a dozen or so galleries had opened there; run on a low budget, their character reflected the often eccentric personalities of their owners.

No. 1, rue Lafitte was the headquarters of the *Revue Blanche*, that long-standing champion of progressive art; at no. 6, Cézanne's dealer Ambroise Vollard had his gallery where he showed Vincent van Gogh, Paul Gauguin and the Nabis; no. 8 was the premises of that renowned family of art dealers, the Bernheim-Jeune; at no. 16 were the Impressionist specialists, Durand-Ruel; next door, Clovis Sagot, one of the first to sell Picasso's work, had his showroom. Further up the road, an adventurous young woman, Berthe Weill, had recently opened a gallery where she exhibited the avant-garde, among them Picasso; in 1917, she was to give Modigliani his only one-man show (forcibly closed on account of the nudes exhibited in the window).

9

31

Nearer Montmartre, Père Soulié, a mattress-maker by profession, stacked paintings by the then unknown artists. He soon acquired a reputation, so collectors, dealers and painters alike visited him.

Picasso, who had been in Paris since 1904, is said to have urged Modigliani to Montmartre, saying it was the place where serious artists lived and worked. It is interesting to see how much the two artists had in common, hailing as they both did from great Mediterranean seaports, coming to Paris in search of fulfilment. The city, like a magnet, attracted young artists of their generation, who all seemed to arrive with a ready-made background of Symbolism and Art Nouveau. Paris became a recurring theme in painting and poetry before 1914, and the Eiffel Tower as a pictorial motif emerged in works as different as those of Marc Chagall and Robert Delaunay. Guillaume Apollinaire and Blaise Cendrars lingered on the nostalgic power of Paris as well as the intense loneliness engendered by the anonymity of big cities.

> *Je suis triste je suis triste*
> *J'irai au 'Lapin agile' me ressouvenir de ma jeunesse perdue*
> *Et boire des petits verres*
> *Puis je rentrerai seul*
> *Paris*
> *Ville de la Tour unique du grand Gibet et de la Roue*

(I am sad I am sad/I shall go to the Lapin Agile to reminisce about my lost youth/Have a few drinks/Then I shall go home, alone/Paris/City of the unique Tower of the great Gallows, of the Wheel)

(Cendrars, *Prose du Transsibérien et de la petite Jeanne de France.*)

10

The Lapin Agile was the renowned cabaret in Montmartre which had, since the 1890s, virtually become the symbol of the Butte to which Modigliani went after his first few weeks of exploration in Paris.

His primary reason for so doing was a mixture of yearning and nostalgia for artists he then revered. His Futurist compatriot, Severini, who had arrived in the same year as Modigliani, said that artists came to Paris to see the Impressionists. But for Modigliani, the latter-day Symbolists and Toulouse-Lautrec were just as important – and they too had congregated in and around Montmartre. Furthermore, living there was a way of advertising oneself as an artist, a way of gaining an identity without necessarily having to prove it. Montmartre was the heart of artistic Paris, just as Chelsea once was in London and SoHo is now in New York. When the centre shifted to Montparnasse in about 1909, Modigliani moved too.

It seems so completely paradoxical that in the tumbledown setting of the narrow streets of the Butte, so old-fashioned, so weighed down with

10 Maurice Utrillo, *Le Lapin Agile*, 1909

tradition there rose a new spirit, at once so clearsighted, so daring, so pure, that inspired a whole generation of artists and writers . . . could one imagine a more inappropriate place to lay down the foundations of Cubism than the cabaret of the Lapin Agile, dusty and romantic, echoing the strains of popular songs of the eighteen-thirties, sung by Frédé, with his florid beard wearing his great fur hat? . . . there lived Picasso, Derain, Van Dongen, Dufy, Braque, Modigliani, André Salmon, Pierre Mac Orlan, Dorgelès, Raynal and Apollinaire was a frequent visitor. . . . The facts stand: for ten years, those who contributed most to the modern spirit lived in Montmartre.

This romantic account of Montmartre was written in 1925 by André Warnod who was a writer well acquainted with the fauna of the Butte; he lived in the Bateau-Lavoir, the famous group of studios in a disused laundry in the rue Ravignan, which was to become synonymous with much of the progressive art before the First World War in Paris.

Cafés, bistrots and restaurants were the meeting-places where heated *10* discussions often occurred, and the protagonists of the contradictory schools of thought often had to be forcibly separated. 'Tell me where you eat and I'll

tell you how you paint' was a popular saying. Restaurant owners frequently accepted paintings in lieu of payment, which accounts for their premises becoming show-cases for the avant-garde.

Modigliani had a letter of introduction from his friend Manuel Ortiz de Zárate to the artist Granowski who remembers him as a shy, well-dressed boy who did not smoke and drank wine only in moderation. Oddly, Modigliani told the older man that he wanted to be a sculptor, though five years were to pass before he started on his earliest known sculptures.

His first studio in Montmartre has been described by the author and poet, André Salmon, as being fully equipped with a piano covered with plush draperies and a plaster cast of Beethoven's death-mask. Such luxury is unlikely and Modigliani could not really have afforded it anyway. This is probably a glorified approximation of his living conditions at the time, but it does indicate a definite taste for comfort. Salmon saw the bourgeois studio as a symbol of Modigliani's conventional approach to his career at the time. Salmon lived at the Bateau-Lavoir until his move to Montparnasse in 1909, and knew most artists in Montmartre, appointing himself as their champion. He was endowed with a powerful romantic imagination which he exercised to the full in his *La Vie passionnée de Modigliani*, written in the mid 1920s, in

11 *Seated Figure*, 1907/08

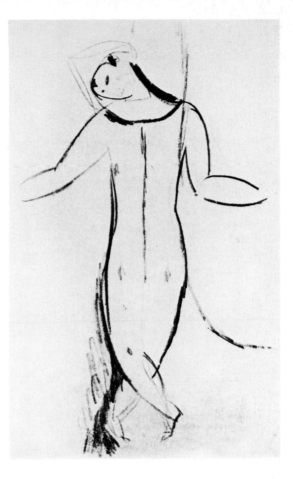

12 *Acrobat*, 1909

which the artist is seen as a timid mediocre painter, led simultaneously to genius and ruin by drugs and drink, and finally martyrized by both. This rather extraordinary novelette set the tone for most of the subsequent literature on Modigliani and has been the source for a number of fanciful reminiscences and films.

Modigliani established his subject-matter early on: with the exception of a handful of landscapes, nudes and portraits were all he ever painted. Following the trend he had set in Italy, he disdained naturalism completely – which was even more out of date in Paris than it had been in Livorno, as were, by Bateau-Lavoir standards, his inclinations towards Art Nouveau.

In his joyless depictions of women, Modigliani attempts to go beyond the *14-18* simple recording of their features to create symbolic evocations of internal tragedy. Later, he was to evolve an expressive language of line and form in

35

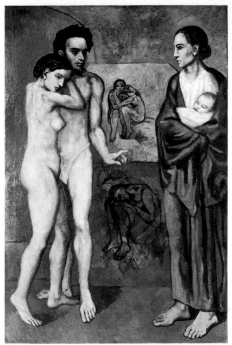

13 Pablo Picasso, *Life* (*La Vie*), 1903

which no formal props were needed. His research into total expression
11 through such concentrated means begins very early in his drawings.

These have much more in common with his later paintings than with
those he was working on at the time. Drawings have the freedom of first
drafts of poems; they are more open to graphological analysis because of
their immediacy, while their intimacy gives us an insight into the artist's
mind. Some reflect Modigliani's daily life: thumb sketches done in cafés, or
12 of acrobats at the Médrano circus where, Fernande Olivier tells us, Picasso
often went with Juan Gris, André Derain, Suzanne Valadon and Modigliani.
And yet, unlike Picasso, the fabric of everyday life never directly entered
Modigliani's paintings; he never copied any European works of art either
(unlike most artists at any period in history). The geometric simplification of
his drawing style at this time not only heralds later paintings, but indicates
Modigliani's early interest in Cézanne and African art, which was to develop
in both his painting and his sculpture.

A number of early paintings are predominantly blue; Picasso's blue period
13 immediately springs to mind as a source, yet Picasso's subject-matter is
decidedly more orientated towards making statements about deprived
categories of society. Modigliani is not interested in making specific social

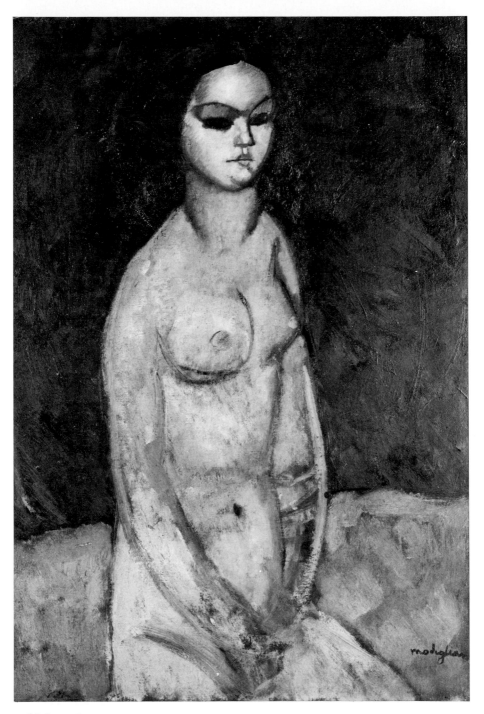

14 *Nude*, 1908

comments in his work – which does not necessarily entail that he was totally without a social conscience, as we shall see later – but aims at a more universal quality: in each nude painting, in each portrait, be it of a prostitute or an upper-middle-class doctor, he tries to say something about the human predicament in general. This is still a harking back to Symbolist attitudes to the function of art.

An early blue portrait of 1908 shows a woman with hair piled high in the fashion of the day. She wears a light blue dress and the background is in shades of cobalt; this is echoed in the pink and blue modelling of her face. The most striking feature is her obsessive blue stare. There are echoes of Toulouse-Lautrec and Steinlen, but Modigliani expresses the tenseness of his rapport with the model in a very personal manner. It is frequently in the depiction of the eyes of the sitters that we uncover the nature of his relationship with them.

> *Maintenant tu marches dans Paris tout seul parmi la foule*
> *Des troupeaux d'autobus mugissants près de toi roulent*
> *L'angoisse de l'amour te serre le gosier*
> *Comme si tu ne devais jamais plus être aimé.*

(Now you walk across Paris alone in the crowd/Herds of bellowing buses go past you/The anxiety of love tightens your throat/As if you were destined never to be loved again)

(Apollinaire, 'Zone', published in *Alcools*.)

If tension and anxiety recur like motifs in all his early paintings, they do not correspond only to a stylistic choice but to existing features in his life which now, in Montmartre, had become raw material for a classic tale of *la vie de Bohème*. Rapidly finding himself without money, he moved through a series of small hotels until he was thrown out, or crept out secretly, unable to pay for his lodging and leaving his paintings behind – this is probably why so little work is left from these years. He had no real studio of his own for much the same reason; the nearest he got to one was a shed at 7, place Jean-Baptiste Clément, near the Bateau-Lavoir.

Modigliani's position as an artist, a foreigner and a Jew in Paris was a precarious one. Since the Dreyfus affair, which had only just come to a belated conclusion in July 1906 with the rehabilitation of Alfred Dreyfus into the French army, anti-Semitism was never very far from the surface. This was something Modigliani had never encountered before, so he reacted violently to any provocation. One day, he challenged a whole group of officers seated at a café table who had been making anti-Semitic remarks. His tone was so fierce that they instantly stopped. It was in Paris that he

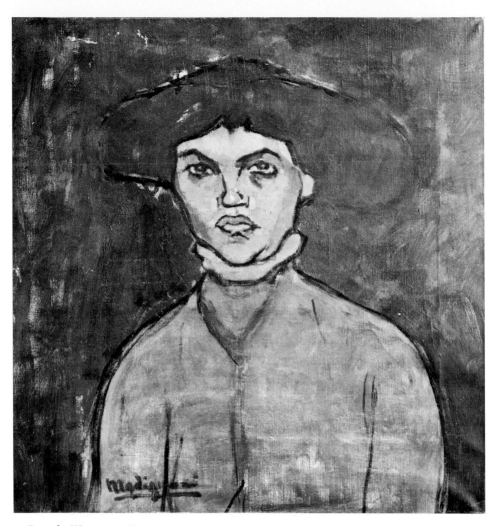

15 *Bust of a Woman*, 1908

developed an enlarged sense of Jewish identity and his closest friends were to be mainly Jewish: Soutine, Moïse Kisling, Jacques Lipchitz, Max Jacob.

As we have already seen in Venice, his general reaction to problems was one of escape: reversals of fortune and loneliness were easier to handle with the help of drugs, and now drink: especially absinthe, a kind of concentrated Pernod, outlawed for its side-effects in 1916. Modigliani rapidly became acquainted with the Baron Pigeard, the Parisian counterpart of the Venetian

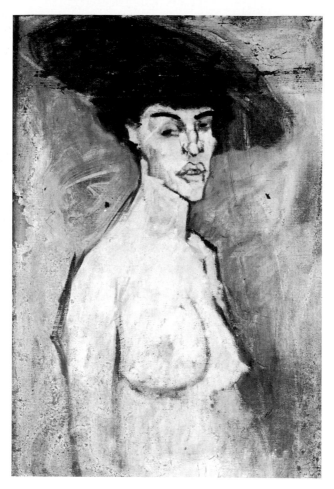

16 *Nude*, 1908

Baron, and his acolytes who kept him – and most of the artists and poets at the time – well supplied with hashish and cocaine. Severini says that Modigliani was never seen without his little box of hashish pills. Inexpensive as drugs might have been at the time, a swiftly increasing consumption was bound to dent his income considerably, as was his newly acquired taste for absinthe, that venomous nectar of the nineties, which Modigliani undoubtedly tasted initially for its romantic associations with late nineteenth-century decadence.

One of the results of poverty was that he painted on both sides of a canvas, and even the paint itself is laid on sparingly. On one side of a 1908 canvas, he
16 depicts a nude with a long neck (this feature, much exaggerated, was to

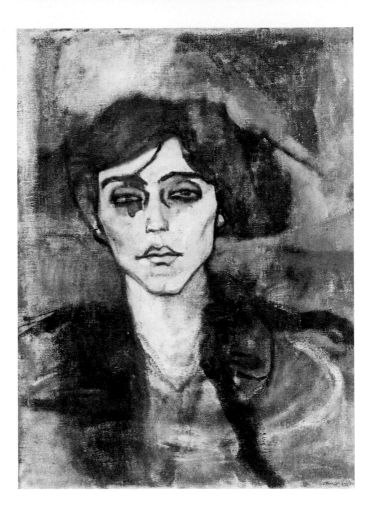

17 *Maud Abrantes* (?),
(reverse of ill. 16)

become a characteristic of his later portraits), sloping shoulders and an attitude of total dejection. On the reverse is a portrait, probably of the same woman, but here she is even more emaciated and haggard. 17

Modigliani's feeling of insecurity was now reinforced in that his work visibly did not live up to avant-garde standards; it was out of date, tediously *fin de siècle* and depressive. Its merits were to be recognized only in later years when its intrinsic quality was being primarily considered as opposed to degrees of modernity. In his cape and large hat, he cut a curiously obsolete figure, beside Picasso and the *mécanos*, clad in workmen's outfits, arrogant with the knowledge that they were creating a completely new art founded on the traditions of cultures hitherto spurned. Modigliani's feeling of

inadequacy – which he would never openly admit – caused him to shun their company completely. One result was that he never befriended the urbane Apollinaire, and this may explain the fact that his influential art reviews do no more than mention Modigliani in passing.

So Modigliani chose to react to his largely self-imposed alienation and extreme timidity by behaving in an aggressive theatrical manner. He chose the company of models, alcoholics and the vagabonds of Montmartre. It is at this time that he probably had an affair with a girl known as 'La Quique' of whom nothing much is known except that she may have been of Spanish origin, hence her nickname derived from *la chica* (Spanish for the girl). Eyewitnesses recall them both dancing naked in front of 7, place Jean-Baptiste Clément, playing at bull and bull-fighter, high on cocaine.

Utrillo became a real friend, Modigliani refusing to see him, like everyone else on the Butte, as the village idiot. They were forever being thrown out of bars, dead drunk, Modigliani wildly declaiming stanzas of Dante, 'Litrillo', as the locals called him, losing his clothes on the way; both were often forced to spend the night in the street.

In a letter to Oscar, he had written 'Your duty is to save your dream.' His dream has now turned into a search for the mysterious qualities inherent in each person he paints. The spirit of his pictures, if not their subject-matter, was still Symbolist. And from his work, it is evident that he had a feeling of cultural sympathy with those artists of the late nineteenth century who were not interested in painting objective or atmospheric reality: the Post-Impressionists, Symbolists, Rose-et-Croix and the Nabis, whose work he saw in Paris. Modigliani more than ever identified with the predicament of the *artistes maudits* suffering for their self-expression in a society that rejected them. He may have felt predestined to this role with his new Parisian nickname 'Modi' (*maudit*, damned).

It is hard to put a label of origin on each of his paintings because the influences are so well digested. An overall feeling of solidarity emerges from the paintings. We feel the young Modigliani is searching for a language, learning to look at others, extracting all he can: the process is slow and patient, akin to an alchemical one, distilling metals and finally extracting the gold of his originality.

18 In 1908, he painted a study of a nude which fully brings out the mood of introspection and anguished uncertainty so typical of this period. This painting is particularly interesting because it is his first explicit sexual statement about women; the straining, taut figure is sexually expressive and has nothing to do with the passive, conventional nudes of traditional painting. The nude here is shown responding to Modigliani's desire and becoming identified with it. It is precisely this sentiment that Modigliani was

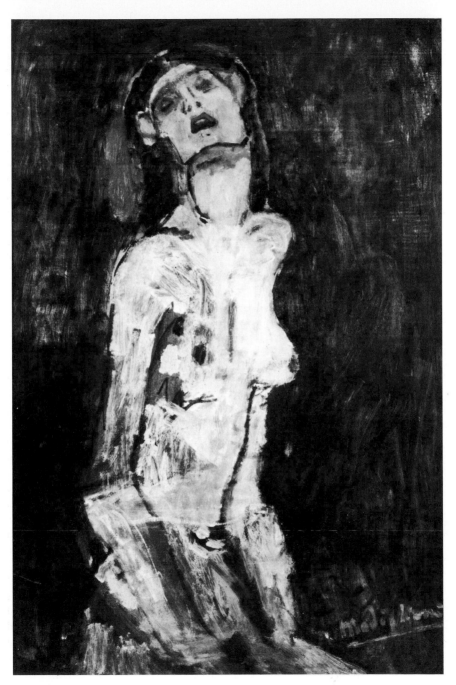

18 *Study of a Nude*, 1908

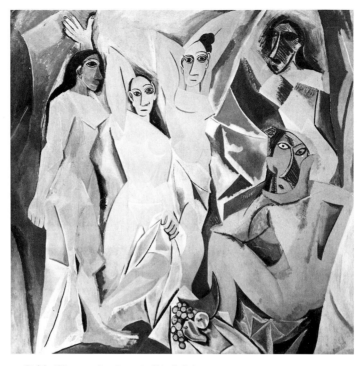

19 Pablo Picasso, *Les Demoiselles d'Avignon*, 1907

to paint in his great series of nudes of 1916 and 1917. At this stage, the tense, nervous and fragile quality of all his early nudes could well reveal his own instability in his youthful relationships. The women painted in his early years are not beautiful: they have an aggressive kind of ugliness revealing a love-hate relationship with women (which was to remain all his life) and a desire to show a certain kind of animal expressiveness, qualities far from the conventions of late nineteenth-century academism and even Impressionist paintings.

Modigliani was not alone in this: in the early twentieth century, there was a cult of what has been called 'negative beauty'.

Nudes came into being, whose deformation caused little surprise – we had been prepared earlier for it by Picasso himself, by Matisse, Derain, Braque, Van Dongen, and even earlier by Cézanne and Gaugin. It was the ugliness of the faces that froze with horror the half-converted.
Deprived of the Smile we could only recognize the Grimace.
For too long, perhaps, the smile of the Gioconda was the Sun of Art.

André Salmon, Modigliani's future biographer, had written this in his
romantic *Anecdotal History of Cubism*, published in 1912 with Cubism in full
swing (reprinted in Edward Fry, *Cubism*). It is worth comparing
Modigliani's early nudes with Picasso's *Demoiselles d'Avignon* of 1907 – and *19*
the works leading to it – or Matisse's *Blue Nude* of the same year, to see how *20*
they all deform the female form to bring out its sculptural, Expressionist
potential.

The picture known as *The Jewess*, painted in 1908, was very important *22*
to Modigliani: he painted it into the background of his three portraits of
Paul Alexandre. Here is Modigliani's most complete statement on blue
miserabilism. The paint is thick in some areas (nose and lips) and somewhat
thin on much of the background. A nervous quality emerges from the sitter
herself, her dull stare and the jagged angles of her sharp face with its novel
broken lighting. This is no longer a *Jugendstil* linear pattern, but a figure
essentially modelled in light and shade like a statue. Modigliani here displays
real interest in sculptural effects (all the more fascinating as the result is a
painting), and this is linked to his discovery of Cézanne and to his growing
attraction to sculpture itself.

Paul Cézanne had died in 1906, and the Salon d'Automne organized a
retrospective exhibition in 1907, thereby consecrating the importance

20 Henri Matisse, *Blue Nude*, 1907

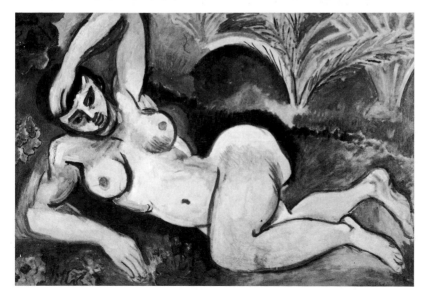

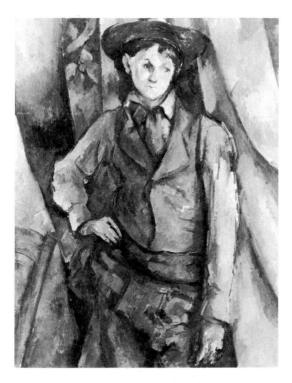

21 Paul Cézanne, *Young Man in a Red Waistcoat*, 1893–95

progressive artists had bestowed on him for years. In the latter part of the
year, Bernheim-Jeune showed sixty-seven Cézanne watercolours in an
exhibition. 'Cézanne's art is the arsenal from which modern painting drew
weapons for the primary struggle to drive naturalism, false literature and
pseudo-classicism from the field.' Cézanne's importance was acknowledged
by perceptive critics right from the start, and Roger Allard (1912, in Fry, *Cubism*) is particularly vehement on this point. The weapons modern artists
drew from Cézanne were extremely varied. His handling of paint and colour
and the resulting deformations brought about a wide range of pictorial
concepts.

In Montmartre and in the Bateau-Lavoir, Modigliani was surrounded by
artists ferociously discussing the new theories. It is said that he frequently got
into fierce arguments about Cubism, which he detested, like all theories, and
turned to blows when he was short of arguments and full of drink. Yet his
interest and respect for Cézanne remains indubitable. As early as 1906,
Modigliani apparently had made a small watercolour copy of Cézanne's
Young Man in a Red Waistcoat and also carried about his person a small

21

22 *The Jewess*, 1908

23 *Paul Alexandre*, 1909

24 *Portrait of Paul Alexandre on a Brown Background*, 1909

reproduction of it. This is a real pointer as to Cézanne's importance, as Modigliani does not appear to have copied the work of any other artist. Furthermore, each time Cézanne's name was mentioned, he would take the tattered reproduction out of his inside pocket, raise it like a holy image and kiss it. It was very much in keeping with his character for Modigliani to get so emotional about the people he revered, dead or alive. He would apparently burst into tears when he received a letter from his mother, and the tears flowed on as he read extracts to his friends in cafés; no other woman would make him weep openly. Cézanne's influence on Modigliani was generally an undercurrent one, unlike the more consistent and direct effect he had on Picasso's work; sometimes it emerges fully, other times it is heavily camouflaged or almost unapparent.

In 1909, *The Jewess* was painted into the background of the portraits of his friend and first serious collector, Alexandre. He had met the young doctor two years previously, and it was he who encouraged Modigliani to show the painting at the Salon des Indépendants in March 1908. Alexandre introduced him to an artists' commune that he had started with his brother in the rue du Delta. When he met the artists who congregated there, Modigliani presented them with a painting each; these outbursts of generosity were to become typical, much to the despair of his dealer Léopold Zborowski. At the rue du Delta, Modigliani probably thought he had landed in an ideal artistic brotherhood, but his relationship with the other artists there degenerated

23
18, 22
22

48

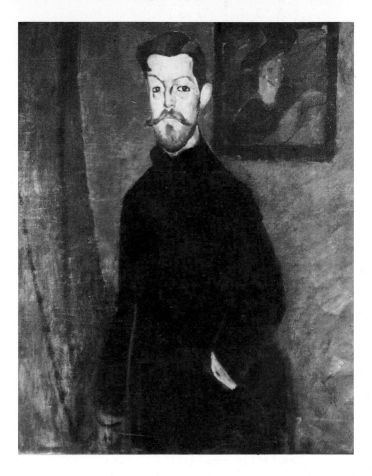

rapidly; in fact his stay ended when one night, very drunk and in a fit of violence, he destroyed all the works he could lay his hands on.

Before this happened, he had painted the portraits of Alexandre; they are *24-26* in the greatest tradition of portrait painting. The first, painted in 1909, is a study for the next which has a brown background: here Alexandre stands with his hand buried in his pocket; in the third, painted with a green background, he spreads his fingers on his side, a proud hieratic stance in the Titian-Velázquez grand manner. In these pictures, Alexandre moves progressively further into the front of the picture plane, dominating it with his emphatic presence, just as Modigliani is getting increasingly self-confident in this particular pictorial situation. He painted him again in 1911 to 1912. The fact that this portrait is the only one he painted during those years when he concentrated on sculpture demonstrates the great value he

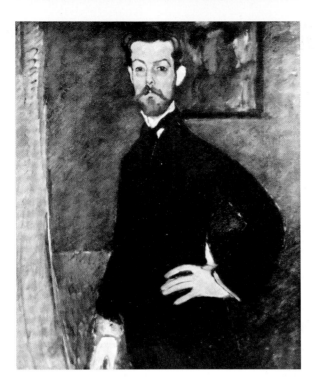

25 *Portrait of Paul Alexandre on a Green Background*, 1909

26 *Paul Alexandre*, 1913

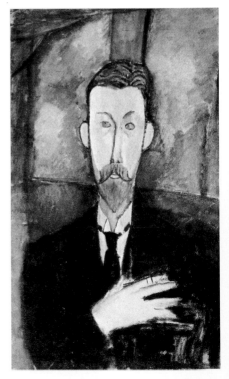

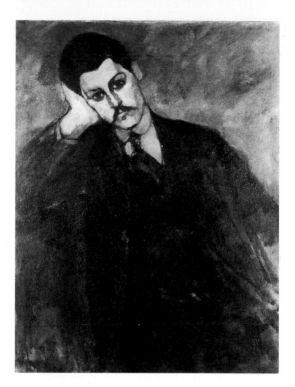

27 *Jean Alexandre*, 1909

bestowed on this friendship. Modigliani painted his fifth and last portrait of
his friend in 1913, and here the colour is much looser and reminiscent of *26*
Cézanne.

The portraits of the Alexandre family and their friends share a number of
characteristics: the sitters are viewed at three-quarter length or head and
shoulders. The effect of light and shade and the suggestion of depth come
from the Cézanne-like hatching in the build-up of the colour, and there is
usually one dominating hue and a few subsidiary ones. We have already seen
this procedure in *The Jewess* and the Alexandre portraits. Modigliani also
painted Jean Alexandre, who looks much more easy-going than his brother, *27*
in reds and browns, but the pose is quite different, as he leans on his hand, and
a certain indolence is suggested.

Alexandre obtained for him his first commission, the portrait of a *28*
baroness. An accomplished horsewoman, she chose to be depicted in suitable
attire, and above all in the red riding-jacket she was inordinately proud of.
Modigliani was displeased at having to paint it that colour and at the last
moment changed it to yellow, harmonizing it with the greenish-blue
background. Predictably, the Baroness refused the painting, and Alexandre

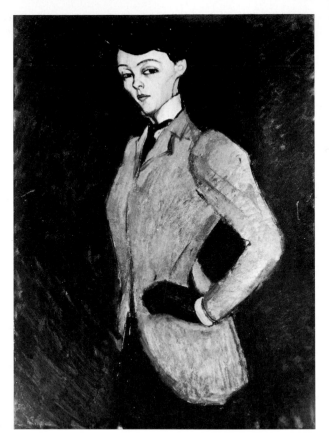

28 *L'Amazone*, 1909

bought it instead. Modigliani certainly brings out her vanity by her proud
stance, and at the same time there is a slight element of caricature in her
highly lit features: in her mean, pursed lips and in the arched eyebrows in her
small angular face. Modigliani's later portraits show this same eye for
character and even caricature – it is usually discreet and accomplished with
an astonishing economy of means.

In the summer of 1909, exhausted by Parisian life and unwell, Modigliani
spent some months with his family in Livorno. He was restless and irritable,
even though his mother did her best to please him – and thereby exasperated
him even more; she spoiled him like a child and had him reclothed from head
to foot. He probably had the greatest difficulty in relating to the continuity
and routine of family life.

He spent some time with his aunt Laure writing articles on philosophy,
something he enjoyed. He felt at ease in the highly cultured atmosphere at

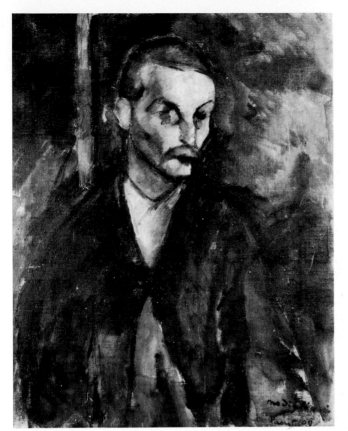

29 *The Beggar of Livorno,*
1909

home, but soon became bored with it. By now he was totally addicted to the
challenges and constant variety of cosmopolitan Paris, and Livorno must
have seemed a stuffy, even claustrophobic backwater in comparison.

While on holiday, he painted the picture that was to be known as *The
Beggar of Livorno*. His daughter says that it was based on a seventeenth- 29
century Neapolitan picture the family had recently inherited. But the style is
very close to Cézanne, and for once gives the impression of having been
painted out of doors, in the warm Italian sunshine. The colours, mainly in
different shades of cobalt, float so lightly as to give the feeling of
watercolour – especially in the area round the eyes: in fact, by his brushwork,
Modigliani is hinting that the beggar may be blind.

On his return to Paris, Modigliani crossed the Seine and took up residence
in Montparnasse. His sense of timing was perfect. Montmartre had ceased to
be the central artists' quarter in Paris.

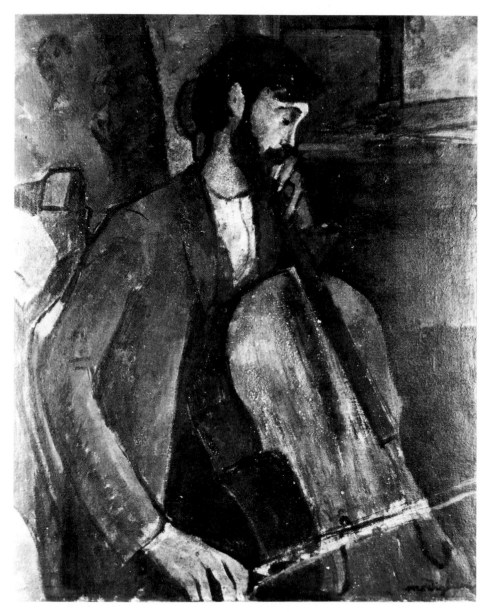

30 *Study for The Cellist*, 1909

Sculpture 1909–14

On his return from Italy in the summer of 1909, Modigliani asked Alexandre to introduce him to the sculptor Brancusi, who lived on the other side of the Seine in Montparnasse. This was an important aspect of a carefully thought-out decision linked to the direction his work was taking. There are few such decisions in his life, but they all concern his career. When it came to his painting and sculpture, an idea would mature slowly before coming to fruition, and his drawings, especially those linked to his sculpture, show that he could build up a project over a period of years. This is in direct contradiction with the rest of his life where he was impulsive and extreme in his likes and dislikes.

On his arrival in Paris three years before, he had introduced himself as a sculptor, which certainly indicates a deep-seated ambition. His desire to realize this aim must be read in all activities preceding his full-time involvement in sculpture, even in his trip to Italy. For his physical health and emotional reassurance, he had sought his family and especially his mother; for his spiritual needs, a journey to Italy, to his artistic roots and away from Paris, where he had difficulty in isolating himself, was paramount.

While painting *The Beggar of Livorno* in 1909, a few things must have *29* become clear. His mentor had been for some time Cézanne, and Modigliani must have realized that he was moving, at this rate, towards a total disintegration of the image that would ultimately lead to problems with the spatial reorganization of the fragments. This is a structural problem that Modigliani would not solve through a personal variation of Cubism.

He began by initially working it out on canvas, and in a number of portraits of 1909 and 1910 the forms are self-contained, almost statuesque. His pictorial style at that time presents more variety than at any other time in his career: concurrently with his sculptural paintings, he produced *The Cellist* in 1909, which he exhibited at the Salon des Indépendants in 1910 and *30* which was acclaimed by Alexandre as 'better than Cézanne'. The synthesis of forms within the confines of the image and the fluidity of the paintwork certainly owe a lot to Cézanne. Modigliani may have felt that he might lose himself in a maze of stylistic possibilities and that sculpture would force him to rethink his formal attitudes to art. He chose carving – as opposed to

modelling and assemblage – as this was the most rigorous test; it demanded the highest discipline and gave no possibility for self-indulgence, especially in the severe way Modigliani was to carve.

He now had to face a whole new set of problems: despite his ambitions, he was not actually trained as a sculptor; and from the start – therein lies the contrast with his painting – he realized that it was not in European sculpture of the past that he could find a precedent for what he was trying to achieve; not even in the immediate past, for Cézanne's great contemporary Auguste Rodin could not help the young Modigliani find himself. He needed someone of his own epoch (in which he must have felt somewhat marooned) to guide him to cultures completely alien to his own and to contemporary artistic concepts.

Constantin Brancusi seemed ideal. He was already fairly well known and had shown at the Salon d'Automne and at the avant-garde Abbaye de Créteil. His sculptures at that time showed a simplification of features, a purification of form to which Modigliani could relate.

31

Photographs indicate that Brancusi looked older than he actually was (he was thirty-three, that is eight years older than Modigliani). He seems always to have clung to his image of the gruff but serene peasant patriarch, although in fact he was extremely sophisticated. This must have seemed reassuring to Modigliani who, at that time, still had a childlike need to look up to someone, to have heroes or to relate to a self-confident father figure, despite (or because of) his female-dominated childhood background. It is significant that he deliberately arranged to be introduced to him, when he had, if he had wanted it, easy direct access to artists.

Brancusi, born in 1876 in the Transylvanian Alps, had arrived in Paris in 1904, after travelling for a year mostly on foot all the way from his native Romania. His work had earned the praise of Rodin, but he had refused to become his assistant, declaring with singular purposefulness that 'nothing grows in the shadow of a great tree'.

In fact, Rodin's massive impact seems to have stunted the development of carving for French sculptors: in the early years of the century, it seemed impossible for them to find the necessary rigour and self-restraint in his luxuriant megalomaniac entourage. Brancusi was one of the band of East European carvers who came from a completely different cultural background, where Western influence had been adapted to meet local demands. Lipchitz, Brancusi, Alexander Archipenko, Jacob Epstein, Chana Orloff and Ossip Zadkine became Parisians in that they needed the ambiance of the city to stimulate (not necessarily inspire) them. They acted as a catalyst on the sculpture scene, and their presence may well have encouraged the efforts of aspiring carvers.

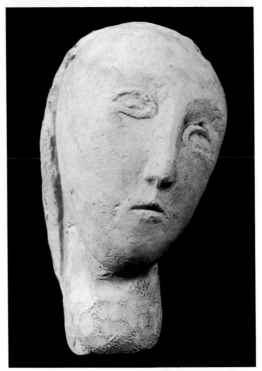

31 Constantin Brancusi, *Head*,
1908

Brancusi himself came from a peasant family, and although he left home
at the age of eleven, he retained a profound attachment to his native folklore,
cultural traditions and handicrafts, which were to form the basis of his work
and outlook throughout his life. During his early career in Bucharest,
however, he produced academic work that earned him praise and an
independent reputation in Romania. In Paris, he strove to maintain a
measure of autonomy from everyday urban life, in that he wore clogs and a
smock and carved all his own furniture, re-creating a somewhat glorified
version of a Transylvanian peasant hut; he built himself a stone oven and an
oil press: his hospitality and the high quality of his cooking were famous all
over Paris. Apart from that, he led a fairly Rive Droite social life in that he
went around with Jean Cocteau, Raymond Radiguet, Apollinaire, and was
an admirer of the Ballets Russes. He also befriended the naïve painter Henri
'Le Douanier' Rousseau, with whom he would regularly play the violin.

Brancusi was characterized by an obstinate independence and persistent
will to control all the elements in his own environment, which is why he so
carefully paralleled his unique life-style in his work; they fed on each other
continuously, and a disturbance in one was bound to hinder the other. The

sophisticated simplicity of Brancusi's outlook, half-way between Eastern and Western traditions, has been understood only in our own time, with the now fashionable return to ethnic values. Before he died in 1952, Brancusi had requested that he be buried directly in the earth, naked, but the officials, embarrassed, would not allow it as they considered it in bad taste.

Modigliani was attracted to Brancusi's strength and sense of purpose, and respected his work, so he felt he could learn much from him. Brancusi, in turn, probably enjoyed the idea of teaching such an enthusiastic student, and Modigliani soon joined him in the cité Falguière, late in 1909.

30
32 On the reverse of the study for *The Cellist*, there is another which is the beginning of a portrait of Brancusi. He has a wide, bony face and a thick black beard; he looks down on his mountainous chest, his eyes looking inwards, sombre, concentrated. We do not know why it remained unfinished, but it is evident from his morose air that Brancusi did not like to have himself portrayed.

Their relationship must have been uneasy from the start, as they obviously had nothing in common – except for nightly excursions to La Rotonde. Brancusi's real need for a harmonious, balanced life meant that co-existence with such a demanding, self-centred person as Modigliani was impossible for any length of time.

For a couple of years or so, Modigliani was based in a first-floor studio (an impractical location for a sculptor) in the cité Falguière, situated at 54, rue du Montparnasse, next door to Brancusi's. It was a group of artists' studios not unlike the Bateau-Lavoir in Montmartre, or La Ruche, south of Montparnasse. These buildings generally provided a space and minimal lighting (often kerosene or candles sold at a profit by the concierge). Although the rent was nominal, Modigliani as a rule could not pay it – nor could most of the Slavs at La Ruche, who were experiencing abysmal poverty at the time; few were as fortunate as Modigliani in receiving an allowance, small as it was, from his family. These studios contributed substantially to the emergence of the Ecole de Paris and its militant subsection. It is obvious that Modigliani could never have settled from his own free will in the Bateau-Lavoir where 'La Bande à Picasso' and Cubism ruled supreme. He infinitely preferred La Ruche, in the fifteenth *arrondissement*, by the abattoirs, which his friend Soutine used to haunt. Highly individual Eastern European artists lived there, mainly Ashkenazi Jews who spoke Yiddish, had experienced the ghetto and known persecutions and pogroms; for Soutine and Krémègne, who had lived through total misery and near starvation in Russia, the poverty at La Ruche felt like affluence in comparison. Chagall, who had lived there since 1910 was among the most eccentric inhabitants of La Ruche, with an extremely pale

58

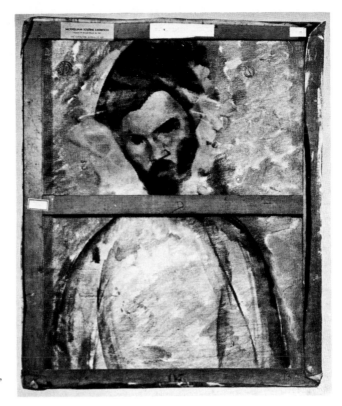

32 *Brancusi* (reverse of ill. 30), 1909

complexion and made-up eyes; he would paint dreams of Vitebsk and his fiancée Bella, at night, stark naked so as to preserve his one and only suit.

Even more than when he was in Montmartre, Modigliani did not really settle in one place; he simultaneously lived in all the *cités* and roamed from one bank of the Seine to the other. The cafés were as much home as anywhere else, especially La Rotonde, after it opened in 1911. Libion, the owner, gave strict orders never to pressurize the customers to renew their drinks, which meant that you could – and Modigliani, like many others, did – sit there for the whole day in front of a single *café-crème*. Café society was to come into its own when Montparnasse took over from Montmartre as the artistic headquarters of Paris, especially in the period of transition from a near-rural suburb to an active part of the metropolis.

Estimates vary, but between twenty and twenty-five sculptures survive from the years 1909 to 1914. Modigliani is said to have produced some

before, but they have disappeared. They probably dated from about 1907 or 1908 and were made of wood which had been removed from the Métro Barbès-Rochechouart then being built: the sculptures were apparently all of the exact dimensions of the sleepers in the Métro. Before he met Brancusi, he probably did not know any stone-carving techniques, and this must have been one of the main reasons why he went to him. Brancusi's highly sensitive handling of surface impressed him, and this is borne out by Modigliani's own handling of texture.

From now on, Modigliani's material was mainly limestone. He quarried the stone from the many building sites in Montparnasse, usually at the dead of night when workmen had refused to give him any during the day. Zadkine mentions polychrome statues, but none have survived. The height *33-36* of the heads varies from 9 in. to about 29 in., averaging 25 in. Many have been lost or destroyed; a large number of such losses occurred during Modigliani's lifetime. The chronology is exceedingly hard to establish, as Modigliani's evolution can be read in several directions. The dating followed here is Lanthemann's. Furthermore, Modigliani's drawings sometimes antedate his sculptures by years: his earliest drawings for the standing caryatid date back to 1910, whereas the surviving statue itself was carved in 1912. The drawings *41-45,* are magnificent in themselves, done in lead or blue pencil, or charcoal with *49* occasional ink washes. They are often on rather large sheets of paper, one of the standard sizes being $17 \times 10\frac{1}{4}$ in. and they are always drawn in a sure hand, with no correction or erasing. The importance of sculpture at this point in his career can be measured by the number of paintings he produced in those years: Ceroni says there are 2 for 1910, 4 for 1911, none for 1912, 6 for 1913, 7 for 1914. There is no way of knowing exactly how many sculptural drawings and life studies he produced in those years, but he drew every day.

His subject-matter in sculpture is, as ever, the human being: tall, silent heads, sometimes with the trace of an enigmatic smile, and caryatids at once sensuous and anonymous. They usually stand directly on the ground or on a minimal pedestal. No background, no gesture, and in the best examples no possible anecdote or obvious emotion. These heads are not portraits, perhaps *33-36* neither women nor men (perhaps both); the basic repertoire is voluntarily limited to the extreme, but the range of expression is infinite. Because Modigliani refuses to make specific references that might locate them in time and place, the heads take on a quality of universality. By the same token, the least successful sculptures – there have to be some – are those of 1912 with *35* short, neat hairstyles, when the features have an air of almost sentimental stylization, not helped by the relatively high finish that Modigliani was later to reject.

60

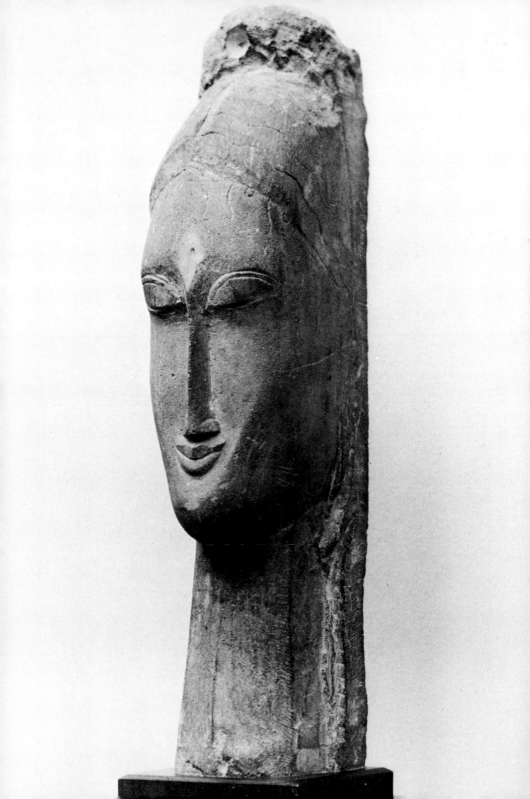

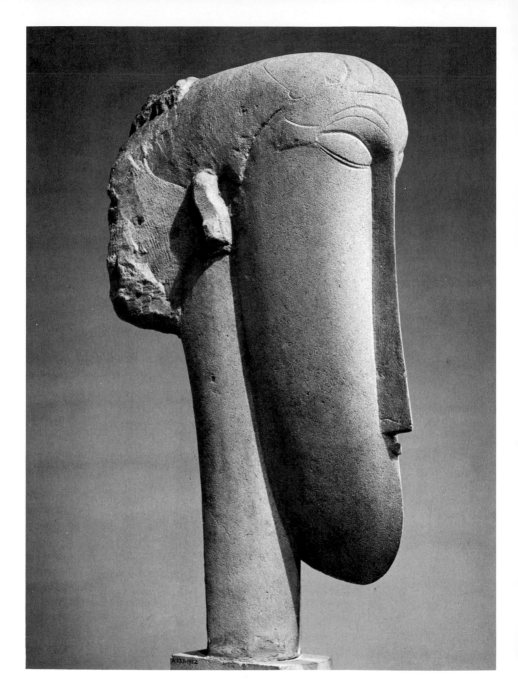

34 *Head*, 1911

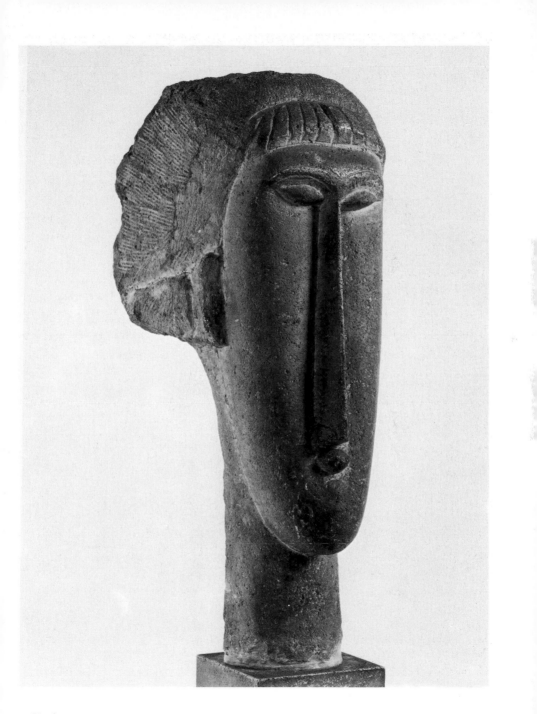

35 *Head*, 1912

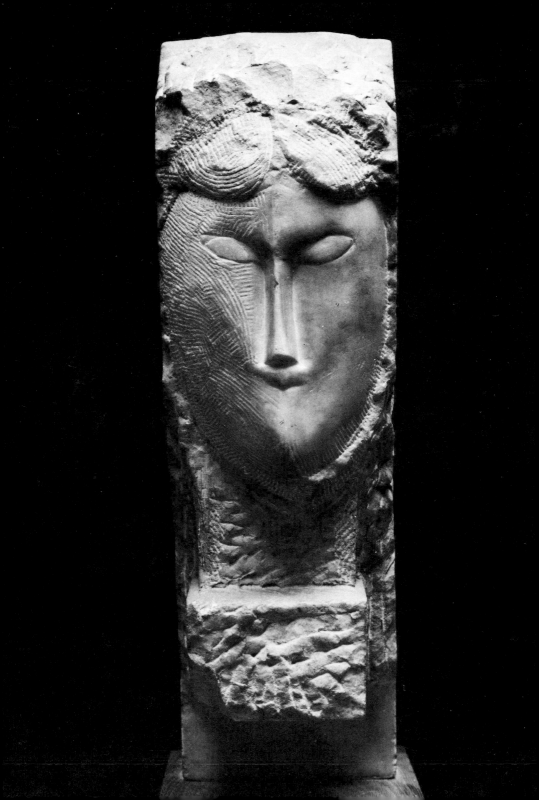

'At night, he would place candles on top of each one and the effect was that of a primitive temple. A legend of the quarter said Modi when under the influence of hashish embraced these sculptures.' Epstein evoked this visit to the studio: he had seen nine or ten heads and one figure. They are immobile, charged presences: a dual quality, not contradictory, of spiritual detachment and emotional involvement that may be nearer to expressing the depths of Modigliani's soul than anything else he ever produced; their effect was haunting, especially when they were seen as a group, as for instance during his exhibition in his friend Souza de Cardoso's studio in 1911, from which the earliest photographs of his work date. 'The stone heads affected me deeply. For some days afterwards, I found myself under the hallucination of meeting people in the street who might have posed for them and that without resorting to the Indian herb.' Augustus John had visited Modigliani in his studio, where the floor 'was covered with statues all much alike and prodigiously long and narrow'. As a mark of favour, he was presented with a copy of Modigliani's favourite book, Lautréamont's *Les Chants de Maldoror*.

The cultural references of Modigliani's heads are those shared by the avant-garde generation of sculptors, namely the so-called primitive arts of Africa and Oceania. Their cataclysmic effect on artistic sensibility in the first quarter of the twentieth century needs some explaining.

African sculpture had been an artistic issue since 1905. The debate about who 'discovered' the first statuette still goes on, but nearly every young artist who made a significant contribution to painting and sculpture from around that year until the onset of the First World War was affected by it.

Young artists, having for the most part completed the most conventional art training, were forced into admitting an art totally opposed to European tradition. Here was a collective social art form: it presented an anonymous, impersonal and supremely static human figure, neither realistic nor conventionally idealized, with no attempt at physiognomy, proportions, emotions or social statement. A sense of the awesome emanated from such figures that had not been experienced in Europe since Romanesque sculpture.

No discoveries of any kind – least of all artistic – ever happen accidentally. They correspond to a social and aesthetic need. Carl Gustav Jung, from about 1909 onwards, also examined primitive myths in order to understand certain universal traits in human behaviour. Likewise, African art regenerated European sculpture in that it forced artists to concentrate their energies on the handling of pure form and an understanding of emotion as a primal force in its own right. African and Oceanic art had the same effect on artists who preferred to work within the framework of Western formal

65

36 *Head*, 1913–14

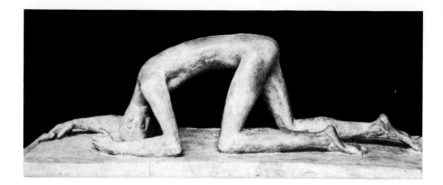

tradition, like Wilhelm Lehmbruck, Raymond Duchamp-Villon and Ernst Barlach.

Sculpture itself, not subject-matter, was at issue. It is for this reason that the avant-garde resorted to the most established subjects of all, mainly the nude and the head, as the range of possibilities was thus extended to its maximum without any limiting reference to a specific situation. When emotions were depicted, as in Lehmbruck's *Fallen Youth* or Brancusi's *Kiss*, they are as basic and universal as the forms of the human body itself. Their sincerity lies in their direct expression of the artist's own feelings rather than a three-dimensional opinion about what such an emotion should have looked like. Compare Lehmbruck's *Fallen Youth* to any monument to the unknown soldier, or Brancusi's *Kiss* to any insidiously coy nymphet of the kind churned out in hundreds at every Salon. A popular style at these official showrooms of contemporary art was sentimental realism, with populist

37
38

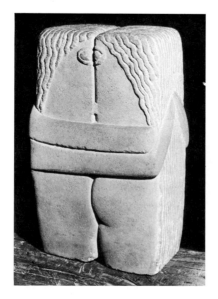

37 (*above*) Wilhelm Lehmbruck, *Fallen Youth*, 1915–16

38 Constantin Brancusi, *The Kiss*, 1911

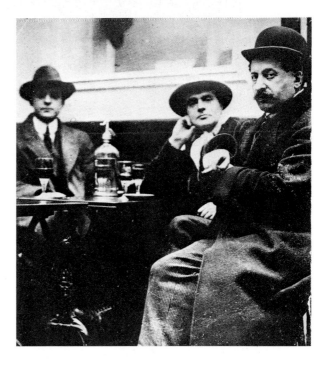

39 Modigliani (centre) with
Adolphe Basler (right) at the
Dôme, c. 1919

themes which produced works with enlightening titles such as *Orang-Outang
Strangling a Savage from Borneo, Man Drowning in Quicksand* or, less
sensational, *Not Everything in Life is Rosy*, or simply *Fascination*. All these
related to contemporary, albeit strictly bourgeois life.

In our epoch of tormented spirits and anguished souls, no-one is satisfied
with the traditional Western forms of art and aesthetics based on Greece and
Rome. Our anxious generation has sought to replace Reason and Beauty by
Fantasy and intense expressiveness. . . . This tendency [interest in primitive
art] will have marked the early part of the twentieth century as much as the
second half of the nineteenth century exalted the charms of Japanese
prints.

So wrote Adolphe Basler in 1929 in *L'Art chez les peuples primitifs*, one of
the very first books on primitive sculpture which actually attempted to
explain its contemporary importance. Basler, one-time dealer of Kisling and
occasional picture-peddler who went on to champion the work of
Krémègne in preference to that of Soutine, had ample opportunity to discuss
the artistic issues of his day. There is a photograph of him in action, typically, *39*
seated at the Dôme, having a drink with Modigliani.

67

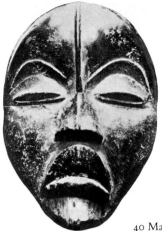

40 Mask from the Ivory Coast

No serious work on the subject seems to have been published before the First World War, although extracts of Gauguin's written works had appeared. His supremely romantic refutation of Western social and cultural values was acknowledged by all the artists of the following generation. Fate was to decree that Modigliani's last studio would be situated just above where Gauguin had had his, at 8, rue de la Grande Chaumière. If Modigliani had wanted to study primitive art, he would have had to consult obscure anthropological journals or erudite articles in museum journals; if the latter mentioned non-European art, it was generally of the recognized kind, Indian or Far Eastern. Otherwise, he could wander round the rambling dimly lit Trocadéro Museum (now the Musée de l'Homme) or go to specialized shops like Au Vieux Rouet in the rue de Rennes, near Montparnasse. Artists like Picasso, Georges Braque, Henri Matisse, Derain, Maurice de Vlaminck, Louis Marcoussis, Lipchitz and Epstein were buying African sculptures, and Modigliani had access to their collections.

> *Tu marches vers Auteuil tu veux aller chez toi à pied*
> *Dormir parmi tes fétiches d'Océanie et de Guinée*
> *Ils sont des Christ d'une autre forme et d'une autre croyance*
> *Ce sont les Christ inférieurs des obscures espérances.*

(You walk to Auteuil, you want to go home on foot/To sleep amidst your idols from Oceania and Guinea/These are Christs of another form of another belief/They are the lesser Christs of hidden yearnings.)

(Apollinaire, 'Zone', published in *Alcools*.)

Apollinaire's long poem 'Zone' documents this active taste for African art among the avant-garde. The whole poem could have been about Modigliani

41 *Nude with African Statue, c.* 1913

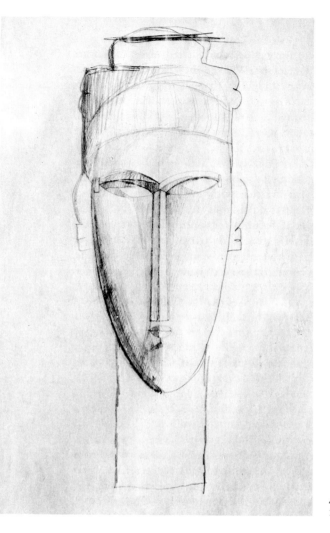

42 *Head with an Abacus*,
1911–12

For Lehmbruck, too, the neck is often the focal point of the spiritual tensions that animate his elongated introverted figures. This young German sculptor's brief tragic life (1881–1919) ended in suicide, and in many ways paralleled Modigliani's; he had arrived in Paris in 1910, and contemporary witnesses imply that they knew each other. Lehmbruck's stance remained an independent one, as his formal terms of reference were strictly European; he first looked to antiquity and then to northern Gothic art, which was best suited for his ascetic figures. He manages to convey private tragedy, without 37 the use of allegory or gesticulation; and this is a mode of expression which

43 *Head with a Plinth, c.* 1910

Modigliani was in complete sympathy with, as shown especially by his subsequent portraits.

Modigliani called his caryatids *colonnes de tendresse*; he planned hundreds of them for a temple of beauty that was never built. Classical caryatids, such as those at the Erechtheion in Athens, stand unperturbed, carrying the temple's superstructure on their heads, whereas Modigliani's support the tremendous weight of an imaginary lintel with their whole body. Both Modigliani's caryatids are life-size; the standing one was carved in 1912; it is 5ft 3in. tall, that is just two inches shorter than Modigliani himself; the crouching one dates from the following year and measures 3ft 3in.

47-50

46

50

We can follow their development in the drawings. Just before starting work on the sculptures, there is a series of rather Apollonian, muscular young men, which indicates, among other interests, a reference to classical antiquity, a source he was later to explore more thoroughly; this is corroborated by the *kouros*-like stance of some of the standing figures he draws, as well as the pose of the crouching one which derives from the classical Hellenistic half-kneeling Venus, of which there are at least two sculptured examples in the Louvre.

73

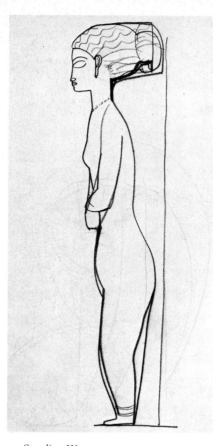

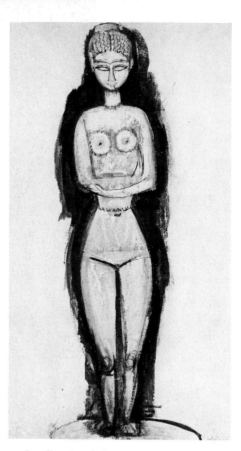

44 *Standing Woman*, 1910–11 45 *Standing Caryátid*, 1911–12

 The framework in which Modigliani works is decidedly classical, as is
Aristide Maillol's or Elie Nadelman's, but in Modigliani's case, the terms of
reference for working out the balance of forms are quite non-European.

44 Sketches of that time show that he was looking at African statuettes of
standing women, which were in fact part of functional objects.

45 It is worth comparing the oil sketch of the standing caryatid with the
46 resulting sculpture. In the sketch, her legs taper, her elbows and hips are
angular, her narrow waist and her neck are encircled by beads: she has the
fragile grace of a young Oriental temple dancer. For two whole years, he
worked out the distribution of the masses, and in the final sculpture, the bulk
of her weight is on the legs – their massiveness is directly borrowed from
African wooden sculpture; now the elbows are completely rounded. And

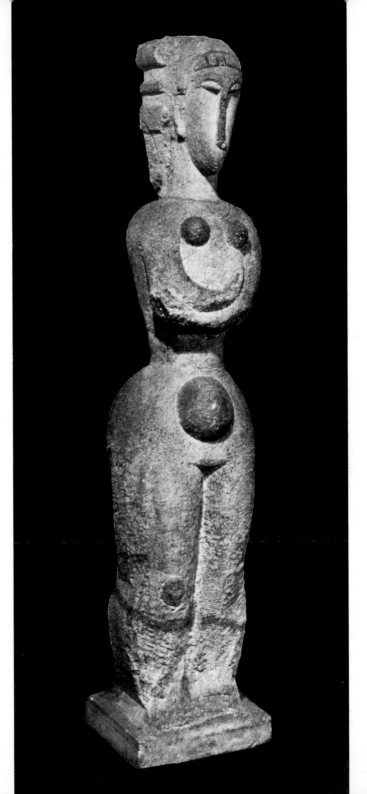

46 Standing Caryatid, 1912

although the overall proportions are monstrous compared to the classical canon, Modigliani has achieved a sensuous harmonization of the whole. The face is typical of the heads he was carving at the time. In 1911–13, Modigliani produced eight oils of caryatids, mainly in a ruddy terracotta tone on a brownish background; they are definitely painted as statues on occasional pedestals, or supporting a lintel above their heads with their upturned palms.

In 1911 to 1912, he began working on his crouching caryatid who in fact began life on both knees, supporting an architrave with her arms. Interspersed are some sketches of nude models trying out different poses. There is a series of large watercolour sketches that must be among the finest works Modigliani ever produced and which relate to the sculpture. In the sketches he experiments with the idea of the female figure supporting a heavy weight; a myriad of tensions results from the opened and closed rhythm of her sinuous curves – the effort is sexual in its intensity.

From all accounts, Modigliani had enormous love within him to give, but once he got involved in the responsibilities of a relationship, a conflict of personalities would rapidly ensue, and his behaviour under pressure could become gross, even violent. He preferred casual affairs and romantic fantasies. His brief intimacy with the Russian poetess Anna Akhmatova combined the two and was to be typical of the kind of encounters he had with northern ladies of literary inclination; his relationship with Lunia Czechowska was to be the supreme example. Akhmatova, then twenty-two – three years younger than Modigliani – was on a visit to Paris without her husband. In a memoir she wrote when she was seventy, she says that Modigliani wandered with her through Paris by moonlight and that they recited the poems of Paul Verlaine together in the rain seated on a bench in the Luxembourg under his enormous black old umbrella. She threw roses through the window of his sculpture studio, and he drew her as an Egyptian queen. To her, he was gentle, courteous and discreet. The presence of the beautiful poetess in Paris had the infinite charm of an intense but fleeting encounter.

The caryatids have no faces, no individuality, but they have personality in that they are defined as Modigliani's ideal love objects, not unlike the glorious sexual goddesses of Indian statuary whose tensions and rhythms they echo. The finish in the sculptures is now rough: woman has become an archetypal force emerging, as it were, from the earth itself. The caryatids are comparable to the great series of nudes he painted in 1916 and 1917, but the difference is that in the pictures it is purely the sexual encounter itself which is glorified (see pp. 143–44, 157–59).

Despite his ambitious plans, these were the only caryatids ever completed:

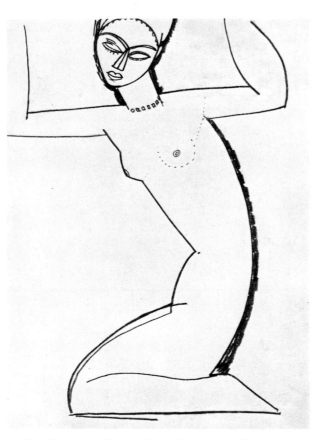

47 *Crouching Caryatid* (preliminary drawing for ill. 50), 1910–11

such blocks of stone were very expensive and for a basically untrained sculptor presented difficulties in handling; carving itself was extremely tiring and dusty and it exhausted Modigliani's strength and fragile lungs.

By 1912 important differences were arising between Modigliani and Brancusi. Brancusi had taught him to look at non-European sculpture and how to extract what he needed from it, while staying clear of Cubism and Expressionism. With Brancusi, he had learnt how to reduce forms to their most essential components and give a unified treatment of the surface. But now Brancusi was moving towards a greater purity of form and ultimate abstraction, and Modigliani neither could nor wished to follow – in fact, he could not bear the overpolished, almost mechanical finish of Constantin's

77

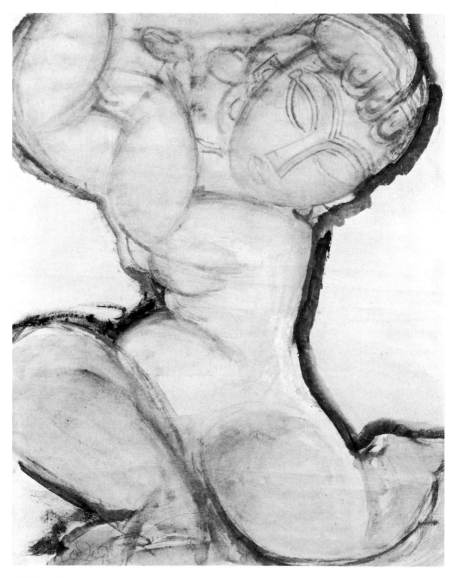

48 *Caryatid, c.* 1913

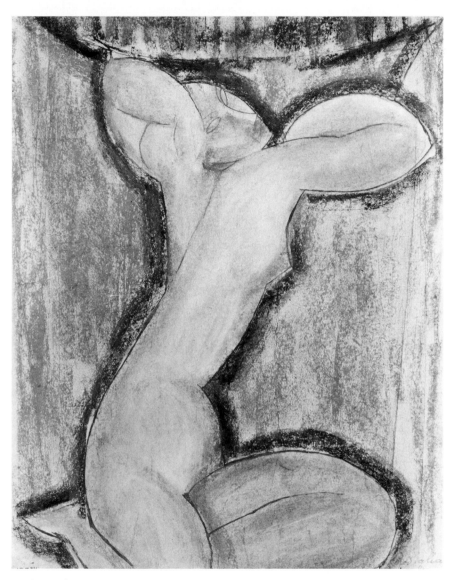

49 *Caryatid*, c. 1913–15

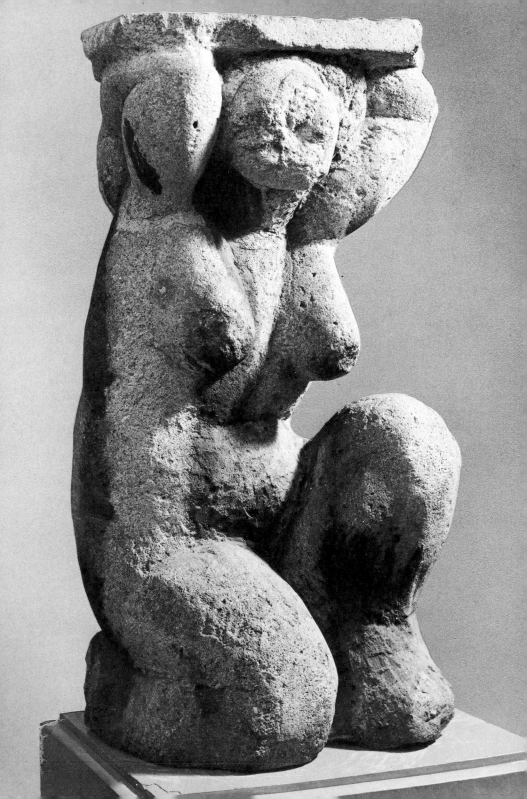

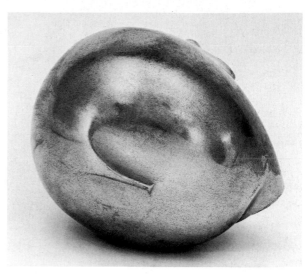

50 *Crouching Caryatid*, 1913

51 Constantin Brancusi,
Prometheus, 1911

precious heads. (Such criticism was frequently to be levelled at Modigliani's *51*
own later paintings.)

In 1909, when Modigliani met him, Brancusi was producing work that
hints only slightly at his potential, and it was on this intuition as much as
anything else that Modigliani had moved to Montparnasse. Modigliani had
great intuition as far as the true value of artists and the evolution of his own
art were concerned; he was among the first to recognize the talents of Utrillo
and Soutine, and Beatrice Hastings was later to say that he was a medium.

What has hitherto been totally disregarded is that Brancusi only started to
make 'Brancusis' in the years Modigliani lived in the cité Falguière. There is *51*
evidence that a real two-way exchange took place between the artists, as
Brancusi's little-known paintings show; in fact, they may well have helped *52*
each other to find themselves. When they fell out, Modigliani moved out to
a tiny glass box of a studio on ground-floor level in the boulevard Raspail.
Modigliani had realized for some time that he needed to move away; in the
summer of 1912 he spent a whole day with Epstein looking for a studio that
the two could share, on the Butte Montmartre; but they were unsuccessful in
their quest, as purpose-built studios were rare, and few people welcomed the
prospect of having a neighbour who hammered and chiselled night and day.
Epstein had to settle in a room next to a baker's, who rapidly made trouble
once he realized that the artist he had rented the room to was not a painter
but a carver.

In 1912, Modigliani the sculptor had found himself. We have seen that in
certain cases, over-stylization could lead to preciosity. Modigliani corrected *35*
himself by returning to the nature of the stone itself and producing a few

52 Constantin Brancusi, *Portrait of a Woman, c.* 1918

36, 55 dramatic boulder-like sculptures where heads emerge from the rock like
archaic figureheads expressing their power through the rough-hewn quality
50 of the stone. The head of the crouching caryatid is one of these.

The change may relate to his very last trip to Italy in 1912, when
Emanuele gave him some money to find work premises in Carrara.
Although he found the climate there too suffocating, a visit to
Michelangelo's quarries must have been very impressive. Michelangelo had
wrenched his sculptures from the mountain itself, and the intimacy of his
relationship to the stone is best shown in the *Dying Slaves* in Florence, half-
embedded in the rock, to which Modigliani certainly referred.

One person understood what he was getting at in these sculptures and was
the very first to write about them, in 1914 and 1915. Beatrice Hastings'

importance will be discussed in the next chapter, but this sensitive analysis of one of those later sculptures should be quoted here. It is dated February 1915.

. . . I possess a stone head by Modigliani which I would not part for £100 even at this crisis: and I routed out this head from a corner sacred to the rubbish of centuries, and I was called stupid for my pains in taking it away. Nothing human save the mean is missing from the stone. It has a fearful chip above the right eye but it can stand a few chips. I am told that it was never finished, that it never will be finished, that it is not worth finishing. There is nothing that matters to finish! The whole head equably smiles in contemplation of knowledge, of madness, of grace and sensibility, of stupidity, of sensuality, of illusions and disillusions – all locked away as matter of perpetual meditation. It is as readable as Ecclesiastes and more consoling, for there is no lugubrious looking-back in this effulgent smile of intelligent equilibrium. What avail for the artist to denounce such a work? One replies that one can live by it as by great literature. I will never part with it unless to a poet; he will find what I find and the unfortunate artist will have no choice as to his immortality.

The sculpture referred to seems to have disappeared: if, as early as 1915, one could find Modigliani heads on rubbish tips, this indicates that a great many more must have been lost in his own lifetime.

Modigliani's technique is particularly visible on the reverse side of the sculpture in the Centre Pompidou. It is a rectangular block 22 in. high on the front of which the face only just projects, as if to emphasize its origin, as if to say that mystery emanates as much from a piece of limestone begged from a building site as from highly polished marble or bronze. One has no way of knowing if a primitive Janus was intended. On the reverse are the beginnings of another face. The outline of the essential features are thinly scratched on the flat surface, and Modigliani has begun to chisel on one side of the nose and cheek. It is evident that he builds up from the axis of the nose outwards, a feature that had been noted in contemporary descriptions: 'lifting up the sheets of drawings he showed me his sculptures, the stone heads with their perfect ovals. Perfect eggs along which ran noses like arrows towards the mouth. They were never finished as if from shame, never wholly sculptured for a mysterious reason' (Zadkine, *Le Maillet et le ciseau, souvenirs de ma vie*).

In those years, Modigliani made one last trip to Italy, this time as a sculptor. The dating is complicated, but it is likely that it took place in the sweltering summer of 1912. The state of his health in Paris was so alarming that it prompted his friend, the painter Ortiz de Zárate to collect money to send him home for a rest. Jacob, who had contributed to this collection, mentions several in his correspondence. Before leaving, Modigliani brought all his sculptures in a wheelbarrow to Alexandre.

83

53 *Head* (reverse of ill. 54), 1913

54 *Head*, 1913

'His head was shaven like that of an escaped convict and more or less covered with a small cap with the visor torn off. He was wearing a miserable linen jacket and open shirt and his trousers were held up by a string tied to his waist.' This is how an eyewitness in Italy describes him; apparently he also gave the impression of a 'phantom who came in and out when you least expected it'. The appearance of a visionary. He told his friends about primitive sculpture, and they mocked him. He proudly showed them photographs of his sculptures, and they laughingly suggested he dump them in the ditch. But he persevered and looked for a place to work. Whether he carved any sculptures is not known; nothing survives of this trip. Now, more than ever, Modigliani realized the extent of his desperate loneliness as an artist in Italy, and it affected him deeply. His friends in Livorno might have

understood if they could have attached the accepted modern label to his sculpture, had it even faintly resembled the work of Medardo Rosso or Boccioni, but its supreme barbaric staticness alienated his carvings simultaneously from Italian academicism and Futurist endeavours. His sculpture, if not his paintings, had even fewer connections in Italy than in France, and he never returned to Livorno.

At the onset of the First World War, he stopped sculpting. Materials were now expensive, as the war had closed down a number of building sites, and this imposed a definite cut-down on available stone. Alexandre said that if Modigliani had had someone to prepare the blocks for him – which was the most exhausting part of it – he could have gone on carving. The fact that he was unable to continue his career as a sculptor was the central tragedy in his life, and he was to grieve for it in all his paintings, as their frequently sculptural character shows. Modigliani was acutely aware of his own worth and deep down knew the value of his own sculpture, and this makes the situation all the more heart-breaking. In many ways, his sculpture is his only purely twentieth-century achievement. Paradises of the artificial kind were increasingly to provide a precarious refuge from this inescapable reality. Despite his participation in exhibitions, he did not sell anything, and this at a time when his close friends were beginning to be successful; during the war even his allowance was cut so he had to face problems of survival. For quick cash, he began to draw people in cafés. The break was not sudden, and he preferred to think of portrait drawing as a sideline; Beatrice Hastings, who met him in 1914, says that his main preoccupation was still sculpture and refers to him in June 1914 as 'the bad garçon of a sculptor' (*mauvais garçon*, bad boy, villain).

In five short years, Modigliani had made significant and influential contributions to sculpture. His work in this field was probably more integrated to the general development of the avant-garde than his painting, which his contemporaries viewed as anachronistic, ever was. But he was not taken seriously in either discipline, and although he craved recognition, he refused compromises, artistic or social; and such independence, as we shall see, was a difficult, even fateful position to maintain, especially in the case of so fragile and insecure a person as Modigliani.

55 *Head*, 1912–13

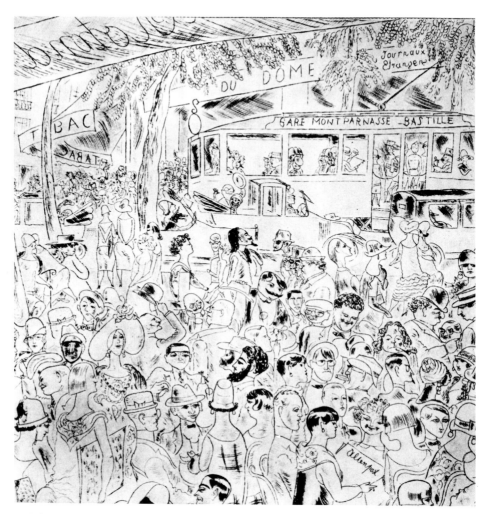

56 Gabriel Fournier, *At La Rotonde*, 1916

Montparnasse 1914–17

> *Un siphon éternue*
> *Les cancans littéraires vont leur train*
> *Tout bas*
> *A la Rotonde*
> *Comme au fond d'un verre*
> *J'attends*

(A siphon bottle sneezes/The literati prattle on/Softly/At la Rotonde/As if at the bottom of a glass/I wait)

> (Cendrars, *Le Panama ou les aventures de mes sept oncles*, 1914)

'Montparnasse henceforth replaces Montmartre. Mountain for mountain, we are still on the heights; art still prefers the summits.' Apollinaire had noted a *fait accompli*: the artistic generation had moved to Montparnasse. Picasso, for instance, now lived in the rue Schoelcher, near the famous Montparnasse Cemetery, Kees van Dongen in the rue Denfert-Rochereau, Kisling in the rue Joseph Bara. Most of the others lived in the cité Falguière, La Ruche or tiny studios dotted all over the left bank. As always in Paris, where they drank and socialized became the focal point of avant-garde developments: this all happened in the area where the boulevard Montparnasse crossed the boulevard Raspail, opened in 1911. Montparnasse is

a country of fresh air and café terraces: the terrace of the Closerie des Lilas presided over by Paul Fort . . . the terrace of La Rotonde, where you can see Kisling, Max Jacob, Rivera, Friesz and others; the terrace of the Dôme where you find Basler . . . Pascin and all other Dôme dwellers ensconced; the terrace of the Petit Napolitain where Pierre Roy, G. de Chirico and Modigliani refresh themselves; and the terrace of the Versailles where Marquet . . . likes to while away the time. These cafés are the oases of a region.

> (Apollinaire, *Apollinaire on Art: Essays and Reviews 1902–1918*.)

Apollinaire (writing here in 1914) could have added the restaurants: Baty's across the road from the Dôme, famous for its oysters, and Rosalie's, a stone's throw away in the rue Campagne-Première, memorable for the rats. In most of these places, you could order one dish (*une portion*) for 60 sous (that is 3

first impulse was not satisfactory, Modigliani took on an air of bored indifference; he would look about him quickly before throwing himself on a blank sheet that he would maul violently with his pencil.' When it was complete, he would ask for a drink. Gabriel Fournier was one of the few witnesses to note the passion that went into even a quick sketch.

56

The mood in those cafés during the war was a very particular one, as Vlaminck noted: 'The done thing was to be or at least look abnormal or strange. Everyone smoked opium, consumed hashish [hashish pills only cost 25 centimes each, but few people restricted their consumption to one a day, took alcohol and ether . . . painters, poets, would-be writers were all poor, but it did not matter, it was not a question of who made the most money. The one thing you had to have was a ferocious sense of humour.' Modigliani was not naturally witty; he may have been too involved with expressing his own emotions to acquire the necessary distance to be able to laugh at himself. Instead, he created *un personnage*, a character, recognizable at a distance by outrageous conduct – a Bohemian of the grand manner. 'It's odd but you never see Modigliani drunk anywhere but at the corners of the boulevard Montparnasse and the boulevard Raspail' Picasso remarked sourly. Modigliani inscribed a portrait of him 'Savoir' ('Knowing'). Picasso saw through everything, everyone. Modigliani was in fact incapable of having any kind of discussion with people with whom he disagreed: when the Cubist controversy raged at La Rotonde, if drawn into debates, he would often come to blows, especially with a drink inside him. It was the same with the women in his life: he would not hesitate to thrash Beatrice Hastings or Jeanne Hébuterne in public, and for these reasons Libion often threw him out or even occasionally banned him from his premises. So Modigliani refrained from discussing art, and his painter friends were generally unaffiliated, like himself: Soutine, Kisling, Diego Rivera, Ortiz de Zárate, Vlaminck, Jules Pascin. In his intellectual background, he was closest to poets like Cendrars, Salmon, Jacob, with whom he would enjoy frequent literary and philosophical discussions. His whole world was made up of these people.

59

85, 68, 65

86

In 1914, Modigliani made a gradual transition from an activity exclusively concerned with sculpture to one concentrating on painting: the linking factor was his incessant drawing. With Cubism the dominant style, painting and sculpture in their simultaneous exploration into tangible form and space were bound to be closely connected, and Modigliani's own research in that direction was integrated into the general trend. 'They say here that he [Modigliani] will do no more of these questionless immobile heads, as his designs begin to set the immobile amidst the mobile.' This may be a reference to the way Modigliani sets his solid figures in fluid backgrounds, as in his drawings and paintings of 1914.

63, 66

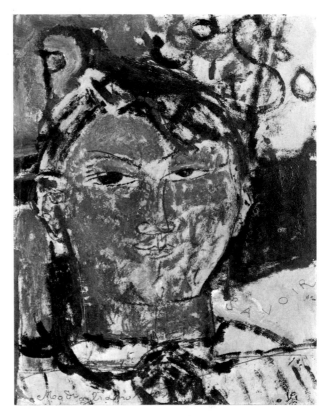

59 *Picasso*, 1915

The critic here is Beatrice Hastings (writing in July 1914), with whom he was to have a relatively long love-affair. Signing herself Alice Morning in her regular 'Impressions of Paris' for the avant-garde review *The New Age*, published in London, she describes her experiences in wartime Montparnasse and often gives unexpected insights about Modigliani that are invaluable for their unsentimental truthfulness and because they reflect contemporary opinion. They are the only writings about Modigliani that are not indulgent reminiscences clouded by the knowledge of his tragic ending, so they will be frequently quoted especially as, in most cases, they have never since been reprinted.

The important thing is that Beatrice, writing in 1914 and 1915, was not convinced of the uniqueness of his talent (except, perhaps, in sculpture) and like everyone in Montparnasse was struck essentially by the extraordinary figure he cut, whom she first introduces in her column as 'the pale and ravishing villain' dressed in corduroy. She met him at the very moment when he was leaving sculpture:

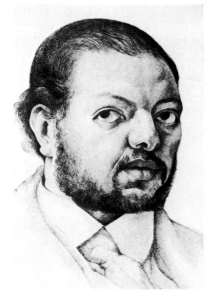

61 Diego Rivera, *Self-portrait*, 1918

62 *Diego Rivera* (pencil study for ill.
65), *c.* 1914

61 reproduced here shows. When he returned to Mexico in 1921 and until his
death in 1957, he revived mural techniques and fresco painting.

In Paris, Rivera was Modigliani's companion-in-arms at most orgies and
violent café-debates; they must have been an impressive pair, not unlike
Laurel and Hardy: Rivera, enormous, convivial, expansive, and Modigliani,
slight, somewhat fragile, and extremely reserved until he was drunk.
Marevna Vorobëv, who bore Rivera a daughter, and herself an artist, has
written most entertaining books on the communal artistic life of those days.

65 Rivera emerges in the painting as a massive, almost three-dimensional
figure from an ocean of light divisionist strokes. His jocund, Rabelaisian
personality comes through in the exaggeration of the sculptural qualities of
the face. Although Modigliani always preferred to paint oval faces, in this
case – and in the drawings and preparatory sketch – he accentuated the
roundness of Rivera's face. At this period (1914–15) and intermittently later

62, 63 on, differences can be seen between those portrait drawings of a self-
contained nature (solely his domain until Matisse, the post-1917 work

96

63 *Diego Rivera* (pencil study
for ill. 65), *c.* 1914

of Picasso, and all their imitators) and the drawings where he is seeking
information that will be useful for a later painting.

The three drawings of Rivera are made up of loose lines in which
Modigliani places the subject in the picture plane and defines the sitter's
plumpness and grandiloquence. In one sketch the space fits so tightly around 62
Rivera that one feels that the picture plane would explode if he attempted
any gesture. In the final drawing, the lines appear in some places as a series of 63
dots, hinting at the painting technique to be used. The fancy lettering here
may be Modigliani's homage to Apollinaire's *Calligrammes*, in which the
lettering is based on Futurist poetry.

By the end of 1914, Modigliani had finally acquired a unified style in
painting, just as he had achieved unity in sculpture. That is not to say that a
distinct artistic personality had not already revealed itself in his early
paintings: an artist in search of a personality is bound to disperse his energy
looking for himself; indeed the reassembled fragments make up a style.
When we look at the paintings before 1914, we can see a kind of progression

97

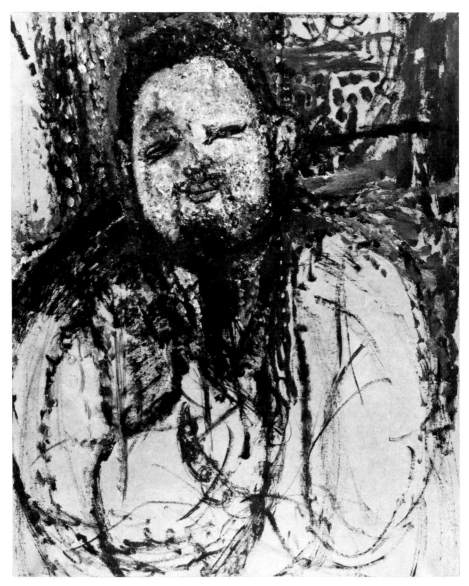

64 *Diego Rivera* (oil study for ill. 65), 1914

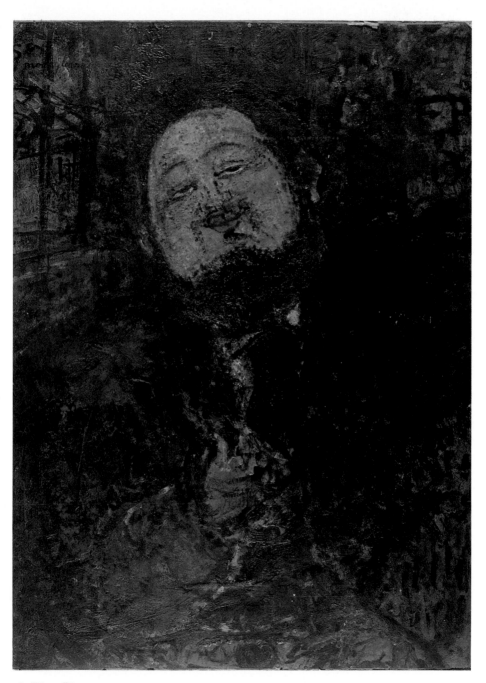

65 Diego Rivera, 1914

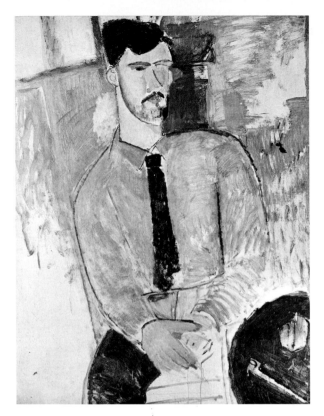

66 Henri Laurens, 1915

that leads naturally to sculpture; after that there is a visual continuity in his paintings, in that a certain evocative vocabulary of facial form has been evolved that becomes recognizably 'Modigliani' of 1914–16: oval or round shapes exaggerated, often modelled, their sculptural potential usually stressed; necks like pillars, only slowly becoming the stems Modigliani's portraits are generally associated with; the noses are ridges dividing the planes or are given Cubist multiple-viewpoint treatment, yet, being one of the sitter's most distinctive features, he allows them considerable realism; likewise for the mouths, although he prefers to depict them small, as in his sculpture. The eyes are the focal point, sometimes simultaneously open and shut, at times blank, yet hypnotic, frequently both; stars, tiny cacti, diamond studs, pools, lakes, whirlpools, metal spheres or endless combinations; microcosms of the sitters' personalities and of the relationships between them and Modigliani.

His own eyes were his most startling feature, transfixing people in a most disturbing way; by all accounts, women were frequently hypnotized by him; maybe cocaine added something to that persistent glare.

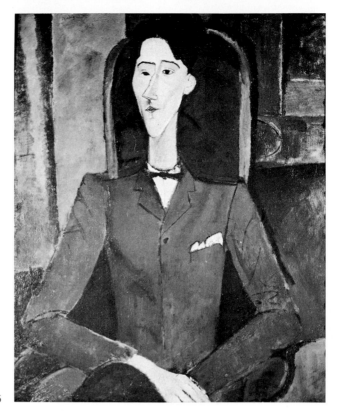

67 Jean Cocteau, 1916

The surfaces of the paintings are influenced by sculpture: in this period, they are never smooth and polished; they are built up, scumbling and impasto are used, the paint is scratched with a dry brush to reveal the layers beneath; locks of hair are sometimes traced with the tip of the brush handle in the wet paint and, just as in his earliest sculpture, an effect of low relief is created that cannot be perceived in reproduction. *66, 69*

Modigliani uses many techniques to express the personalities of his sitters. In both his portraits of Henri Laurens, the Parisian sculptor's powerful build *66* emerges from the canvas like granite; even his features seem hewn from rock. In the seated portrait, the simultaneous viewpoints of the shoulders, the forward tilted angle of the table, the beige-green colour scheme and the sparse, dry quality of the brushwork in the deliberately unfinished work indicate a greater interest in Cubism than Modigliani would have admitted to.

Radiguet is seen as the frail, sensitive adolescent rather than the literary *69* prodigy he was to become, soon to be 'adopted' by Cocteau. Here he is only

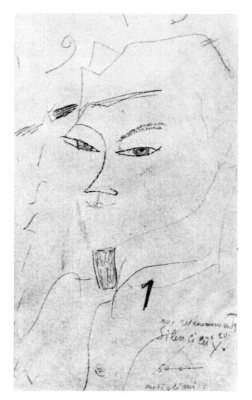

68 *Moïse Kisling*, 1915

twelve, and by the time of his death from typhoid at the age of twenty, he
had written the astonishing *Le Diable au Corps*. The intensity of his immense
blue eyes is at once childlike and prophetic; one eye is blank and inward
looking. Modigliani often portrayed in this way people whose minds he

66, 86 respected: Laurens, Picasso, Jacob, for example.

68 Kisling is depicted with a directness and simplicity that correspond
exactly to the way he always behaved towards Modigliani, to whom he often
lent his studio and even painting materials. They sometimes painted side by
side, as their portraits of Cocteau show: Kisling shows the poet as a sensitive
withdrawn soul, absorbed in his thoughts in a large room; Modigliani's
portrait, all sharpness and angles, is a frontal attack on Cocteau, whom he
found insufferably pretentious. As so often happened with Modigliani's

67 work, Cocteau came much later to look like this portrait, which he hated:
even at the time, he saw himself portrayed as Dorian Gray. 'His curled hair
seemed to sit on top of his angular drawn face, his skin had an ochre tinge and

102

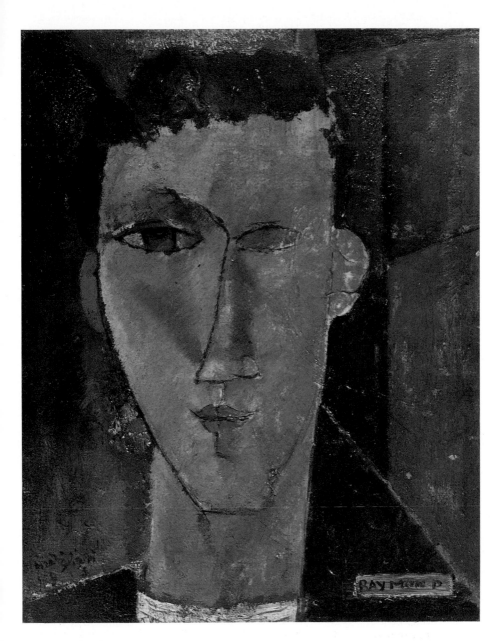

69 Raymond Radiguet, 1915

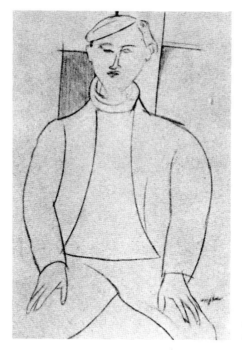

70 *Jacques Lipchitz* (preparatory drawing for ill. 73), *c.* 1916

his eyes were emphasised with a blue line. Everything in his artificial personality repelled me.' Fournier's description of the man fits the painting.

By 1916, the drawings map out the exact composition of the finished painting, but he still needs the actual presence of the model. 'To do any work, I must have the living person, I must be able to see him opposite me' he told Léopold Survage later. Frontality is most important, there being hardly any profile or three-quarter views and practically no full-length portraits, as Modigliani needed to retain mental, emotional and physical closeness with his sitters.

Lipchitz, the sculptor, commissioned him to paint a double portrait of
73 himself and his wife Bertha.

He came the next day and made a lot of preliminary drawings one right after the other, with tremendous speed and precision. Finally a pose was decided on – a pose inspired by our wedding photograph. The following day at one o'clock, Modigliani came in with an old canvas and his box of painting materials and we began to pose. I see him so clearly even now – sitting in front of his canvas which he put on a chair, working quietly interrupting only now and then to take a gulp from a bottle standing nearby. From time to time, he would get up and glance critically over his work and look at his models. By the end of the day, he said 'Well, I guess it's finished.'

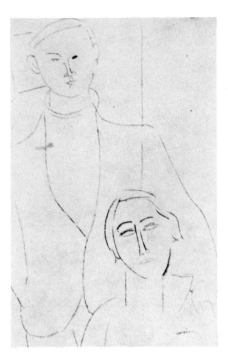

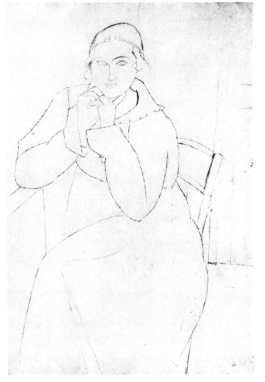

71 *Jacques and Bertha Lipchitz* (preparatory drawing for ill. 73), *c.* 1916

72 *Bertha Lipchitz* (preparatory drawing for ill. 73), *c.* 1916

As Modigliani charged per sitting, and Lipchitz wanted him to make more money, he asked him to continue the next day; Modigliani said 'if you want me to ruin it I can go on', but was persuaded grudgingly to continue into a second session, although this was uncharacteristic of his painting methods. Of the preparatory drawings, 5 survive, all remarkable for their terseness and evocative economy of line; 2 are of Lipchitz, 2 are of his wife, and only 1 of them shows the fully elaborated composition. The background is defined by a few lines around the head, as is frequent in the portrait drawings of 1916–17.

70-72

In the middle of 1914, two people stepped into his life and attempted to organize it: Beatrice Hastings, with whom he had his first serious emotional relationship, and Guillaume, the first art dealer to believe in Modigliani as an artist.

Before Beatrice, 'the English poetess who gets drunk on her own on whisky' as Jacob described her to Apollinaire, there had been many affairs, none lasting more than a few weeks: chiefly models, performers, *demi-mondaines*, the occasional poetess; he carefully cultivated his reputation as a cruel *tombeur* (literally, 'he who makes women fall'). But what he experienced with Beatrice was new to him.

A complex character. A pig and a pearl. Met in 1914 at a 'crémerie'. I sat opposite him. Hashish and brandy. Not at all impressed. Didn't know who he was. He looked ugly, ferocious, greedy. Met again at the Café Rotonde. He was shaved and charming. Raised his cap with a pretty gesture, blushed to his eyes and asked me to come and see his work. Went. Always a book in his pocket, Lautréamont's Maldoror. Despised everyone but Picasso and Max Jacob. Loathed Cocteau.

This short memoir was written after their affair was over and had left her bitter. Her first impressions, recorded in *The New Age* and which in parts read like a diary, make no attempt to assess the situation objectively, but simply record the elements that struck her the most; in fact, she was very impressed and far more taken than she is ready to admit: 'He is a very beautiful person to look at when he is shaven, about 28 I should think, always either laughing or quarrelling à la Rotonde . . . he horrifies some English friends of mine whose flat overlooks his studio by tubbing at two hour intervals in the garden and occasionally lighting all up after midnight apparently as an aid to sculpturing Babel.'

Others have recorded his personal fastidiousness and his tendency to exhibitionism, and Beatrice's last comment reinforces what Epstein says about how he would illuminate his sculptures (see p. 65). Modigliani was, in fact, thirty; Beatrice was at least five years older but kept her true age a secret.

106

73 *Jacques and Bertha Lipchitz*, 1917

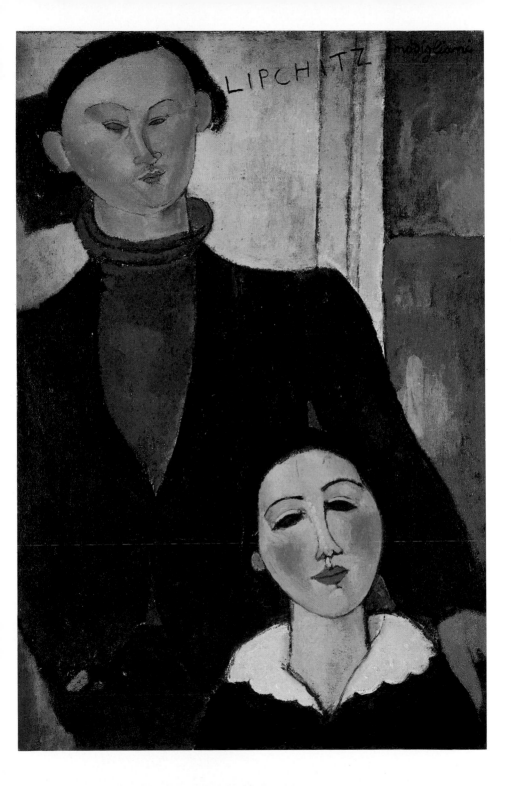

She was born in South Africa and at an early age married a professional boxer, whom she divorced; she then moved to England and soon became the editor of *The New Age* with A.R. Orage; contributors to the magazine included G.B. Shaw, G.K. Chesterton, Hilaire Belloc, Havelock Ellis, Arnold Bennett; there were some poems by Ezra Pound (whom she claimed to have discovered) and articles and reviews by Katherine Mansfield, with whom, it has been said, Beatrice had an affair.

She had decided to live in Paris, which when the war began was an extremely courageous thing to do: life as she describes it was full of real hardship and danger from the bombardments. Although she does not say it directly, Modigliani may have had something to do with her staying on there. The reason she would not admit this openly in her column or elsewhere is that up to now in her journalistic writings she had taken a very strong feminist line, campaigning for abortion, as she believed childbirth as a social imposition to be degrading, as well as anything that detracted from the development of a woman's independence. She amazed Parisians by smoking in public, wearing sandals, walking hatless in smocked Liberty dresses, decrying the hobble and the corset which prevented women from moving freely. In later years, she changed her opinions completely and became a Fascist sympathizer; there was in her – and we can guess this from her writings – a rather desperate, potentially fanatical side, as if through extreme self-discipline and rigid self-denial she could annihilate her inner pleas for emotion and a little self-indulgence. This may well account for her tendency towards alcoholism and her ultimate suicide in 1943: she was found dead in front of the gas oven with her pet white mouse.

She had written an unpublished novel in French about her life with Modigliani called 'Minnie Pinnikin' which Max Jacob helped edit, but it has been lost; the short memoir quoted above might be a summary of it.

They lived first in her flat at 53, rue Montparnasse and then on and off in her small house at 13, rue des Norvins in Montmartre. He painted her some 14 times; in this she is second only to Jeanne Hébuterne, his last companion who bore him a daughter, and who was depicted 25 times or so.

What they had in common appears very limited: Modigliani did not speak much English (although later in their relationship he was to affect an English accent in French), and her French was initially rather limited, although she did learn fast.

Beatrice must have been one of the rare women who did not reproach him for drinking, indeed they drank together: as she did not like wine, she introduced him to whisky and gin; she understood that conventional moralizing was useless in his case, if not harmful. Contemporaries in Paris remember her making grand entrances at La Rotonde, dressed as a

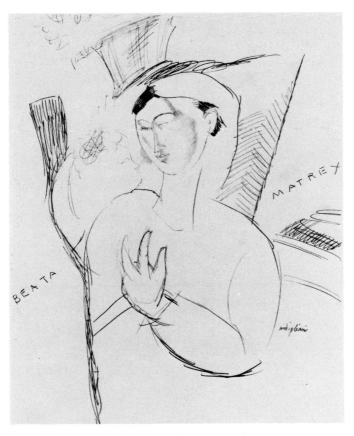

74 *Beatrice Hastings (Beata Matrex)*, 1915

shepherdess carrying a basket that contained live ducks; she was a recognized eccentric whose remarks could be as biting as any Montparnasse café–hero's.

Modigliani painted her as 'Madam Pompadour'; at the best of times, 75 Modigliani's spelling is atrocious, but here he must have meant to use the English spelling of 'Madame': Beatrice is posing as the grand courtesan, but the blankness of her stare and the Mardi Gras quality of her plumed hat give her away.

They also took drugs together; she has been frequently reproached for encouraging Modigliani in his habits but she knew that she could not stop him, and respected him for what he was. Besides, the drugs may have

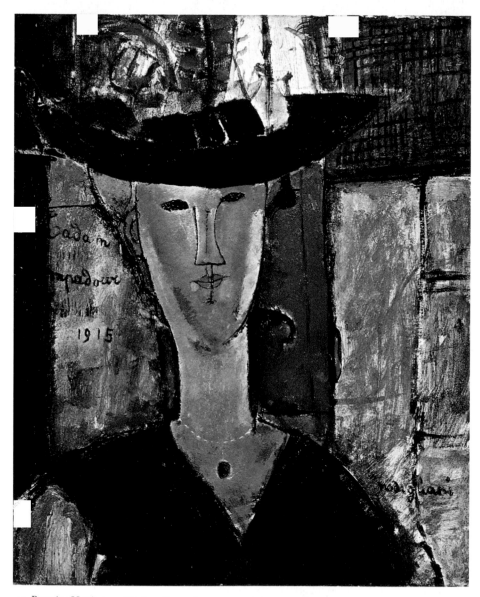

75 *Beatrice Hastings as Madam Pompadour*, 1915

76 *Beatrice Hastings*, 1915

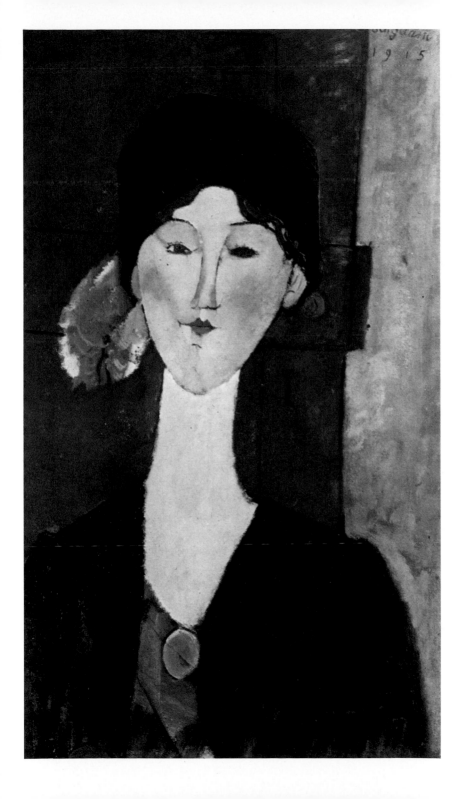

77 Francesco Parmigianino,
Madonna and Child with Angels
(*Madonna del Collo Lungo*),
c. 1535 (detail)

liberated her sexually. Her militant social attitudes, as well as the rather fanatical aspects of her nature had caused her to repress her more feminine instincts as well as, perhaps, her sexual response to men. Her articles in *The New Age* became more mellow and distinctly less virulent. Modigliani showed that he understood her inner conflicts by depicting her as a gentle, almost maternal, fully rounded creature, whereas she was rather thin and flat-chested; he goes so far as to label one drawing 'La Vita Domestica', which may be connected to an article she had written on the virtues of domesticity.

74, 78

While he is painting, he is not impatient; he listens to Beatrice's fragility, to her fears, to her essential bitchiness, her wholeness as a person, and he acknowledges these features in his private code: a smile, a twisted grin, a satisfied gaze that accepts him, beady eyes that criticize, a craning neck, a quivering stalk, a solid pillar.

76

Maybe it is this tacit understanding of her needs that kept her close to him. She provided a permanent challenge, variety and intellectual stimulus against a continuous backcloth of material security. And there certainly was love – if of a wild, often violent and extreme nature – between them.

'Someone has done a lovely drawing of me. I look like the best type of Virgin Mary, without worldly accessories as it were', Alice Morning reports in November 1914. On an idealistic level, Modigliani, who knew Dante by heart, was enchanted by the thought of having a muse named Beatrice, which may be why he frequently depicts her directly or through allusions as a latter-day Madonna, of the Parmigianino kind. It was natural he should

74

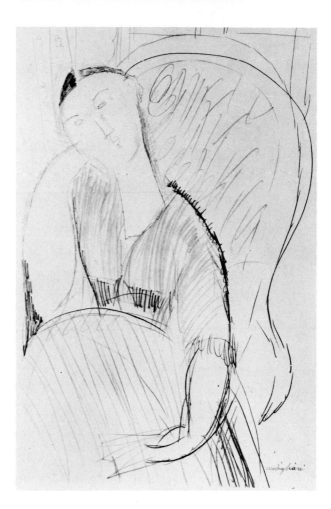

*78 Beatrice Hastings in an
Armchair, 1915*

turn to his native artistic background while alluding to his own culture.
Mannerism seemed to be an ideal source for him, conscious or unconscious;
his earlier sculpture tended, to a certain extent, towards Mannerist 76
elongation, and, moreover, Beatrice's physique, long neck and high, small 78
breasts suggested these sources. There are echoes of the *Madonna del Collo* 77
Lungo in many of the more serene portraits.

Sometimes, she is anything but 'the best type of Virgin Mary'. Some 79
drawings give the impression that Modigliani pulled her off the bed after
intercourse and told her to hold the pose. She looks like a weary Primaticcio,
her tousled hair falls about her, and loosely she holds the sheet. Violence
came to characterize most of their encounters, sexual or otherwise, and they

often came to blows. Although Marevna Vorobëv recounts the day Modigliani literally threw her out of the window, Beatrice was not always the victim. One night Modigliani rushed to Lipchitz in a state of shock, gasping 'Elle m'a mordu aux couilles' ('She bit me in the balls'). It takes two to maintain a violent situation over a period of years and it is evident that they both had a taste for it.

Modigliani's fantasies were built on Lautréamont, whom he loved to recite in graveyards, but Beatrice thought this writer absolutely perverse. She in turn often frightened Modigliani, who would run into La Rotonde begging people to hide him: 'Cachez-moi, c'est une vache' ('Hide me, she's a bitch'). Beatrice was not the type to go around complaining; it is the tone of her articles that indicates that she was steadily getting depressed, although she never allowed herself any self-pity and tried even to be humorous about the situation.

A creature said that all he knew about love was from his friends and that he supposed it to be a business of eating from the same plate so as to be close enough to prevent each other from being the first to get it as a weapon. We picked enormous holes in this theory, but he stuck to it, that they do eat off the same plate and break it on each other's head afterwards. I never did anything with a plate exactly, but what *is* love?

The creature here is certainly Modigliani – he frequently professed such cynical views – and if Beatrice spared her crockery, anything else would serve as ammunition.

Early in 1915, Alice Morning said that she was staying indoors 'nursing a sick wasp and writing a comic romance. The wasp strays in, eats a little honey, warms itself, tries to sting and travels to some winter lair. I suspect it is more sleepy than sick.' But Modigliani was getting more and more haggard; he was destroying himself in this relationship and needed more drugs to function. Beatrice, too, was by now little short of an alcoholic. All their arguments ended in violent fights, so often that when passers-by heard the usual screams of 'Help, he's killing me' they would shrug their shoulders and walk away. Several witnesses have described Modigliani becoming very calm after such outbursts, smiling like a child, singing to himself in Italian and then systematically peeling the wallpaper off Beatrice's walls. 'First he scratched away the plaster, then he tried to pull away the bricks; his fingers were so bloody and in his eyes there was so much despair' that Ilya Ehrenburg could not bear to watch and left the party, walking through 'the filthy courtyard with fragments of sculpture, broken crockery and empty crates'.

Before his first serious professional relationship with the dealer Paul Guillaume, Modigliani had a kind of arrangement with Paul Chéron, an ex-

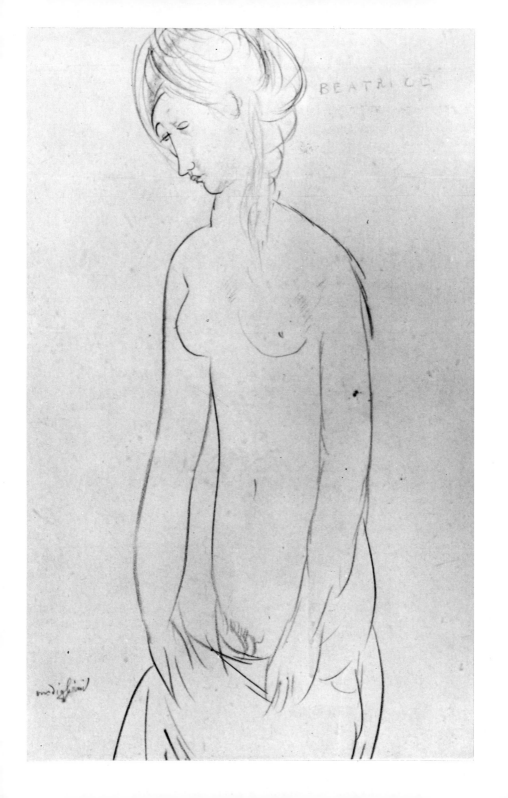

bookmaker turned art dealer. Legend has it that he locked Modigliani in his cellar with his servant girl, a bottle of brandy and painting materials. Both would be released when the picture was completed, and Modigliani was paid fifteen francs for his efforts. Fortunately, he painted rapidly. It was not likely that such a humiliating state of affairs could last very long. The final straw came when, one day, following a Cubist whim, Modigliani pasted to a picture a fragment of a popular song; Chéron thought it in bad taste and replaced it by a quotation from Baudelaire, probably claiming to understand Modigliani's intentions, as dealers and critics often do, better than Modigliani himself. That blew the arrangement sky-high.

Chéron and dealers like him saw that Modigliani was a potential money-maker; simply from the evidence of his paintings, Modigliani could have become a successful society portraitist like Van Dongen, for instance. Van Dongen's formula was very simple: enormous eyes and jewels, tiny waistlines. Modigliani saw each portrait as a fresh challenge: he brought out the most intense and sensual aspects of his sitter's features with great perception and subtlety; and despite the frequent element of caricature (Modigliani could not help being outspoken) his talent should have guaranteed social success. His portrait of Léon Bakst of 1917 shows that he did already have access to such a milieu. There are some drawings of small groups of people like *La Famille Ferdinan* drawn inside a bourgeois home. This may have been followed up by a painting, now lost. These sketches indicate that had he so desired, he could have built up a career on these lines. But he was not prepared to make any concession for a financial success which in any case did not interest him. Even Beatrice noted his complete lack of commercial sense: 'the Italian is liable to give you anything you are interested in. No wonder he is the spoiled child of the quarter, enfant sometimes terrible but always forgiven. Half Paris is in morally illegal possession of his designs. "Nothing lost" he says and bang goes another drawing for two pence or nothing while he dreams off to some café to borrow a franc for some more paper.' (*The New Age*, July 1914.) No wonder he was the despair of any dealer who attempted to work with him.

Moreover, recognition from people he did not respect was insufficient: he wanted it to come from the art élite, the critics, the artists, perhaps the good dealers. However he was dogged by bad luck and never received the full recognition he craved. By 1914/15 most of the artists in his entourage had found competent dealers or were selling fairly well themselves: the worst years were over, even though their relationships with their dealers who generally had control over their entire production were not necessarily easy.

Modigliani was initially enthusiastic about the dealer Guillaume, inscribing his first portrait of him 'Novo Pilota' and 'Stella Maris' – guiding

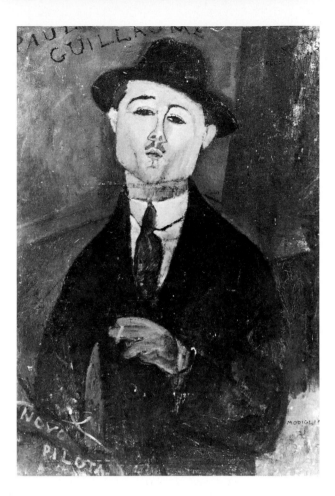

80 *Paul Guillaume* (*Novo Pilota*), 1915

star of the sea. Guillaume dealt in African art, which may have given *83*
Modigliani a measure of confidence in him. He hired a studio for him in the
Bateau-Lavoir, thinking that he was better on his own than with Beatrice
with whom he was then living. Guillaume was very interested in money: he
wished that Modigliani's paintings were more commercial. 'There's nothing
French in it and that's a great pity because the young man has a real gift.' By
French, he meant Cubist, as he moaned to Zborowski who was later to take
up Modigliani.

Modigliani's distrust of Guillaume's motivations comes through in the
portraits Modigliani painted of him in 1915 and 1916. Even in the apparently
optimistic 'Novo Pilota', the wispy moustache above the thin parted lips, the *80*
trilby hat neatly perched on his head, the feminine way of holding his arm

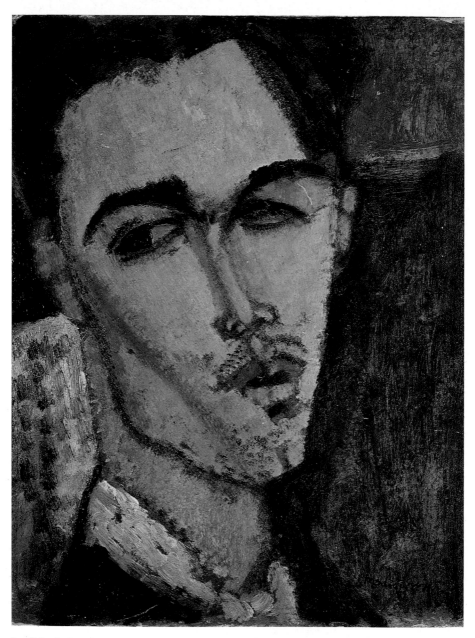

81 *Celso Lagar*, 1915

82 *L'Arlequin* (self-portrait?), 1915

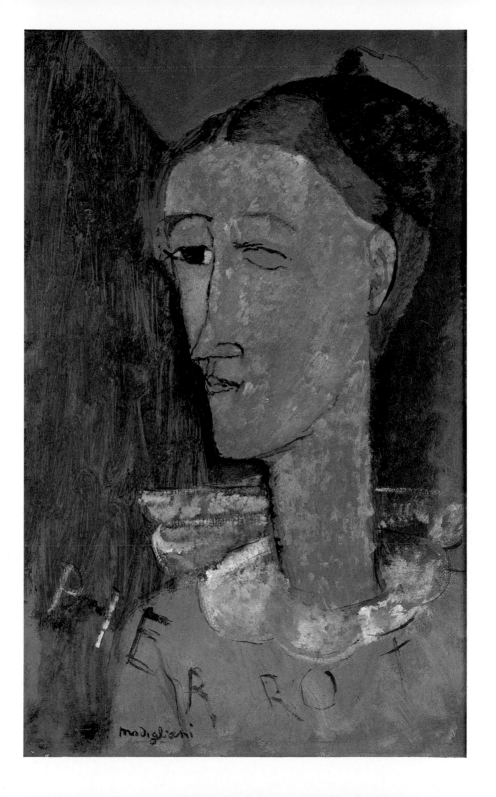

close to his body, waving a finger as he holds a cigarette – all this reveals the poseur.

A year later, in 1916, he painted him in similar attire: the colours, rusts, blacks and browns are much the same but the sitter is more relaxed. Modigliani has painted one eye white – the same colour as his shirt, and the other is a spiky green hedgehog, always a coded sign of disapproval: he painted Beatrice with the same feature at least once, expressing a particularly stormy phase in their love-hate relationship. An important collector of the time, André Level, noted the asking prices for Modigliani's works. Early in the war, Guillaume, from whom he had purchased some African masks, sold him some pictures by Modigliani: 'Heads of Women' for 25 and 30 francs each, a large portrait of Beatrice Hastings for 60 francs, an early Modigliani 'which must have been painted a long time ago in Italy' for 50 francs. Guillaume had obviously not bothered to get any details down with any precision.

On another occasion, Level was drinking at the Dôme with Picasso, Apollinaire and Léonce Rosenberg. Modigliani joined them and Picasso decided to take them all back to Modigliani's studio, saying that he 'sculpted stone heads and painted portraits of women and friends'. That Picasso discerned Modigliani's talents early on has hitherto been ignored, though it is well known that Modigliani respected him. 'He is always ten years ahead of us' Modigliani would say. An introduction to Rosenberg, one of the best dealers in town, was very valuable – especially now that Kahnweiler, who had been Picasso's dealer, being a German, had had to return to his own country because of the war. Level noticed that Picasso, with the commercial sense Modigliani lacked, acted as intermediary, asking Modigliani for prices, probably discussing them with him before telling the others. Unfortunately Level only noted down one price, that of a caryatid watercolour at 25 francs. When he was on his own. Modigliani asked 5 francs for his portrait drawings and was furious if anyone gave him more and he told Lipchitz that he charged 'Ten francs and a little alcohol for each sitting.'

Prices of paintings varied enormously for everyone. Jacob noted that at the beginning of the war, they actually went down. Wives of artists at the Front attempted to keep their families by selling their husbands' work. The buyers decided the prices, not the sellers. Many people cashed in on the situation, tourists from all over the world, would-be artists, all drawn to Montparnasse by its myth. A more sinister aspect of this situation is that police officers used their power to extract paintings from artists at minimal prices or in lieu of payment of a fine: it was easy, all they had to do was to threaten them with expulsion, most of them being foreigners. Thus the policeman Descaves bought lots of ten paintings at 100 francs; his colleague

83 Advertisement for an exhibition and book of African sculpture, 1917

Zamaron, who when off duty was to be found at La Rotonde, accumulated literally hundreds of works by Modigliani, Soutine, Utrillo, Chagall and Tsugouhara Foujita. He in fact was a sympathetic officer who got Utrillo and Modigliani out of trouble more than once. But such policemen were rare. And there were shady dealers who exploited the situation, like Basler (the writer on art) who had one price, 15 francs – take it or leave it – for Utrillo, Modigliani and Kisling. In fact, the established dealers – Kahnweiler, Rosenberg, Vollard, Durand-Ruel – ultimately performed a great service to modern art by imposing respect through high prices. An artist on his own stood no chance.

It is difficult to see how the above sums relate to today's prices without examining those of other commodities. Food prices rose phenomenally during the First World War and especially in Paris where they could be three times as high as, say, in the South of France because of the difficulties of transporting foodstuffs through the war-ridden provinces. Rationing and acute shortages of sugar, salt and milk were frequent. In 1917, the cheapest cheese (Cantal) cost about 4 francs a kilo, a chicken cost about 10 francs, and potatoes, on which most people survived throughout the war, were 20 centimes a kilo. In canteens and restaurants it was still possible to eat cheaply but reasonably at about 3 francs; Rosalie maintained that you should never spend more than 5 francs for any meal at a restaurant, at least not in hers. In a letter dated September 1914, Jacob claims triumphantly to have found a restaurant where the veal was 22 sous (that is 1 franc, 10 centimes), but prices rose very rapidly all through the war, and life appears to have been

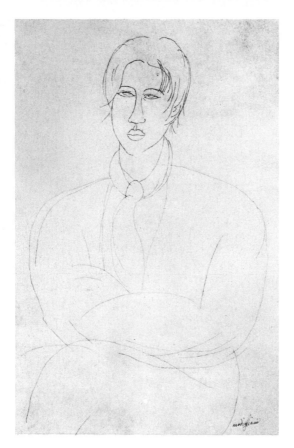

84 *Chaïm Soutine*, 1917

much more expensive than it is now. Beatrice paid 65 francs a month for a two-room flat with running water in Montparnasse; but she said she was exceptionally lucky as the area had now become fashionable, and 150 francs a month would have been normal.

81, 85

In the portraits of these years, Modigliani is attentive to the physical characteristics and idiosyncrasies of his sitters as well as to the reality of the situation that links painter and sitter at the moment at which he is painting. Everything else – the drinking, the self-hate, the daily nightmare – that concerns him personally is locked out of the image. That is why the atmosphere of the paintings appears to be so opposed to what seems most obvious in his personality. This is the essential difference between his work and that of his great friend Soutine, whose canvases exclude anything that is not directly connected to the expression of his hallucinatory anguish.

134

122

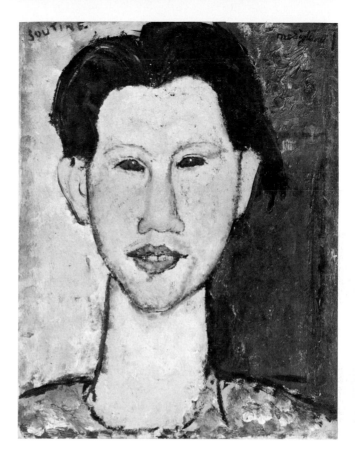

85 *Chaïm Soutine*, 1915

Modigliani often made real efforts for his male friends (which he certainly would not have considered making for the women in his life). Slowly and patiently, he taught Soutine to hold a knife and fork, how to blow his nose with a handkerchief instead of his fingers. Once, both artists were invited to a dinner-party and Soutine sneezed; frantically, he searched his pockets for a handkerchief and finding nothing, he turned his huge, desperate eyes to his friend; Modigliani, unperturbed, calmly continued his conversation with his host while he unknotted his cravat and passed it discreetly to Soutine under the table. One could not imagine two more different people: Modigliani, highly literate, urbane, sophisticated, always conscious of personal hygiene, wearing his faded velvet suit with incomparable style and studied neglect; and Soutine, barely articulate, covered with vermin, pathologically afraid of washing, forever obsessed by the violence of the ghetto and the starvation he had known in Russia, and to whom Mediterranean logic was totally alien.

123

Soutine said later that it was Modigliani who gave him self-confidence. Certainly there is not a hint of condescension in Modigliani's portraits of Soutine, whom he respected as an artist; indeed in them he restores his dignity as a human being. Soutine worshipped Modigliani and was given to wearing his cast-off shirts; then he said he felt much more confident, as he thought he had actually become Modigliani.

Both Modigliani's and Beatrice's lives were continually traversed by homosexuals. Jacob, the poet mystic and etheromaniac was close to both of them; they both knew Cocteau and his young protégé Radiguet, with whom Beatrice later had an affair; and there was Brancusi whose allegiance has never been completely specified – his company was largely homosexual and also included the poets just mentioned. At different times in Modigliani's life, such as in 1910 (the year he spent with Brancusi) and in 1916 (after Beatrice left him), there are series of drawings of young men, buoyant and muscular, radiating self-confidence: many appear to be dancers. There is a picture entitled *L'Arlequin*, which has sometimes been catalogued as a self-portrait. It is a curiously androgynous figure in delicate scumbled rose and greys that has the delicacy and pathos of Picasso's pink period, but also a haunted introverted feeling. In this connection, it is worth remembering that Modigliani's stone heads often appear to be neither male nor female.

If there were nothing else, it would be easy, and painfully obvious to conclude that Modigliani was homosexual. He had been the darling child of an essentially female household, and it had been his mother who introduced him to Wilde's writings in the days when he idolized his friend Oscar Ghiglia. No taboos in this family except failure. But I think that the fantasy remained an aesthetic, often narcissistic one which he accepted artistically, but which in the reality of everyday life he rejected: it was acceptable to paint Celso Lagar or Gris as effeminate creatures, but that is where he stopped. Astrologers would ascribe his extreme sensitivity to his native sun-sign Cancer, the feminine sign *par excellence*.

Maybe Beatrice understood this, but she could not put up with unsophisticated people like Soutine and Utrillo as well, and above all she was by now completely worn out by the relationship and left him.

Jugement de femmes: Aux enfers, Dante et Virgile inspectaient un baril tout neuf. Dante tournait autour. Virgile méditait. Or ce n'était qu'un baril de harengs saurs. Eve toujours belle habite en ces lieux, courbée par le désespoir bien qu'elle ait à sa nudité la consolation d'un nimbe. Eve se pinçant le nez déclare 'Oh mais cela sent mauvais' et elle s'éloigna.

(*The judgment of women*: Dante and Virgil were examining a new barrel in hell. Dante was going round and round it. Virgil was meditating. But the

truth was that it was only a barrel full of herrings pickled in brine. Eve, still beautiful, lives in these regions, bent double by despair even though her nakedness is consoled by a halo. Eve held her nose and declared 'Oh but it stinks' and walked off.)

<div align="right">(Max Jacob, <i>Le Cornet à dés</i>.)</div>

Dante may well be Modigliani, Eve Beatrice and the pickled herrings the Russian colony, perhaps even Soutine (in fact the Slavs in Paris were often referred to as 'herrings', as this was one of their national delicacies). Virgil must then be Jacob. *Le Cornet à dés*, from which this is an extract, is a series of prose poems, written largely when Jacob, Beatrice and Modigliani were virtual neighbours in Montmartre and saw each other daily.

Jacob was born in Quimper in Brittany in 1876; he was the magician and philosopher of the Butte. He also qualified as a cabbalist, a palmist, an astrologer, an antiquarian, a man of letters and a painter. He had had every kind of employment from shop-floor sweeper to art critic. Picasso, with whom he had shared a room when he arrived in Paris, encouraged him to write and illustrated his first published book *Saint-Matorel*. His style is a mixture of improvisation, subtle wit and linguistic refinement that parallels Satie's approach in music. Both he and Modigliani were experts at declaiming verse and making speeches, but people preferred Jacob, as he never caused a fuss or took his clothes off in public as did Modigliani. A friend's remark about Jacob also applies to Modigliani: 'How many times have I seen Max play the fool with the haggard look of a desperate man.'

Modigliani painted him twice and drew him many times. He appears either as the *grand mondain*, wordly-wise, refined in top hat and cape lined with red satin, or as a quiet, genial mystic – always elegant (even if desperately poor), a quality appreciated by Modigliani. Jacob had one set of evening clothes he always wore when he went out, even to the most casual functions and at La Rotonde. When he came home, even in the company of friends, he would remove his elegant apparel, fold it neatly away in his trunk and slip into old shabby clothes.

86, 92

Modigliani and Jacob would meet in Montmartre and later on, in war-stricken days, in Montparnasse cafés filled with foreigners and Frenchmen discharged from military service, while everybody else was at the Front.

The sudden onset of the First World War unleashed xenophobia. All foreigners were immediately suspect and had to register with the police. Anti-Semitism once more became rampant. Modigliani instantly retorted by approaching strangers at cafés with his sky-blue portfolio full of drawings, summarily introducing himself as 'Modigliani, juif, cinq francs' ('Modigliani, Jew, five francs'). Shopkeepers with foreign-sounding names (Ashkenazi names are often German) had to place large placards in their

windows to say that they were French, otherwise vandals would attack their premises. German artists disappeared from their headquarters, the Dôme (a group of them had exhibited before the war in Düsseldorf under the name of Dômiers'). Beatrice says that before the war Montparnasse was full of Germans and that during the war they were replaced by Poles.

Kisling, then Zadkine, enlisted for the Foreign Legion and soon realized that officers treated all the soldiers in that regiment particularly badly because they were foreigners and therefore had no right, it would seem, to protest. 'Artists who had been called up were made to camouflage lorries. It turned out that for the purpose of camouflage, it is necessary to break up the basic forms, and the streets were full of lorries looking like cubist canvases.' Like Ehrenburg who here describes wartime Montparnasse, Modigliani volunteered, in a fit of unprecedented patriotic fervour; he was instantly turned down (so was Ehrenburg, to his relief); but Modigliani was genuinely disappointed and drowned his despair for a couple of days in whisky and brandy, absinthe having been outlawed. Picasso refused to be drawn into any kind of nationalist partisanship and would staunchly remain seated while the 'Marseillaise' played on. Jacob's correspondence, Alice Morning's column and Modigliani's daily drawings document different aspects of the war. From them, we can see who was still there: Picasso, Gris, Archipenko, Foujita, Soutine, Krémègne, Rivera, Kikoine, Lipchitz, Ortiz de Zárate, Brancusi. In 1915, there was a new influx of Russians: Natalia Goncharova, Mikhail Larionov, Ehrenburg, Voloshin, and La Rotonde was the first port of call for artists and poets on leave, such as Apollinaire, Cendrars, Fernand Léger, Braque. There were grand banquets given in their name in artists' canteens run by charitable souls like Marie Wassilieff; on other days, meals at cost price were provided. The need for such places was real, as finances and morale were at a low ebb. Modigliani's allowance from his family in Italy was stopped. Soon cafés were closed at 8 p.m., restaurants at 9.30; there were black-outs, newspapers suspended publication for a while, and only one-page handouts on the situation at the Front were available, and when publication returned, censorship (nicknamed 'Anastasie') was such as to make the papers useless. And when the bombardments began and people had to hide in the Métro, real despair set in. 'Now the sky is all aeroplanes with their sound of tearing out your bowels. Horrible machines, the ideal of mechanical efficiency perfected in blood and destined to serve man for the sinister destruction of himself and his works' (*The New Age*, June 1915).

Jacob noted that orgies went on everywhere, even in the artists' canteens: he could well understand his friends' desperate mood but this behaviour depressed him. An end-of-the-world atmosphere was reflected in popular songs as well:

126

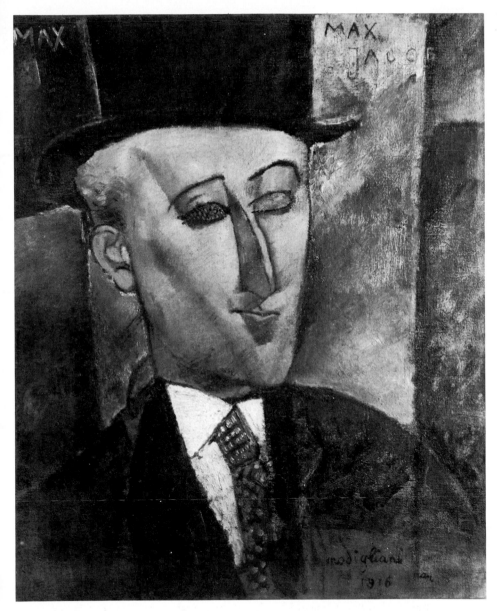

86 *Max Jacob*, 1916

La vie est belle
On n'en fiche pas un coup
Sur toute l'échelle
Tout le monde s'en fout.

(Life is great, no one in the whole world gives a damn, no one could care less.)

Even Modigliani did not shock people any more. Like everyone, he went to Marie Wassilieff's fancy-dress parties, but he never would dress up specially. 'After a time, Modigliani decided to undress. He wore a long red scarf round his waist like the French workmen. Everyone knew for certain when he was going to undress, as he usually attempted to after a certain hour. We seized him and tied up the red scarf and sat him down. Everyone danced and sang and enjoyed themselves till the morning.' Nina Hamnett was the life and soul of such parties as she enjoyed dancing naked; her memoirs (*Laughing Torso*) provide an interesting insight on the whole period.

And there were also secret clubs like *Mon Oeil* (French slang for 'Who're you kidding?') in the rue Huyghens, which was a black market centre where people could drink illegally and dance all night. This was the first aspect of wartime Paris Modigliani painted and drew: the women in fancy-dress, the garish entertainers, the Rive Droite socialites who sought to relieve the monotony of their day-to-day existence in cosmopolitan Montparnasse – the only place in the country where the last young men were to be met, all the rest of French youth being at the Front. *The Bride and Groom* may have been painted at some late-night haunt. As in the drawings of the same kind, the woman sits and the man stands, like in the photographs of the day. They are both in evening dress and their ruddy faces are modelled by strong white light; they stare stiffly, blankly, maybe drunk beyond recognition; and Modigliani has given them both preposterous noses: the man's appears to be viewed from both sides, and his face looks as if it had been cut in two and stuck together a little hastily. This is hardly a Cubist attempt, but rather a subtle and sardonic view of the revellers.

The other aspect of the period Modigliani brings out is the mystic mood of the time, by which he is affected. The First World War was a great period for mystical escapism of all kinds: La Rotonde was full of Russians who told fortunes, necromancers, palmists, theosophists and spiritualists. Modigliani was as affected by the atmosphere in Paris as by the events going on outside on the battlefield. Ehrenburg remembers how 'he sat on the stairs, sometimes declaiming Dante, sometimes talking of the slaughterhouse, of the end of civilization, of poetry, of anything except painting'. He was forever quoting Nostradamus, and some drawings are inscribed with his predictions.

87

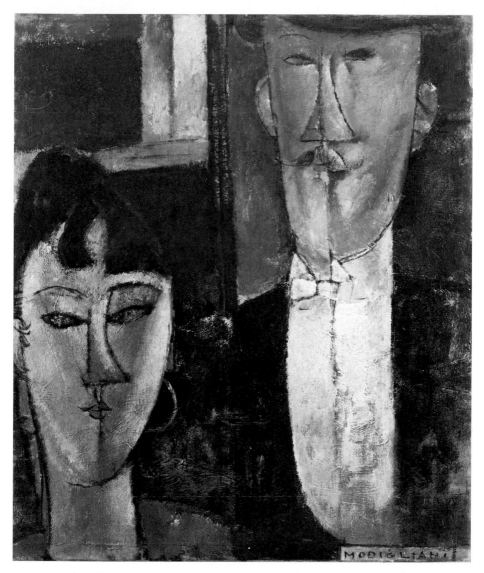

87 *The Bride and Groom*, 1915

88 *Monk (L'Estatico)*, 1916 89 *Crucifixion (Christos)*, 1916

Legend has it that a revolution was being discussed by Russians in the back room of La Rotonde. Trotsky was a regular and had long discussions with Rivera and also with Vlaminck, whom he admired but whose absence of social comment in his work he deplored. It has been said that Lenin also frequented this haunt and once sought work as an artist's model but was turned down as he was too short. Ehrenburg says that Modigliani's brother Emanuele, the militant socialist, came to Paris in the early days of the war and met Martov and Lapinski. He was extremely upset at the state in which he found his brother 'and put it down to bad companions and the Rotonde in general'. 'When the first news of the revolution in Russia arrived, Modi came running to me, embraced me and began screeching enthusiastically. Sometimes I could not understand what he was saying.' One result of the revolution was that La Rotonde became suspect to the authorities and was made out of bounds to soldiers.

There is a mysterious series of drawings of penitents and crucifixions of 1916 for which no paintings survive; probably none were painted. They are so untypical of Modigliani's legend and *œuvre* that critics have ignored them completely and in sale-rooms they go for far smaller sums than any other of his works. Most of them show naked figures of men and women kneeling and praying – one of them is of a monk labelled 'l'estatico'; the reference may be to seventeenth-century Lombard depictions of saints in mystic trances, generally referred to as 'Ecstasies'. In fact, the emotionally charged atmosphere seems related to that particular school of painting with which Modigliani was familiar. On them are inscriptions in Latin: 'Dies Irae' ('Day of Wrath'), 'Dies Resurectionis' ('Day of Resurrection'), 'Purgatorius Animae' ('Purgatory of Souls'); also 'I Santi' ('The Saints') and 'où es tu?' ('where are you?'). The stylistic references are less important than the considerations behind these unusual drawings. They may have been a mystic reaction to the slaughter going on at the Front and a way of expressing a deep apocalyptic feeling. But after all, Modigliani was Jewish, although more or

88

90

90 *Kneeling Woman (Dies Irae, Dies Illae)*, 1918

less an atheist, and these Last Judgment images were quite alien to his background.

Jacob may well be the key to this mystery. Like Modigliani he was Jewish, but converted to Christianity after having had a vision of Christ in his room in the rue Ravignan in 1909; when he was finally christened in 1915, Picasso agreed to be his godfather. Most of his friends doubted the sincerity of his conversion, as he would indulge in alternate extremes of debauchery and sanctity, indulging in one to repent in the other. And yet, his works became increasingly mystical in tone. In 1921, he moved away from Paris to the vicinity of the ancient monastery of Saint-Benoît-sur-Loire, and the importance of his writings was recognized. During the Second World War, Paul Eluard, involved in the Resistance, was to come especially to tell him how much the young poets of his generation owed to his genius. Despite Jacob's conversion to Catholicism, the Nazis made him wear the yellow star, like all Jews: they arrested him in 1944, and he died on his way to the gas chambers in the French transit camp of Drancy.

There are two drawings of the crucified Christ with forked arms, according to an ancient tradition, and they are inscribed in Greek 'Christ'; this Christ is scrawny and under-nourished, he does not hail from Nazareth but from the artists' ghetto in Montparnasse. Did Modigliani, like Jacob, go through a major religious crisis?

Around 1916, Jacob dedicated a little-known poem to Modigliani that might provide the clue: 'A M. Modigliani pour lui prouver que je suis un poète' ('To Monsieur Modigliani to prove to him that I am a poet'). It is a complex poem in which he describes in a seemingly light-hearted way his conversion and what God meant to him, 'instead of meeting a woman, one day I encountered God . . . he is all calm and gaiety, he has given me security' and that his mission is now to be his secretary. If Jacob dedicated a poem about conversion to Modigliani, this at least indicates serious discussions on the subject, although religious fervour of any kind could never profoundly affect Modigliani.

In 1919, Jacob published *La Défense de Tartufe*, subtitled *Extases, remords, visions, prières, poèmes et méditations d'un Juif converti* ('Ecstasies, remorse, visions, prayers, poems and meditations of a converted Jew'); the title is based on *Le Tartufe*, Molière's play about a hypocrite, but it was originally entitled *Le Christ à Montparnasse*. This book is about the difficulties he encounters, the extremes of temptation and repentance he suffers, as a converted Jew, in his search for Christ. The central themes running through the book are also found in his earlier works linked to his conversion, and there are signs that he was working on *Tartufe* as early as 1916.

The subject-matter of Modigliani's religious drawings is remarkably close

A M. Modigliani pour lui prouver que je suis un poète. ▬▬▬▬▬▬

LE nuage est la poste entre les continents
 Syllabaire d'exil et que les Océans,
Condamnés par l'Enfer à se battre en pleurant
N'épèleront pas sur le vernis de l'espace.
Le noir sommet des monts s'endort sur les terrasses
Sillons creusés par Dieu pour cacher les humains
Sans lire le secret du nuage qui passe
Lui ne sait pas non plus ce que portent ses mains
Mais parfois lorsque son ennemi le vent le chasse
Il se tourne, rugit et lance un pied d'airain.
J'étais, enfant, doué. Mille reflets du ciel
Promenaient, éveillé, les charmes de mes songes,
Et venaient éclipser l'étendard du réel.
Au milieu des amis, enseignés par les anges
J'ignorais qui j'étais et j'écrivais un peu.
Au lieu de femme un jour j'avais rencontré Dieu
Compagnon qui brode mon être
Sans que je puisse le connaître.
Il est le calme et la gaîté
Il donne la sécurité
Et pour célébrer ses mystères
Il m'a nommé son secrétaire
Or pendant les nuits je déchiffre
Un papier qu'il chargea de chiffres
Que de sa main même il écrit
Et déposa dans mon esprit
Dans l'aquarium des airs vivent les démons indiscrets
Qui font écrouler le nuage pour lui voler notre secret.

91 Poem by Max Jacob from *Le Laboratoire central*, 1921

to Jacob's themes, and the feelings of despair, guilt and humility that run through *Tartufe* (despite the frequent humour) seem to be echoed by Modigliani in these drawings.

It is not impossible that while working out the preliminaries for *Tartufe* in 1916, Jacob could have asked Modigliani – whom he was seeing daily – to do a series of illustrations for it. In this close-knit circle – Picasso had engraved the frontispiece of his *Saint-Matorel* in 1909, and Kahnweiler had been his publisher – such a suggestion would not have been unrealistic.

Jacob was one of the few people (according to Beatrice, only Picasso and herself were the others) who understood the contradictions that raged in

93 *Reclining Nude (Almaïsa)*, (preparatory drawing for ill. 94), 1916

93, 94

96

Before he embarked seriously on sculpture, Modigliani repeatedly drew from the nude to learn from it and simply because he enjoyed the shape of the female form – hence the extreme sensuality of the caryatids. Between 1914 and 1916 his studies of nudes were preliminaries for paintings, and, even when drawing and painting present formal similarities, their effect is not the same. In the drawings, the line is harmonious and controlled, and there is a classical quality in Modigliani's approach to form. In the paintings, the brushwork has a vibrant, highly animated life of its own, contained by calm rhythmic linear patterns. The surface is highly worked and is covered in variations, sometimes minute, in intensity and direction of brush-strokes, and the subtle colour transitions are often visible only at close quarters. In this contrast between drawing and painting, Modigliani's work differs from Picasso's at this time. Picasso's overall style was then essentially linear, and the harmony of his painted works derives from its graphic unity. In concept, Modigliani's painted nudes may perhaps best be compared to Matisse's sculpture, where the harmonious forms are complemented by the almost aggressive treatment of the texture.

136

94 *Reclining Nude (Almaïsa)*, 1916

An interesting characteristic of the nudes is the fact that they were generally done in series, that is often painted consecutively, indicating their importance as an exclusive activity. With one exception, of 1917, now at the Courtauld Institute Galleries, there are no isolated paintings of nudes interspersed among the portraits.

When his studies were preliminaries for paintings, his method was to work round the model, experimenting in each study with a different pose and angle. This was quite different from his method in the portraits, where the pose was fixed right from the start.

After his 1916 series, there are no surviving drawings of nudes directly linked with paintings. The life sketches of 1917 show standing and crouching figures in which Modigliani experiments with the changing appearance of the female figure as it moves slowly across space, adjusting its position by degrees, as if directed by a choreographer. The drawings are, therefore, quite naturally produced in series. Modigliani could paint only in private, painting being an exclusive, concentrated activity, whereas he frequently went to draw at life classes with other artists and students.

95, 97

137

98 Theda Bara in *Cleopatra*, 1917

99 Mary Pickford, *c.* 1918

100 Titian, *Venus with the Organ-player*, *c.* 1548 (detail)

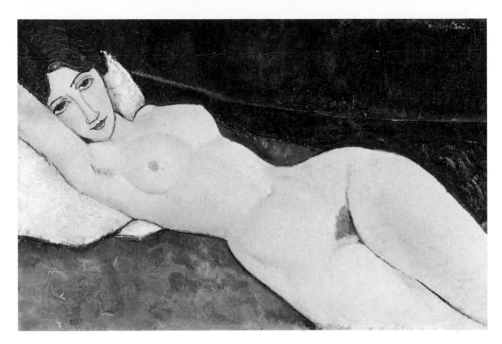

101 *Reclining Nude*, 1917

from the sexually charged atmosphere of the paintings, but should not be presumed. Although these nudes could, in their satisfied poses, be seen as a paean to his amatory skills (which were said to be considerable) and also to the ephemeral glory of these transient but fulfilled encounters, they represent above all an ideal, and just as one does not need a virgin to paint the Madonna, an encounter with a woman limited to a successful painting session could have been sufficient consummation.

His models are of two kinds: powerful archetypes, full-breasted with wide hips, usually dark and Mediterranean; and, far more rarely, high-breasted women, childlike and demure: Modigliani evidently chose these types because he thought them beautiful, yet they correspond very much to period stereotypes, eagerly adopted by early cinema. Hollywood simul- taneously launched Theda Bara ('The Vamp') and Mary Pickford ('America's 98, 99 Sweetheart'). These types derive from a long tradition which opposes the two male ideals of love, what Plato's later critics called *Venus naturalis* (natural Venus, earth) and *Venus coelestis* (celestial Venus, heaven). Modigliani now turned to Venetian and Florentine art of the Renaissance, which has been described in terms of this opposition. But neither Botticelli, the champion of *Venus coelestis*, nor for that matter Parmigianino, could help 77

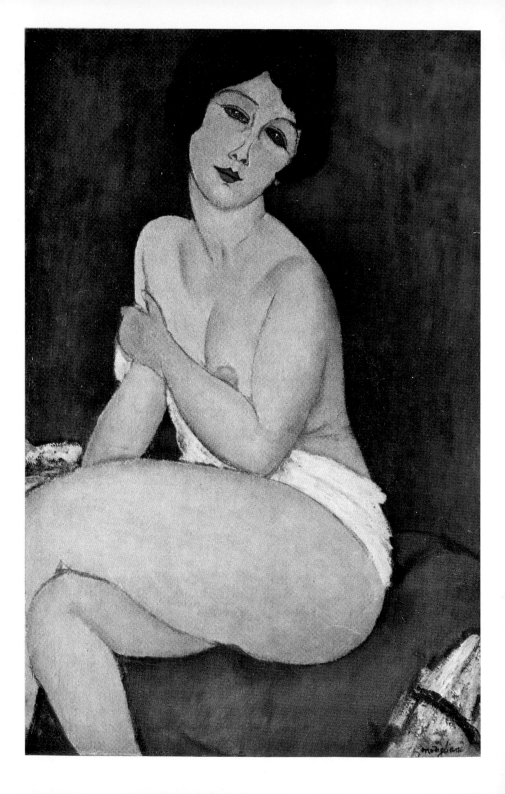

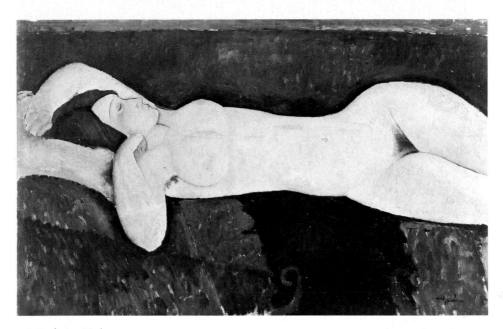

103 *Reclining Nude*, 1917

Modigliani convey exactly what he was trying to express (except for a few isolated cases, as we shall see); it was to Giorgione, and Titian especially, both champions of *Venus naturalis*, that he turned.

The Venetian school glorified the self-confident sensuous nude, resplendent with a vitality new to the development of Italian painting. Titian, the great master of recumbent femininity, painted countless Venuses and Danaës, lying on their side, their sex frontal, in anticipation of the *100* delights imminently arriving from just outside the picture space. Modigliani adopts the pose, but, unlike Titian, makes the setting very stark: the simplest indication of a bed or a sofa, or in some cases just planes of colour, in which the model's stability is ensured by her own gravity. The pull is always downwards, even when she is reclining. When she is not parallel to the *101* picture plane, the legs and elbows always point earthwards – basic reassurance, *Venus naturalis*. The sensuous line leads the spectator's eye slowly round the woman, and the rhythm of the brushwork gathers momentum in the area surrounding the pelvis. All the nudes present these features, with slight variations, and they are all characterized by a harmony only rarely found in the portraits. The emphasis in the portraits on the eyes and

143

102 *Seated Nude*, 1917

the mouth has now been shifted to the sexual parts, from argument and debate to wordless communication; the model loses her mystery as an individual to become an eternally familiar female who presents far more similarities to, than differences from, other members of her sex.

Modigliani subtly pushes this point to distortion. In most of his reclining nudes painted in 1916 and 1917, the woman lies on her back, one breast is seen in profile so that the upper part of the torso is seen in most cases from the side, but the pelvis is viewed frontally, indeed it is thrust right out in the front of the picture plane, complete with dark pubic triangle. This is significant, since the position is impossible to achieve without bending the knees, as it presupposes an independently articulated lumbar spine. Modigliani chooses – deliberately or unconsciously – to conceal the woman's legs from the thighs down, and this only emphasizes his focal point all the more. And he stresses this further: he centres on the torso, by cutting off arms and legs, not unlike the photographic cropping that goes on in centre-folds today. In some of the seated and standing nudes, the antique *Venus pudica* cliché is used convincingly: the models conceal their sex with a convenient piece of drapery, or better still with their hand, thereby only making it more obvious.

The colour scheme is usually very warm and the background has luxurious reddish tonalities from which the soft peach-coloured flesh emerges, its extremely tactile texture glowing with pink shadows. In these paintings, the women never cease to be sexual, whether they are awake or seem to be asleep; in fact, in most cases, their facial expression seems to be the same whether their eyes are open or shut – a far cry from Modigliani's approach in the portraits. When Modigliani appropriates sleep, here just as in other paintings, he acknowledges mutual desire.

Neither the model's sleep nor her sexuality are allowed to be her own: both must be a response to Modigliani as a man – and this response is a projection of his physical and artistic desires. So she is twice an object, first sexual then painted. This is not to say that the women did not acquiesce in this, but their persistently beatific poses indicate that they belong to Modigliani's compensatory fantasy world, made of dreams of success and permanent recognition.

Maldoror was passing by with his bulldog; he saw a young girl asleep in the shadow of a plane tree, and mistook her at first for a rose . . . it is impossible to say which first came to his mind, whether the sight of the child or the resolution which immediately followed. He undressed swiftly, like a man who knows what he is about to do. Naked as a stone, he threw himself on the young girl's body.

(Lautréamont, *Les Chants de Maldoror*)

The *Nu blond* (1917) which belonged to Francis Carco shows a fragile *108*
young girl who appears to be sexually unaware; this is not a glorification of
her state nor a homage to Jeanne's virginity, but Modigliani casting himself
in the role of a male predator, very like the hero of *Les Chants de Maldoror*,
surveying his prey with an acute knowledge of what his immediate
intentions are, even if they are only in fantasy. Such 'Florentine', Botticelli-
like nudes occur twice in 1917 and then three times in 1919, the last of his
paintings on this subject.

However, Modigliani does not always depict the female nude as a sex
object. His religious drawings consist almost entirely of nudes (see pp.
131–34) and are exactly contemporary with his first great series of paintings
of reclining nudes of 1916. In the religious drawings, the figures are divested *88-90*
not only of their clothes, but also of any indication of sexuality. They seem to
be engrossed in some spiritual activity, looking upwards, utterly oblivious of
their nakedness. A number of life studies of the female nude present nudity in *95*
a similar way, that is as a natural divine state that becomes sexually significant
only when the model looks outside herself and joins in a momentary fusion
with the artist.

While he was painting the *Nu blond* in 1917, Zborowski, by now his
dealer, burst into the room. Modigliani was furious, threw the girl out of the
room and threatened to destroy the picture; he finished it with great violent
slashes of colour. All these paintings are the result of an intimacy slowly
created during the process of painting; such an emotional atmosphere was
essentially private, and any intrusion was tantamount to violation.
Afterwards, he was completely exhausted, mentally and physically. Lunia
Czechowska says he would immediately bathe, flooding the Zborowski
apartment. Several witnesses noticed the physical effort he put into painting.
Foujita, the Japanese artist who knew him well, termed it 'orgasmic': 'He
went through all kinds of gesticulations, his shoulders heaved, he panted. He
made grimaces and cried out.' Foujita was surprised at the delicacy of the
result. On that occasion, Modigliani was working on a portrait, so when he
was painting a nude woman, the effort must have been even more intense
and the atmosphere of the session highly charged.

In projecting his own attitudes to emotional and sexual relationships,
Modigliani was naturally not unique. In 1919, Modigliani met Auguste
Renoir, who had apparently heard of him. The eighty-seven-year-old artist,
paralysed by rheumatism and decrepit with age, told him to paint a woman's
buttocks as he would fondle them with his hand. Modigliani thought this
remark particularly facile and, incapable of discussion at the best of times,
simply stormed out. The soft palpability of Renoir's nudes is at one with the
fruit, flowers and children of his harmonious world picture, and maybe the

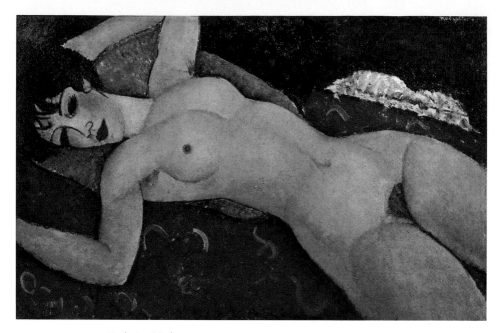

104 *Reclining Nude*, 1917

106 element of wistfulness is caused by the fact that when he painted them, he was no longer at the height of his powers. Both artists painted women as objects of pleasure, and Modigliani's nudes, although never linked with nature in the same way, display a similar epidermic sensuousness.

107 In 1917, after a great deal of debate, Berthe Weill agreed to give Modigliani a show in her new premises in the rue Taitbout, unfortunately situated opposite a police station. As an art dealer, she cut a singular figure on the Paris art market. A tiny, bespectacled woman, always dressed in tailored suits, she exhibited most of the avant-garde from Picasso onwards, without ever making a great deal of money out of her adventurous enterprise; her own taste was her only guide. This was to be Modigliani's first, and last, one-man show, although he had participated in several mixed exhibitions. The leaflet announcing the show was illustrated with a drawing of a nude, and a poem by Cendrars about a Modigliani portrait served as an introduction.

109 Cendrars, whom he painted and drew several times, was one of the foremost poets of his day. Unlike Apollinaire, he was no snob; Ehrenburg described him as a 'romantic adventurer' who had travelled the world over and had had the most extraordinary life: 'He was a Bohemian in Peking, a

146

105 *Seated Nude*, 1917

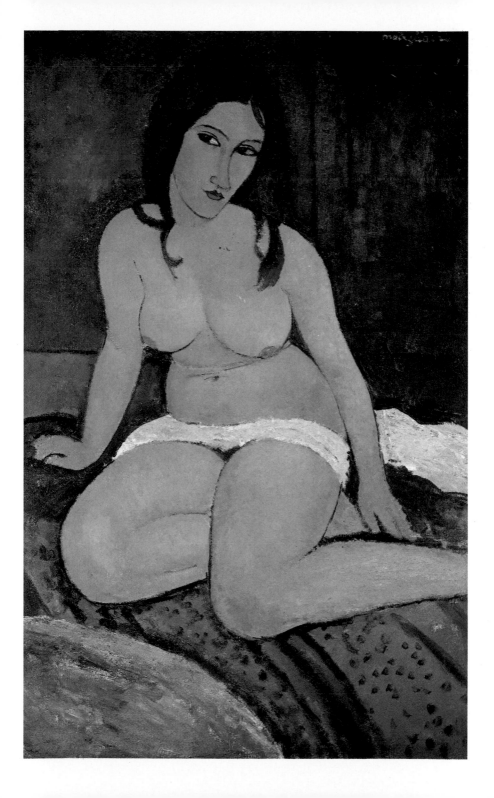

wandering juggler in France, was a bee-keeper, a tractor-driver and wrote a book on Rimsky-Korsakov. I have never seen him depressed, unnerved or without hope' and this despite losing his right arm in the First World War. Modigliani and Cendrars struck up a lifelong friendship which was based on a profound mutual respect.

The show was scheduled to last just over four weeks. On the day of the private view, passers-by were attracted by the noise and also by the nudes prominently displayed in the window: this was Zborowski's idea, intended to attract potential buyers. The small group leering at the paintings grew into a throng and brought the police officer over from across the road. Berthe Weill says that from his office window, he had a full view of one of the large nudes. Having first ordered her to take down such filth ('ces saletés') from public view, he had the rest of the pictures removed from the walls. The show had not even been open for one full day. Berthe Weill says that the war gave enormous powers to police officers who took the law into their own hands and abused it. Modigliani found no one to champion his cause: as a *métèque*, an alcoholic, a Jew and being unfit for service even in the Foreign Legion, he stood no chance of redress from the authorities or the public, to whom he was unknown.

The social structure that caused such a violent reaction to Modigliani's paintings is still with us today. A few years ago the New York postal authorities demanded that the Guggenheim Museum withdraw from sale

106 Auguste Renoir, *Reclining Nude, c.* 1918

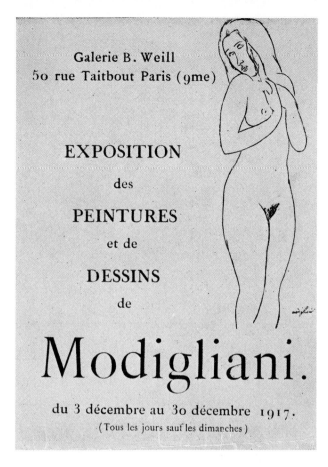

Galerie B. Weill
5o rue Taitbout Paris (9me)

EXPOSITION

des

PEINTURES

et de

DESSINS

de

Modigliani.

du 3 décembre au 3o décembre 1917.

(Tous les jours sauf les dimanches)

107 Exhibition catalogue, 1917

the postcards of Modigliani's nude in their collection. In 1927, Giovanni Scheiwiller wrote one of the earliest monographs on Modigliani without using one single reproduction of the nudes 'so as not to run the danger of incurring the sanctions foreseen by Art. 339 of the Penal Code'. Have matters really changed? When *Life* magazine published an article, this time illustrated, on Modigliani, an irate reader wrote 'Nothing prevents me from ripping the dirt from the pages of your magazine before such "art" contaminates my children.'

Artistic scandals – of which Modigliani's was only a minor one – are a very good indication of the moral climate of the time, with all its double standards. Artists and writers who openly discredited the unwritten convention were bound to incur penalties, and it is only with this background in mind that we can understand the brutal reaction of the police

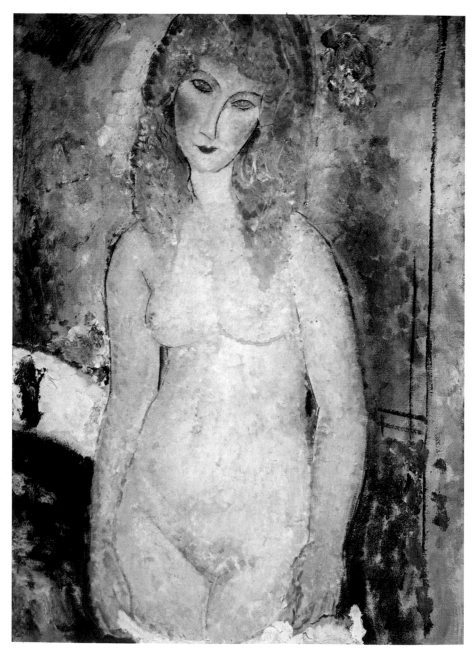

108 *Standing Nude* (*Le Nu blond*), 1917

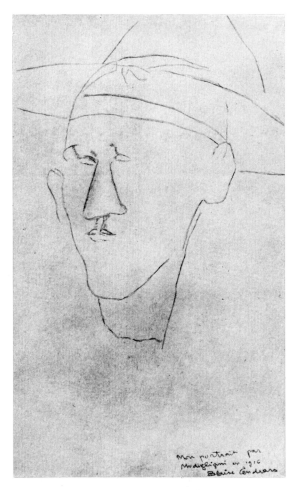

Mon portrait par
Modigliani en 1916
Blaise Cendrars

109 *Blaise Cendrars*, 1916

to Modigliani's exhibition. The fact that a number of artists fared well from the publicity they inadvertently received must have made Modigliani feel even more wretchedly alone when no one took up his defence.

Nijinsky's performance in *L'Après-midi d'un faune* (which he himself had choreographed) in 1912 created an enormous scandal in the press, especially as the Ballets Russes had enjoyed an unparalleled success ever since Diaghilev had brought them over to Paris in 1909. The editor of *Le Figaro*, Gaston Calmette, condemned the ballet outright: 'We have seen a grossly indecent faun, whose movements are full of bestial eroticism and shamelessness.'

110

151

110 Nijinsky in *L'Après-midi d'un faune*, 1912

111 *Dancer*, 1916

When Rodin, in a long article in *Le Matin*, came to Nijinsky's defence, Calmette furiously demanded that the French Government expel Rodin from his home, the Hôtel Biron, where he exhibited 'a series of libidinous drawings and cynical sketches'. The public outcry which ensued resulted in Rodin being granted the Hôtel Biron for life; at his death, it was turned into a museum dedicated to his work.

Brancusi was not to be exempt from such censorship; his frequent use of phallic symbolism, albeit subtle, caused endless trouble, and once resulted in the forcible removal of a sculpture from an exhibition. It is as if the representation of male genitalia was seen as a threat to the virtues of militarism and the patriarchal tradition. It is strange to think that such a stern attitude came from a city which had recently erected the most gigantic phallic monument of self-congratulation, the Eiffel Tower. Modigliani, 111 however, was evidently sufficiently at ease with his own sexuality to bring out the sensuousness of men in his portraits and drawings of them.

In 1913, Van Dongen caused an outrage when he exhibited a nude simply 112 entitled *Tableau* at the Salon d'Automne; it was removed by the police on grounds of obscenity and the affair was turned into an issue about freedom of expression by opposing factions in the press. Van Dongen was criticized for having painted a prostitute in far too realistic detail: not only were the allusions to fetishism decried – they obviously had an embarrassing air of familiarity about them – but also the pubic hair. Furthermore, the woman depicted dominates the picture with an air of self-sufficiency and casual in-difference to the grovelling voyeur. But Van Dongen, although a foreigner, had been very successful in France through the efforts of his dealer, Bernheim-Jeune, and his own social ambitions, ingratiating himself with a wealthy clientele in Paris; whereas Modigliani's paintings at the time were far from being considered as investments. So Van Dongen was bound to gain the support of his most influential patrons, and as a result the liberal press defended him throughout the scandal.

When Berthe Weill asked why Modigliani's paintings had been censored so savagely, the police officer stammered with embarrassment that it was because of the pubic hair. Pubic hair, admitted only in recent years in popular pornography, had been tacitly banned from depictions of female nudes, as being too suggestive of a tactile reality. The appearance of secondary sexual characteristics are indications that the primary ones can be put to use, so in accordance with Western morality (rather than aesthetics, which would have been the concern in the East), any such reminder of active female sexuality was forcibly removed. Even Titian had observed this convention. And the existing social order depended on the upholding of moral standards.

154

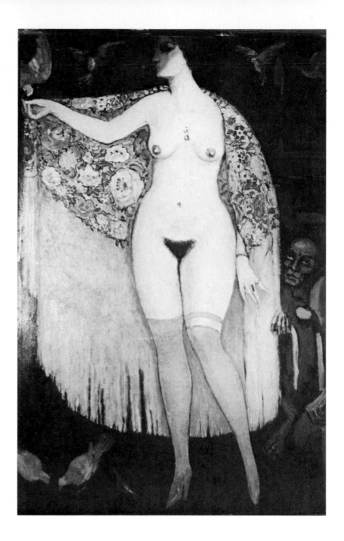

112 Kees van Dongen,
Tableau (*Le Châle espagnol*),
1913

In this post-Second Empire age, any public reference to the female libido was considered obscene: sexual enjoyment, when not an accidental by-product of perpetuating the species, was a male preserve; and, moreover, it belonged to the realm of the illicit, the clandestine element being part of its charm. Popular songs, even before Mistinguett and Josephine Baker, had often exalted the woman's view of sexual love, although in the days before the wireless not everyone would have been familiar with them. Pornographic postcards could easily be concealed in an inside pocket, and hard-core pornography (which differs only in incidental detail from the kind

113 Postcard, 1915

113

printed today) was available, under the counter. But public manifestations, such as exhibitions, were something else as they implied an official acceptance of a mode of behaviour hitherto unmentionable in middle-class society. A contemporary postcard shows a nymphet reclining in the same pose as that of many of Modigliani's nudes; she appears in an Eastern setting, complete with opium-smoking apparatus. However, this would have been less offensive to the authorities of the time for exactly the reasons many people today would find it so pernicious: the girl who cannot be much older than fifteen is not participating, she is one of the sinful exotica offered to the voyeur's delectation.

Throughout history, nude women in art having any degree of self-confidence are always supposed to be courtesans. What turns an ordinary woman into a courtesan is the detail surrounding her: instead of the forest (Diana), a letter (Bathsheba), a view of a garden (Eve), a couple of peacocks (Juno), there is a realistically depicted bed and symbols of material wealth. In the postcard mentioned earlier, for example, the Oriental paraphernalia is stressed. The purpose of the details in all these images is to build up a fantasy world which the voyeur can enter at any point: the voyage, the chance discovery or the invitation, as in Titian's *Venus*, Boucher's *Mlle O'Murphy*, Manet's *Olympia*, and Van Dongen's *Tableau*. From Manet onwards, social comment is implicit: the male spectator is very clearly identified with the

100, 114
115, 112

client because the woman looks directly out at him; he therefore shares responsibility for the situation depicted. And yet although traditionally accepted male behaviour may be called into question, it is still the woman who is condemned because she continues to offer herself to every spectator/voyeur who will ever see the painting.

In Modigliani's paintings, the one point that flouted conventional morality was the attitude of the women. They are emancipated in that they appear to accept their situation without expecting any financial or emotional

114 François Boucher, *Mlle O' Murphy*, 1751

115 Edouard Manet, *Olympia*, 1863 (detail)

remuneration. They are not prostitutes, wives or mythical figures, yet they present a sexual challenge. The shock value of Modigliani's nudes was their directness and immediate appeal to the senses. In Kisling's similar pictures of these years, the studio and model may well have been the same, but the impact of the nude is delayed because of the descriptive detail (the still-life in the foreground, the embroidered pillow and blanket), detracting from the effect of the suggestive pose. In Modigliani's paintings, there are no gifts, no conversation, no dallying. The nudes (with the exception of the static, sleeping ones) are liable to change their position at any moment to receive the spectator, and the rhythm is one of steadily growing excitement. One painting represents a woman's sexual response to Modigliani at its fullest pitch, not unlike his earliest picture of a nude. She is twisting her body in opposite directions and clenching her fists, expressive of the high sexual tension that Modigliani has created – the invisibly caused orgasm, the paintbrush instead of the penis.

For Modigliani's nudes, physical pleasure is sufficient. Whether this was actually true of the women he painted is irrelevant – there was no other way

116 Moïse Kisling, Reclining Nude, 1918

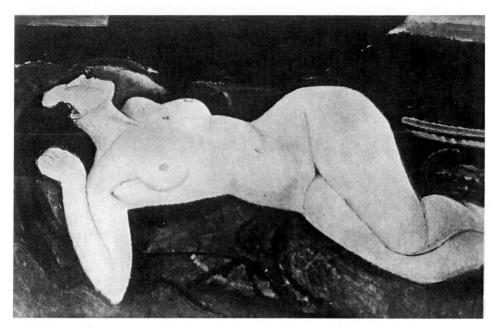

117 *Reclining Nude*, 1917

that Modigliani, the bourgeois, was able to reconcile his strong sense of privacy and territory with such blatant statements about his sexuality: the women depicted had to be those who did not matter to him. After painting them or making love to them, he could reject them, and, as far as he was concerned, they could belong to anybody.

Even if there were conclusive proof that the models for *Venus, Mlle O'Murphy, Tableau* and *Reclining Nude* were the artists' wives, these pictures, in a male-orientated society, would never have been entitled 'Mrs Titian', 'Mrs Boucher', 'Mrs Van Dongen', 'Mrs Kisling' or, for that matter, 'Mrs Modigliani'. Modigliani was instinctively aware of this situation: his well-developed proprietary instincts did not allow his women to be painted by fellow artists, nor did he paint them nude. When Kisling asked to paint Beatrice's portrait, Modigliani forbade it, saying that for a woman to allow herself to be painted was tantamount to giving herself to the artist. Modigliani was in this respect anything but controversial in his attitude towards the women he painted.

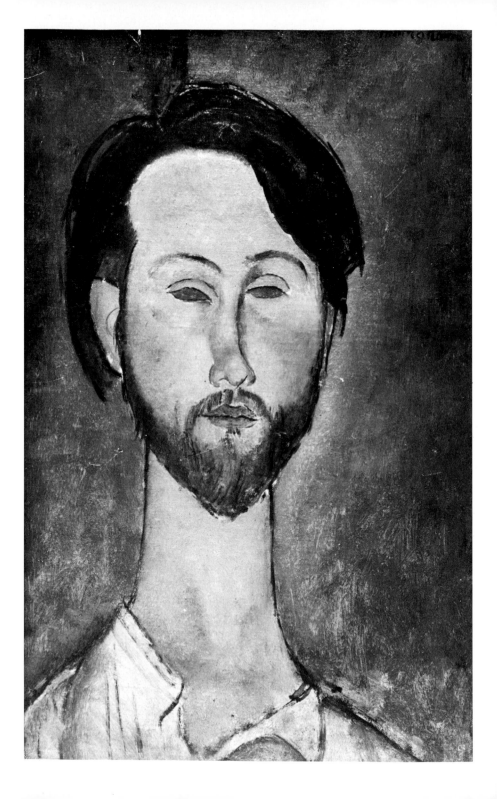

The last years 1917–20

In the last two years of his life, Modigliani's work is more cohesive than at any other period in his career. The works of late 1917 lead to those of winter 1919 with unprecedented logic. His production in those years is impressive and averages just over one painting, and sometimes several drawings a week; fewer pictures were lost than before because Zborowski, his new dealer, made sure that his paintings did not go astray, but he had no control over the drawings which Modigliani frequently gave away.

This in the eyes of the public has become his most popular period: the works of these years command the highest prices at auction-rooms and are often reproduced on the covers of romantic biographies – especially paintings of children. And Modigliani now enters coffee-tabledom, as the serene painter of wide-eyed innocence. The reasons are not hard to find: by now Modigliani had relinquished control of his career to Zborowski, who found him models, makeshift studios (usually wherever the Zborowskis themselves happened to be living) and above all the means for survival. Besides, Modigliani found himself gradually entering a near-matrimonial state, complete with *bambini* and disagreeable mother-in-law.

The result was that Modigliani withdrew into himself, a silent world of his own, a kind of aquarium where all that mattered was his compulsive desire to paint. His contacts with the outside world became increasingly remote, and stylistically he referred only to his own pictorial experience; even his sitters, especially the women (Hanka Zborowska, Lunia Czechowska, Jeanne), began to look alike on canvas. His consumption of drugs and drink was now suicidal, but it was with pride that he displayed the stains on his handkerchief, when he began to cough up blood two months before his death.

There are three phases in this last period: the first starts in late 1917, after his failed exhibition at the Berthe Weill gallery until his departure to the South of France in March 1918; the second covers his stay there which lasted over a year, until May 1919; the last is the eight months that preceded his death on 24 January 1920 in Paris.

Zborowski, known to all as 'Zbo', had been handling his work since 1916 to the best of his ability, using all the resources of his imagination. He had come from Cracow in 1914, at the age of twenty-five, on a Government

118 *Léopold Zborowski, 1918*

research grant which ran out a month later, when the war broke out. He thought of himself as a poet, but his main quality was an enormous enthusiasm for art, which in the case of Modigliani knew no bounds. So he immediately endeared himself to the artist, with far greater effect than the efficient and professional Guillaume, who was primarily interested in making money. So Zborowski scuttled around Paris, paintings under his arm, looking up names of potential buyers in the telephone directory. It is said that he addressed envelopes at three francs an hour, gave up smoking and sold his clothes so that Modigliani could drink. It is also said that the innumerable accounts describing Zborowski as some kind of self-made saint are an exaggeration. The initial contract was that Modigliani was to receive fifteen francs a day in exchange for his entire production of paintings, but Modigliani remained free to dispose of his drawings as he pleased; the stipend increased later on, as his paintings started to sell for higher prices.

Zbo's devotion to, and trust in, Modigliani are undeniable. It was only because of Modigliani's repeated entreaties that Zbo took up his protégé, Soutine. Polite and refined, a distinguished Gentile with an aristocratic wife, he could not bear Soutine's savage Jewishness that reeked of ghetto, pogroms, and starvation. At least Modigliani did not throw that at him. He symbolically imposed his friend upon the Zborowski household by painting a life-size portrait of Soutine on one of their doors. Both Modigliani and Zbo were incurable Romantics and corresponded to each other's ideals; the poet wanted a heroic, unrecognized artist he could fight for, and the painter identified with this image and craved for someone to devote himself entirely to him for the sake of his talent alone; their mutual gratitude comes out in all six painted portraits and the many drawings: in all of them, Zbo remains gentle and patient, slowly graduating from a timid idealist to a more self-confident, if reserved, dealer. The very last drawing gives him a broader build, as if his narrow shoulders had enlarged with success. Some people said, a little maliciously perhaps, that he took himself for the new Vollard.

118 The first portrait of 1918 is the most intimate, as it shows him head and shoulders without his usual collar and tie. Maybe Zbo wanted 'to save his dream' (as Modigliani had put it, aged seventeen, in one of his letters), or at least a fragment of it, a dream that was still concerned with a nebulous world of ideals and poetry; in this most Romantic of portraits, he looks out at a distant horizon, his unkempt hair falling about his head, emerging from a grey-blue background with a sky-coloured halo. Both the art dealer and the artist were, in fact, rather bad poets, but fortunately neither needed to write to express their personal lyricism.

Hanka Zborowska was of aristocratic birth, unlike her husband, and loved elegant clothes. She put up with Modigliani's frequently outrageous conduct

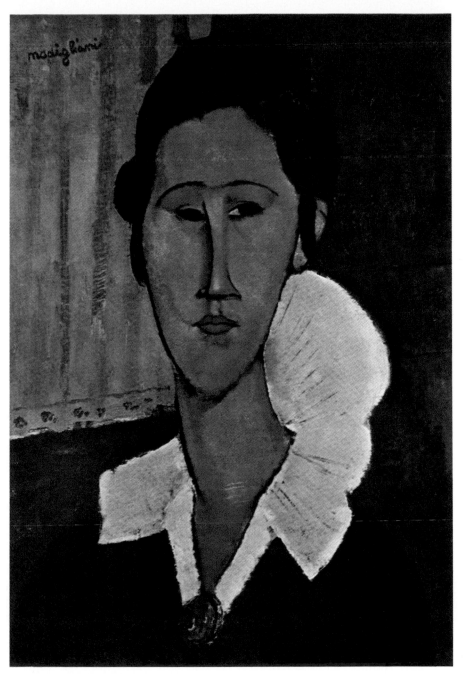

119 *Hanka Zborowska*, 1917

because it was increasingly clear that he was a worthwhile investment; she was to endure Soutine for the same reason. The couple lived extravagantly whenever possible, especially when they moved to an apartment in the rue Joseph Bara in Montparnasse; but they frequently found themselves penniless, and Lunia Czechowska has recounted that they often faced the prospect of carting large paintings about on foot simply because they did not have the tram fare. So it is as a measure of economy that Hanka let herself be painted by Modigliani. They kept the professional models to a minimum, and they were usually reserved for the nudes. Modigliani respected Hanka in the most bourgeois way possible, that is as Zbo's wife, thereby mirroring exactly her toleration of him. There is distance but not mockery, as in the earlier portraits of night-time revellers or high-minded ladies, but this is not due simply to politeness or feigned respect, of which Modigliani was now totally incapable. Modigliani in his self-absorption had lost his critical

119 sharpness. The earliest portraits of Hanka set the type for all the succeeding ones of her: an elongated oval face on a long slender neck; the interest is elsewhere, generally outside the picture plane, except when his attention is caught by incidental detail, such as a collar which seems to be growing by itself. The coldness of her unsmiling features does not express anything; they have become a pictorial motif on which Modigliani works in a detached, near-abstract way.

Lunia Czechowska was the Zborowskis' closest friend; her husband was a poet and a revolutionary, and he was away at war. She had a small-boned body and an oval face with a pointed chin, high Slavic cheekbones, slanted blue eyes, and looks almost Mongolian in some portraits.

Modigliani painted her in 1917 and 1919 and made drawings of her throughout their acquaintance. In each rendering she is different and expresses aspects of her self-possessed character; what is most important is that Modigliani, exceptionally for this period, allows himself to be sensitive to these variations which repeatedly challenge him into a new picture. In these paintings, she increasingly warms to him: at first she poses for him formally, her head slightly on one side.

I'll never forget the first time I posed for him. As the hours gradually went by, I was no longer afraid of him. I can see him now, in his shirtsleeves, his hair tousled trying to put my features down on canvas. From time to time, his hand would extend towards a bottle of cheap brandy. I could see that the alcohol was having its effect, he was getting increasingly excited; I no longer existed, he only saw his painting. He was so absorbed in it that he spoke to me in Italian. He painted with such violence that the painting fell on his head as he leaned forward to look at it more closely. I was terrified; he was genuinely sorry to have scared me and began to sing Italian songs, to make me forget the incident.

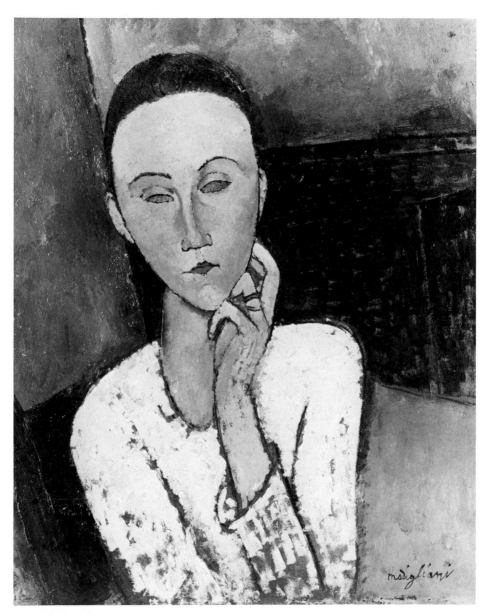

120 *Lunia Czechowska,* 1917

In the next paintings of Lunia, she is no longer afraid, and we see her smiling or carrying on a conversation; later she moves right to the front of the picture plane with a gesture that must have been very typical of her, cupping her chin on her hand, and resting one bent arm on the other, a gesture of deep attention, which recurs in the drawings as well; this is Modigliani's first and only continuous dialogue with a woman he never ceased to respect. She says that he made declarations of love to her but that she resisted his advances; yet it was she who guarded the door when Modigliani painted the nudes at Joseph Bara, apparently to keep out the over-solicitous (or simply curious) Zbo, but also maybe to make sure that nothing else but painting went on during the sessions. She was after all a respectable wife, as she said so often, but Jeanne was to be very jealous of her.

120

In 1918, Modigliani produced two portrait drawings of Lunia which are of a particularly finished kind; they are large – the size of a small painting – and are drawn in pencil with soft highlights. The elongation and the quality of the shadows prefigure the very last paintings; this has happened throughout his *œuvre* and even appears to be the very function of his drawings – that is to prepare the internal process of the paintings long before they occur.

121

In the main drawing, Lunia is supremely graceful and strong, gazing straight in front of her, something of a tragic queen of antiquity; top right, Modigliani has written *La Vita è un dono dei pochi ai molti de coloro che sanno e hanno a coloro che non sanno e che non hanno* ('Life is a gift from the few to the many, from those who have and who know to those who have not and do not know'). Not his invention entirely, but it does not matter; maybe Modigliani, distantly remembering D'Annunzio's *Convito*, meant they were among the happy few who shared the secret of life.

Zborowski initially found sitters and clients in his immediate environment of expatriate Polish intellectuals; so Modigliani twice painted the portrait of Elena Pawlowski, as an early *garçonne*; but Modigliani has chosen to belie her masculine clothing and cropped hair with the fragility of her features.

122

123

A year later, in 1918, when he painted the portrait of Baranowski in a very similar way, the sexual borderline is not so clear: he poses with a kind of coyness that is no longer affected. Modigliani smiles but does not criticize. This is the kind of commission he would have shied away from earlier on, as his vicious treatment of Cocteau shows: femininity in men, interpreted as gentleness and sensitivity, was something he understood and may even have been attracted to, as his portraits of Gris or Lagar indicate, but theatrical mannerisms he found repulsive and *les grandes folles* he loathed.

166

121 *Lunia Czechowska (La Vita è un Dono . . .), 1918*

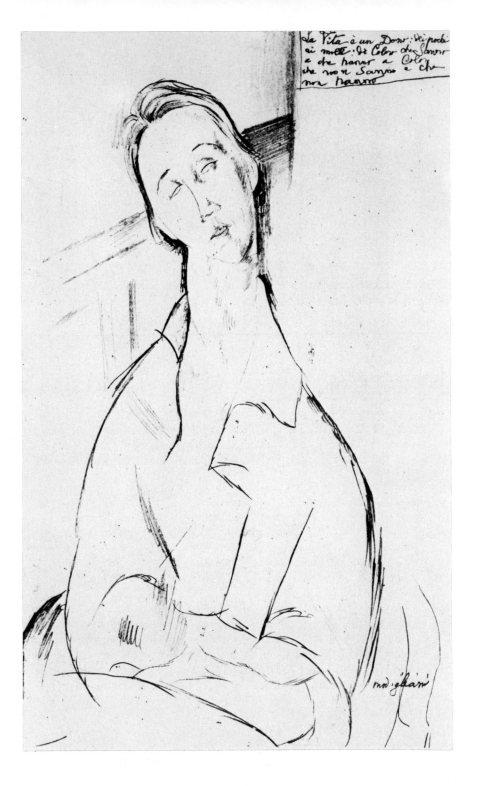

La Vita è un Dono: dei pochi
ai molti: Di Color che sanno
e che hanno a Color
che non sanno e che
non hanno

modigliani

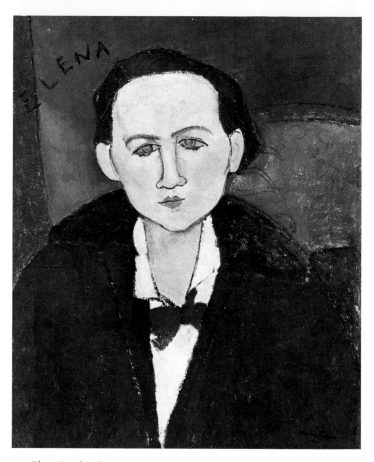

122 *Elena Pawlowski, 1917*

In July 1917, Modigliani met Jeanne Hébuterne, aged nineteen – he was thirty-three. Both attended the Académie Colarossi, a drawing school for professionals and students. Her remaining drawings show great promise; some have even been mistaken for originals by Modigliani, especially those showing him.

Of all the women he was to know for any length of time, she was the most trusting, the most fanatically devoted, the most unquestioning. Undoubtedly, she was a virgin when she met him. Within months they were living together in cheap hotels in the area. She had long reddish braids framing a bony face, her extreme pallor causing her to be nicknamed 'Noix de Coco' (coconut), a swan neck, a small frail body; she dressed in clothes she

168

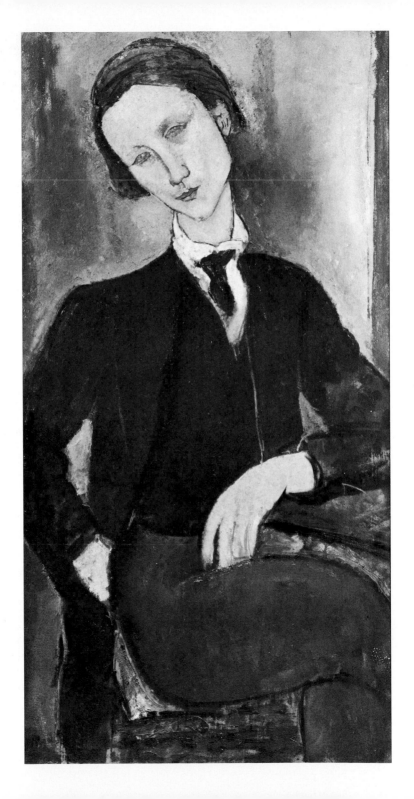

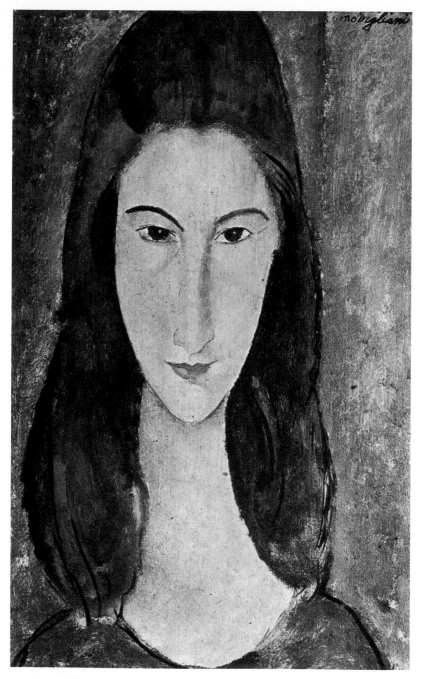

124 *Jeanne Hébuterne*, 1918

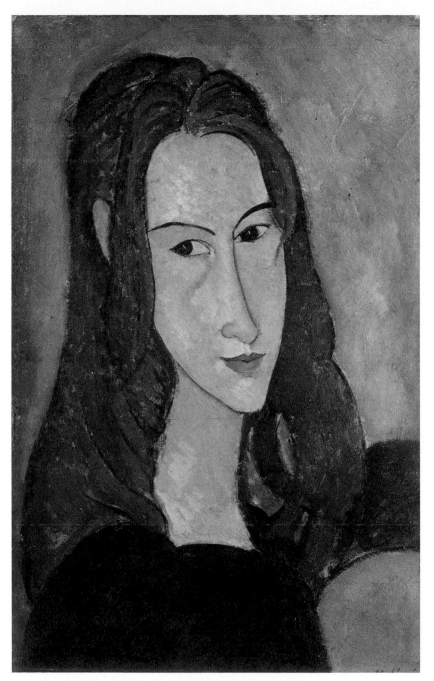

125 *Jeanne Hébuterne*, 1918

designed and made herself, a slight air of fancy-dress. She was very fond of music, Bach especially, and she would play the violin in the studio they later shared. Surviving photographs indicate a greater strength and individuality than Modigliani allows for in his paintings (except in the very earliest), especially the one where she stands in front of a picture, eager and vivacious, something of a coquette, wearing a hat and a necklace. She certainly needed forcefulness and courage to impose her own life-style upon her horrified, staunchly Catholic petit-bourgeois family. More than anything, the fact that Modigliani was a Jew brought dishonour upon them.

Early on in their relationship, Jeanne seemed to have given up any form of thinking and left decisions to Modigliani, a kind of shrivelling of mental capacity. She did not dare attempt, even slightly, to curb his drinking and drug-taking, and she did not participate in either: he seems to have had the power of narcotics over her. She would often be seen late at night, timidly looking for him at La Rotonde, and often he would respond to her entreaties with brutality, which he would alternate with private tenderness. 'He was dragging her along by an arm, gripping her frail wrist, tugging at one or other of her long braids of hair, and only letting go of her for a moment to send her crashing against the iron railings of the Luxembourg. He was like a

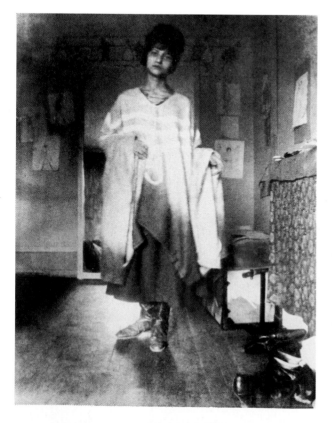

126 Jeanne Hébuterne

127 *Jeanne Hébuterne, c.* 1919

madman, crazy with savage hatred.' And yet Salmon, the author of *La Vie passionnée de Modigliani*, one of the earliest romantic biographies, assures us elsewhere that in his opinion they were a most admirably suited couple.

I see that you have in your heart goodness and justice: but we could not live together. Right now you are full of admiration for those looks of mine which have been the ruin of more than one of your kind: but sooner or later you will repent that you have given me your love, for you do not know my soul. But put this in your head never to forget it: wolves and lambs may not look at each other with gentleness.

(Lautréamont, *Les Chants de Maldoror*.)

Both Modigliani and Jeanne suspected that this inherent imbalance was woven into their relationship. It may well be that Jeanne insisted they live

together so as not to lose him. Modigliani had no reason to fight off the timid advances of a girl who demanded nothing of him but the daily enactment of all his fantasies, however humiliating for her; being with him provided all the gratification she desired. But her total lack of resistance did not provide him with the renewed challenge he needed, so he sought distractions elsewhere, with customary lack of discretion and much to Jeanne's grief. It appears that about the same time he had a rather involved affair with a Canadian student called Simone Thiroux who was slowly wilting away with tuberculosis. She claimed to have had a son by him about the time when Giovanna (Modigliani and Jeanne's daughter) was born, but he was adopted on condition that the name of his parents never be disclosed, so the mystery will never be solved. Also to be remembered is that these are the years in which he painted his great series of nudes in which sexual involvement (even if only in fantasy) is indubitable. Jeanne was insanely jealous of every woman he ever painted, every moment of attention he gave to another. It may be for this reason that she made no attempt to look after his own daughter or to save the child she was carrying.

The paintings of Jeanne are portraits of submission; after the first, it is impossible to imagine the woman depicted anywhere else but indoors, uttering anything more than a few soft-spoken syllables, abdicating. Three portraits of early 1918 are exceptional for their depth of feeling. Modigliani

124 has marvelled for one moment at Jeanne's extreme youth, genuinely grateful for the wholeness with which she has given herself. A profile view of Jeanne in the same mood makes her look even younger than she is; she has cut her hair shoulder-length, a symbol of her transition to womanhood. In both, her soft skin is translucent, a Botticelli pallor; her expression is at once candid and all-knowing, and it is exactly in this way that he henceforth painted children.

125 In the third painting of the series, her face is tilted and she is dishevelled; she looks suggestively from the corner of her eyes and the focus is on that very dark indirect look, something animal-like in it; her hair falls about her face, which has a slightly olive tinge and seems to shine with perspiration. This is the sexual Jeanne, a little wild and secretive. Here for the first and only time she expresses her willingness to submit to a new-found carnal reality in which a certain violence is not exempt.

In the rare nude drawings of Jeanne, she appears reticent at being depicted this way and clutches her chemise: timidity mixed with Catholic guilt.

Through Jeanne, he became interested in painting adolescent girls on the threshold of womanhood. While recalling Lautréamont's fantasies, Modigliani was perfectly capable of appreciating the subtle mixture of nascent unselfconscious sensuality and childlike trust: Modigliani observes them as they respond to him on both levels.

174

In March 1918, following a general trend, Zborowski decided to send his troupe of artists and their closest companions to the South of France; the deprivation of war, the shortage of food and coal had weakened their resistance, and especially Modigliani's already fragile health. So Soutine, Foujita with Fernande Barrey, Modigliani, Jeanne and, rather incongruously, her mother, arrived in Nice.

At the best of times, Modigliani could not bear living in a community set-up, so when the others went to Cagnes, he stayed in Nice. Not for him the landscape of the Midi and the brilliant light of the Riviera: they exasperated him and drove him to seek refuge in small hotels in backstreets with inner courtyards filled with shade. He sought Paris everywhere and, to the Osterlinds, friends of Zborowski, with whom he stayed a little later, he declared that the Pernod poster for absinthe he found in a local café was the most wonderful work of art in the whole world. The others, starved of warmth and colour, were revelling in the magnificence of the surroundings; maybe it was because he was the only one of the group who had actually been brought up in a Mediterranean climate that it had no appeal for him. Most of the pictures were painted indoors. Here models could not be arranged as in Paris, and local people had to be asked to pose. In fact, although he met up with old friends like Cendrars and Survage (not to mention the presence of Soutine), he did not paint their portraits here. He needed them in the Parisian surroundings natural to him, even though these were not necessarily visible in the paintings; here his friends were like fish out *128, 136* of water. So he painted, without a hint of malice, servants and children and *137* peasants in their everyday context. Late in February 1919, Jeanne became pregnant. This may have moved him to paint children with an unexpected tenderness, bordering on sentiment. He stresses their helplessness by exaggerating the roundness of their eyes, always defining the iris, and by diminishing the size of their mouths. They all pose decorously, on their best behaviour, but their look is resolute and trusting. Modigliani evidently did not play down to them and treated them as he would their parents: except that he has a supreme respect for their innocence, and this is precisely where the sentimentality stems from, rather than his latent paternalistic fantasies. In his experience, childhood and adolescence had been periods filled with grandiose dreams and ideals, and it is their imminent passing that he mourns in these pictures. A kind of Romantic 'et in Arcadia ego', Arcadia not being 300 miles away, across the water, especially with a child of his own invisibly growing beside him.

The tragedy hinted at in the paintings may also be an economic one; with a brother who was a socialist militant, imprisoned for the intensity of his beliefs, and his own personal experience characterized by sudden reversals in

176

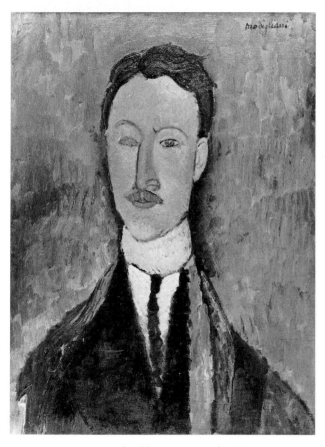

129 *Léopold Survage*, 1917/18

fortune, he was bound to be aware of social inequalities as he painted these
deprived children. One of the most poignant pictures shows a little girl *128*
standing in the corner of a room. It is a hot day outside. Everything is painted
in different shades of pastel blue, the walls, the dress, her strong, confident
gaze. She clasps her hands tightly; the floor paved with pink tiles tilts towards
us, and her feet appear very distant; as the eye travels bottom to top, she
seems to be growing taller. A legend attached to this particular painting
suggests that his paternalistic feelings were mostly withheld; Modigliani
demanded a litre of *rouge* (rough red wine) for each sitting, and the models,
whatever their age, brought it up with them; this little girl was confused and

carried in a bottle of lemonade; it is said that Modigliani painted this in a shaking rage, probably with withdrawal symptoms associated with deprivation of alcohol or drugs. Hanka believed that it was in these conditions that he painted best. The sheer act of painting calmed him; with all passions spent, the atmosphere of the painting is one of serenity.

Life in Nice was not all peaceful; early in 1919, Modigliani moved away from Jeanne, probably on account of her overbearing mother, and Jeanne was to recall this period (in fact the whole stay) as a most unhappy one. He did not moderate his drinking in any way and went around with the Parisian crowd and especially the Russian-born Léopold Sturzvage (alias Survage), *129* whom he painted in late 1917 or early 1918. This is one of the last portraits where Modigliani displays an intelligent awareness of the sitter's personality, taking that as his starting-point; the painting, in browns, beiges and black, is full of movement: Survage appears to have just come in, moving across the room, displacing the air about him.

(To Zbo, 1 January 1918)
Midnight on the dot

My dear friend

I embrace you as I wanted to on the day of your departure. I'm out on the town with Survage, at the Coq d'Or. I sold all the paintings. Send money quickly. Champagne flows like water. We both wish you and your dear wife all the best for the new year.
Resurectio vitae
Ic incipit vita nova
Il Novo Anno.

In reality, not a single picture had been sold, and Survage said that they were celebrating with wine. But this must have been one of Modigliani's last celebrations. Zborowski, as usual, took the letter very seriously, so Modigliani hastily wrote back: 'You are an oaf who does not understand a joke. I haven't sold a thing. . . .' A little later, Modigliani lost all his papers and his money, claiming they had been stolen; this was followed by numerous letters to Zbo, pleading for money; never a letter-writer, he felt embarrassed by his repeated entreaties, and casts himself as the victim and the culprit at the same time.

My dear Zbo

Here is the question or 'That is the question' [in English in the text] (see Hamlet) that is to say. To be or not to be. I am the sinner or the bloody fool, that's for sure: I recognize my mistake (if there be indeed a mistake) and my debt (if there be indeed a debt). But now the question is as follows: if I am not completely bogged down, I am at least seriously stuck. Do you understand.

178

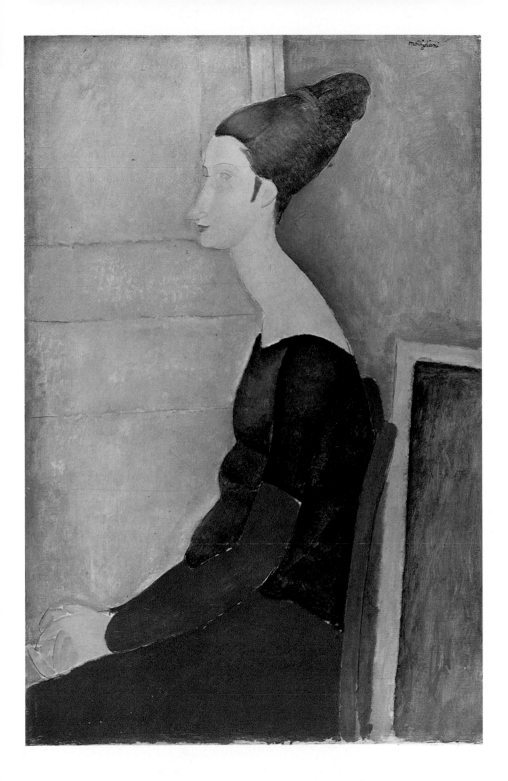

You sent 200 F., 100 of which had to go straight to Survage, whom I have to thank for not being totally bogged down . . . but now, if you free me, I shall recognize my debt and will carry on with our arrangement. Otherwise I shall stay, immobilized where I am, hands and feet tied and in whose interest would that be?

131 A photograph taken casually by a street photographer in 1918 or 1919 shows him strolling down La Promenade des Anglais with Guillaume, whose brisk gait is that of a busy entrepreneur, briefcase under his arm. Modigliani has not had the time to pose, he is haggard, shabby; this visual document of his real misery is the only one we have, because it is accidental, and he would have censored it. That he should be seen with Guillaume is significant; Guillaume was again becoming interested in Modigliani because his works were beginning to command higher prices. In December 1918, he showed some of his works in a mixed exhibition, side by side with paintings by Matisse, Picasso, Derain and Vlaminck, in his new gallery in the faubourg Saint-Honoré. Zborowski's attempts in Nice were not very successful; he had been right in presuming that there were a great number of refugees from the war here, all wealthy, but they were now more determined than ever to hold on to their precarious wealth. He appears to have done much sitting about in hotel lobbies, waiting to corner dukes and businessmen whom he

131 Modigliani with Paul Guillaume in Nice, *c.* 1919

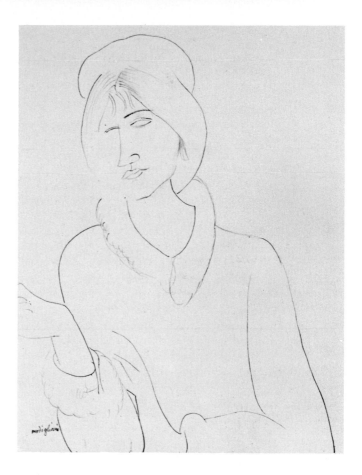

132 *Jeanne Hébuterne,*
c. 1919

annoyed intensely. But he managed to arrange portrait commissions with a number of well-known personalities; so Modigliani painted Roger Dutilleul, a famous collector from Paris, Gaston Modot, an early film star, and Frans Hellens, the Belgian poet.

Modigliani has now refined his technique so much that there are no areas of uncertainty any more; one line springs from the other, the linear flow is continuous, the paintwork is much smoother; elegant as they may be, the faces have become masks, perhaps death-masks of the sitters; their expression is empty, any indication of spiritual life has disappeared.

An analogous process has taken place with Jeanne. From the pictures, we can see that she has put on weight with her pregnancy (she sports an endearing chin) and she appears to be at peace with herself. From the pointedness of his pictorial treatment, Modigliani seems to be saying that

142

181

impending maternity has had a stultifying effect on her: she poses sheepishly
130 and her vacant stare, light blue now instead of brown, expresses neither
emotion nor physical sensation. It is probable that she retained far more
character than Modigliani in his pictures allowed for; for reasons that
concerned himself, he preferred to negate completely the personality of the
woman with whom he was living. Yet from the pictures, we can see that she
is still making herself original clothes, and her sense of colour is very
individual: she mingles bright red and violet, ochre and bottle-green.
Modigliani echoes her colours in the background; in one painting where she
wears mainly scarlet, he paints the chair and the door bright red and the effect
is almost Fauve. It may be due to Jeanne's influence that he hereafter
brightens his palette; the light in Nice also plays a role in this, but even on his
return to Paris he uses lighter and brighter colours.

He repeatedly remoulds Jeanne's body according to the aesthetic needs of
the moment; one of the main motifs is the line which forms the head-neck-
127
130, 142 shoulder axis and in his preparatory sketches it becomes dominant. In the
paintings, an elongated African mask is perched on a swan neck and a suite of
curved arabesques form the body; these works are certainly elegant in their
mannered polish, but the relationship between the distortions (mainly of the
neck, and overall elongation) and the realistic detail (double chin, enlarged
belly) is uncomfortable: Jeanne has turned into a slightly monstrous freak of
nature, mentally arrested; perhaps this indirectly symbolizes his feelings
towards the relationship: domesticity definitely constrained him.

On 29 November 1918, a girl was born to them; she was registered as
Jeanne Hébuterne, but her father was to call her Giovanna. She was in fact
illegitimate: Modigliani apparently was so happy that he got drunk on the
way to the town hall where he was going to register her birth and in the end
never got there. His paternal enthusiasm is recorded in scribbles, which
reassured his mother.

A few months later, he went to Cagnes, leaving Jeanne and the baby in
Nice. He spent some time sharing a studio with Soutine who was painting
134 extraordinary landscapes of twisted roads, tumbling skies, houses and trees
jumbled up together. These paintings retained special significance for
Soutine all his life; in later years he sought to buy them all back from dealers.
When they finally left the studio, with the rent considerably in arrears, it was
in a terrible mess, fouled up, everything even slightly breakable broken, and
the owner in revenge took the landscapes they had left behind them and used
them to cover his chicken coops and rabbit hutches. A few years later, after
Modigliani's death, he realized they were priceless and tried to salvage them
without any success, much to his eternal sorrow. There are many such tales,
all with a ring of truth; many drawings bear signs of early ill-treatment.

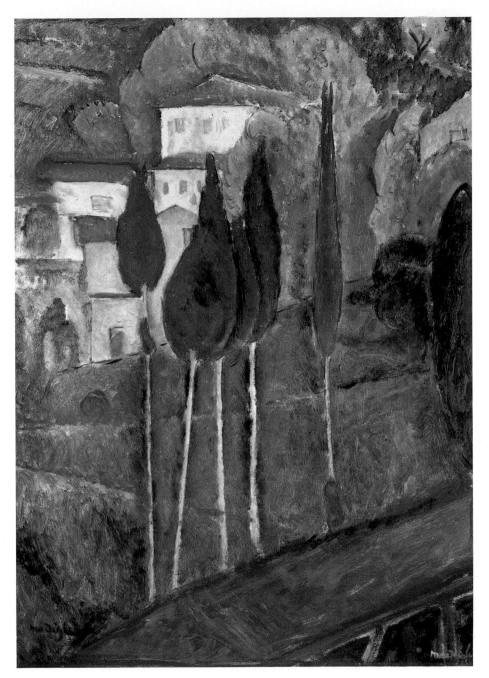

133 *Landscape at Cagnes*, 1919

134 Chaïm Soutine, *Road to Cagnes*, 1919

133 It may be here that Modigliani painted his rare landscapes. 'I'm going to start on landscapes. The first attempts will probably seem to be those of a beginner', he writes to Zbo. Four such attempts and one related drawing survive. They are all, interestingly, painted vertically like portraits, and their size is roughly that of head-and-shoulders subjects; in all of them there are houses, as if he needed perpetual reminders of the human presence; the idea of wild, untouched nature must have appeared a little awesome to him. In each painting, a tree dominates: reminiscences of the montagne Sainte-Victoire where Cézanne used this device. In two paintings there are cypresses, curiously reminiscent of the way Modigliani paints people: the leafage is an elongated oval, and the trunk is a thin wavering stem; the diagonals and the movement are slightly reminiscent of Soutine, but the transparent tonalities and the surface relate to Cézanne: in the same climate as the Jas de Bouffan, whether in Livorno or Cagnes, he always paid homage to this artist. There is a harsh loneliness in these works. In a typically romantic account of Modigliani, Michel Georges-Michel says that he saw

him while he was painting Bakst's portrait; they asked him why Utrillo painted such miserable landscapes. 'You paint what you see. Put artists in places other than the suburbs. Ah! collectors and dealers are always so shocked when we [?] give them, instead of landscapes, only filthy suburbs with trees twisted and black as salsify, full of soot and smoke, and interiors where the dining room is next to the toilet.' Modigliani was extremely unlikely to launch himself into such grandiloquent speeches, especially if he was sober and with people he did not know well; but he probably made a few inspired remarks which Georges-Michel vastly inflated, so they do reflect a part of his opinion. What is true is that he could not, within his own terms of reference, lie in a painting. If he did not possess grandiose feelings about nature, he could not paint pure landscapes, however magnificent the background.

There is also a portrait of a shopkeeper painted out of doors, probably also *136* at Cagnes; the background is a whitewashed wall with a tree in front, completely flat, as if stuck on the wall, and behind a ledge, two more trees emerge; they are all stunted, perhaps dead; the effect is Surreal and it all has a disquieting incongruity that recalls Giorgio de Chirico in spirit. The young woman sits, like a massive lifeless weight, her fixed stare the colour of the wall, her neck monumental with goitre.

At Cagnes, he stayed with Anders and Rachèle Osterlind. They were *135* teetotallers, and Modigliani actually gave up smoking and drinking for a couple of months. Rachèle suffered from intestinal tuberculosis; like

135 Rachèle Osterlind with Modigliani's portrait of her

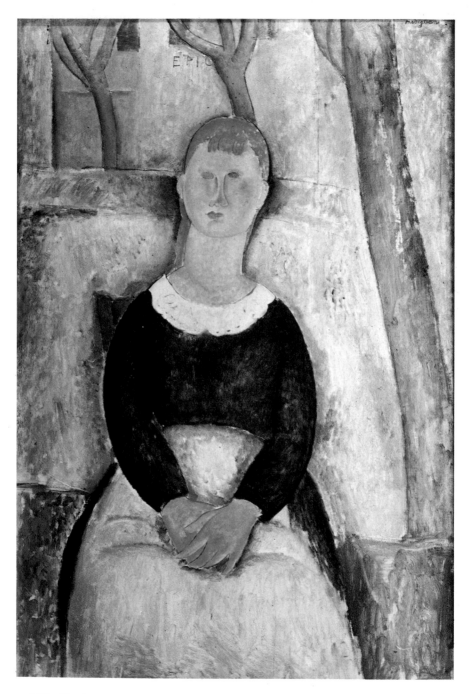

136 *The Shopkeeper*, 1918

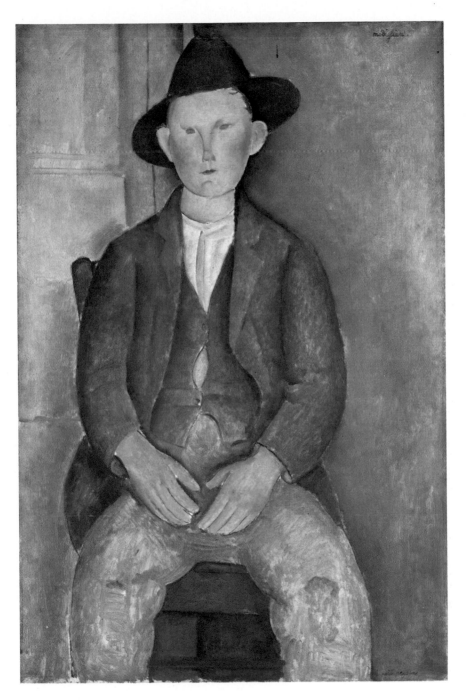

137 *The Little Peasant*, 1919

Modigliani, she was in the region for her health, and he painted a meditative picture of her, with an acute, if pessimistic, understanding of what was slowly happening to her. It was with her husband that he went to visit Renoir in 1919.

Modigliani painted several pictures of peasant boys, which, unlike his depictions of city children, are deprived of sentimentality; just as for Cézanne, his sitters have become pure subject-matter, like mountains or still-life. He is very detached emotionally; the pictures – and we can add the shopkeeper to their number – are studies in mass and volume; incidental anecdotal detail, like an outgrown jacket or an overtight waistcoat, serves only to stress this point further. A comparison of his early *Beggar of Livorno* of 1909 and his *Little Peasant* reveals the distance travelled: the first, in its flickering paintwork, owes its visual effect to Cézanne, but the second is closer to the *Card-players* in its conception, with the added practical experience of sculpture; this is confirmed by all the pictures painted at Cagnes.

29
137

There are signs in this series of works of a kind of subconscious self-mimicry, in that he has transposed the achievements of one medium into another. Instead of evolving the stylistic vocabulary of the picture on the kind of relationship he has established with the sitter, he resorts to a kind of ready-made formula based on the achievements of his later sculpture. Painting sculptures of heads instead of faces, the effect can be a little and probably unwittingly one of caricature, especially as he only slightly adapts some features in order to achieve a kind of resemblance to the model. The sculptures are expressive compared to many of these paintings which are mute.

On 27 May 1919, he finally received his papers and four days later he decided to return to Paris. Jeanne stayed behind in Nice. She was pregnant again.

His reaction to Paris must have been one of relief. 'I'm getting fat and becoming a respectable citizen at Cagnes-sur-mer. I'm going to have two kids. It's unbelievable, it's sickening', he told Marevna Vorobëv.

Family responsibilities had become a firm reality in his life, inescapable save for a brief period alone in Paris, when he could once more savour an illusion of independence. He threw himself into work with an unprecedented fervour. He met Lunia again. With habitual discretion, she says that they met often, and he frequently depicted her.

After dinner, we would go for walks in the Petit Luxembourg; that summer, it was particularly hot. Sometimes, we went to the cinema; otherwise we would stroll across Paris. One day he took me to a funfair to show me 'La

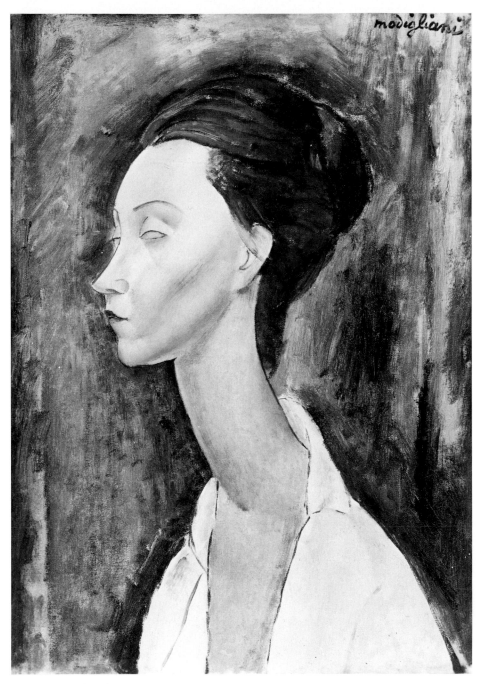

138 *Lunia Czechowska*, 1919

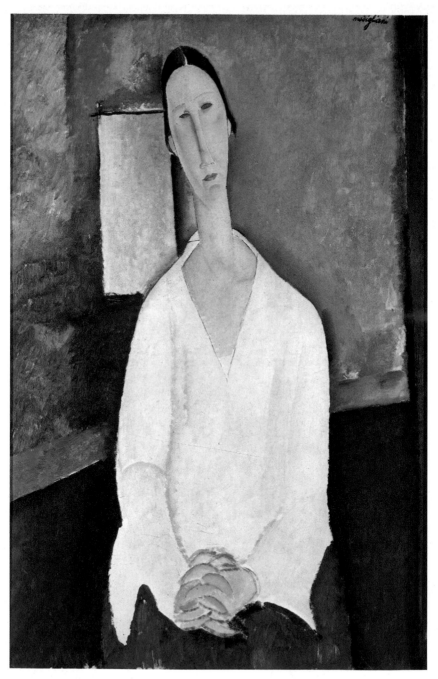

139 *Hanka Zborowska*, 1919

140 *Jeanne Hébuterne with Sash*, 1919

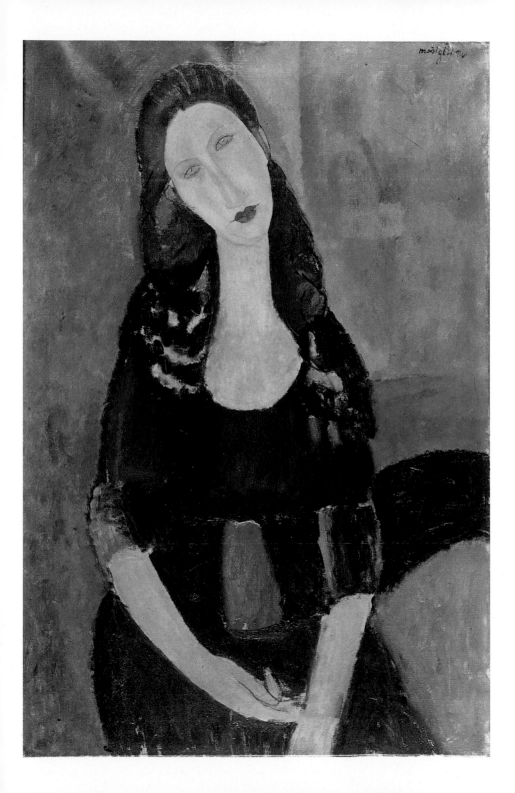

Goulue', once Toulouse-Lautrec's favourite model, who was performing in a cage with wild beasts. This reminded him of earlier times and for a long time he spoke of this period, its painters and its celebrities, all famous now. We would very often go for long walks. We would rest on a small wall in the Luxembourg gardens. He had so much to say that we would never leave each other. He spoke about Italy which he would never see again, about his daughter who he would never watch growing up but he never said a word about his art.

There is a romantic, poetic Modigliani who is lovingly remembered by a number of highly educated, sensitive women; none of these were French, but Russian, English, Canadian, Polish and Swedish, and Modigliani showed them the nostalgic *fin-de-siècle* Paris that had initially drawn him there. The most beautiful portrait of Lunia must be the hieratic portrait of 1919. In essence it is very similar to the profile views of Jeanne, but whereas in her case the distortions cross the narrow borderline into caricature, they now emphasize the sitter's aristocratic mien; Lunia looks inwards, all the features of her face harmonize delicately, with the grace of Nefertiti. Anna Akhmatova had also been drawn like an Egyptian queen, eight years before.

Lunia's memoirs are not really specific as to her true feelings or their relationship. Now that her husband was dead, she did not give herself to Modigliani, out of respect for Jeanne she says, and this resistance (exceptional in his long sentimental career) continued to attract him. But the temptation to cede to her own desires must have been a permanent torment to her, although she would not admit to it. When she started going out with another man, Modigliani was jealous of the feelings she might have for him. Modigliani 'reproached me for this so much that I began to feel guilty towards him; I had to remain his spiritual friend and that was my destiny. I was young and probably over-romantic, and I had to suppress my feelings as another man needed me. I had no experience of life and I simply followed my instincts; so I forced myself not to love the man I had just met.'

There are three reclining nudes of 1919, thinly painted in more muted colours, and curiously chaste in their passivity and lack of detail; they appear to show the same model, although he changes her colouring in each painting; one of them, blonde and blue-eyed, is awake and curiously resembles Lunia. Whatever happened, Lunia in her discretion would never have told anyone. There is a possibility that she did pose, or, more likely, that this is a visual expression of Modigliani's desire – and perhaps hers too. The situation was unbearable for her, and shortly afterwards she left for the South of France, apparently for health reasons. The Zborowskis suggested that Modigliani, in need of a rest, go with her; but Jeanne would not hear of it, and her alarm may well have been justified.

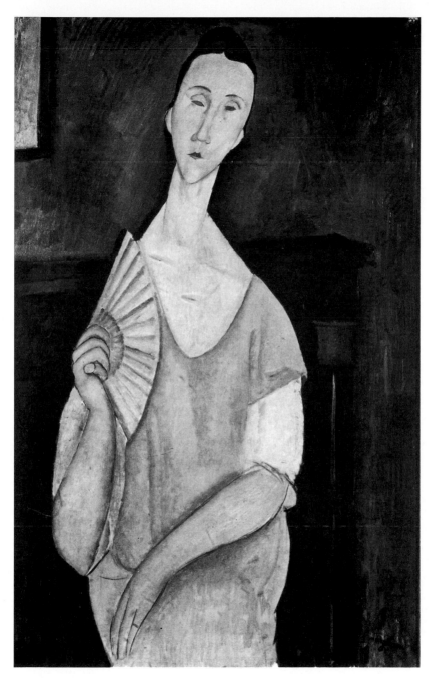

141 *Lunia Czechowska with Fan*, 1919

There are two portraits where Lunia sits in the Zborowski living-room which was papered in deep red, with Napoleonic furniture. Now she peers at us through a mask-like face; its shape is echoed by the triangle of her acutely sloped shoulders. The paintings, especially the one illustrated here, appear to be built up from overlapping surfaces like stage sets. Some of the later portraits of Hanka and Jeanne are constructed in the same way, as if Modigliani now had resorted to a pre-established formula for portraits in the grand manner. The difference between the late Lunias and the late Hankas is not what distinguishes their personalities but a purely stylistic one. Hanka is painted with even greater precision and illusionistic depth than Lunia; her face appears like a three-dimensional polished metal sculpture, a kind of elongated Brancusi, features tightly compressed. When the last portraits of the two women are viewed together, one can see how the face gets thinner and the painting more mannered, as if each actual portrait had posed for the succeeding one: the effect is hallucinatory.

By now Modigliani was becoming well known, his pictures selling at respectable prices. In the summer of 1919, Zborowski arranged a show of French art at the Mansard Gallery in London with the help of Osbert Sitwell, where Modigliani's pictures got favourable reviews in the press, and a portrait of Lunia sold for the highest price in the show (a record sum of 1,000 francs); it was bought by Arnold Bennett, who said that she reminded him of his heroines. About that time, an important article appeared on him in a review published in Geneva called *L'Eventail*. It was written very sensitively by Carco, and Modigliani sent a copy of it to his mother. It prompted a few Swiss collectors to buy, especially with the favourable rate of exchange.

One sign of success was that he could sell paintings that were not portraits of the buyers; nudes apart, this is documented by the fact that the paintings of 1918 onwards are mainly of unknown people who could never be considered as potential buyers, or of those closest to him whom he painted repeatedly on an organized basis. Most of the time now he exercised his talents at portraiture in cafés, as the drawings of Jacob, Utrillo and Picasso, all of 1919, show. It is also possible that these sitters may not have been able to part with the sums wealthy collectors were willing to pay for their portraits, and that it is for this reason that Zborowski preferred him to paint the eminently saleable portraits of his female environment. As an art dealer, his concern had to be money, but although he tried to, he could neither stop Modigliani from giving his drawings away, nor could he get him to increase his now derisory asking price of five francs. The Garsin distaste for money never left him.

Success did not, could not change Modigliani. When fame came Soutine's way, he moved to the Crillon and wore silk underwear; but he was still afraid

194

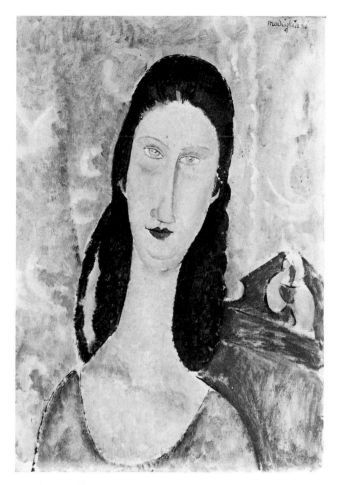

142 *Jeanne Hébuterne*, 1919

to wash. Modigliani had never really known total poverty. In his case it was
more a question of choosing to spend the greater part of his allowance and
income on escapist narcotics; he did not own anything that could indicate a
change of financial status, and he even broke up various copies of his precious
Lautréamont into more portable sections. His standard of living hardly
changed, except that on Jeanne's return in June, they moved to a studio
apartment at 8, rue de la Grande Chaumière which Hanka and Lunia cleaned
and painted. Jeanne wept with joy: it was their first home. The studio,

composed of three small rooms, was on the third floor, just above that of Ortiz de Zárate. Ortiz brought up the coal once a week and frequently carried Modigliani up the stairs at night when, dead drunk, he had collapsed at La Rotonde, two streets away. The second-floor studio had once been Gauguin's, which he had occupied with Ana, the Javanese girl. Modigliani painted sections of his walls in bright Gauguin reds and oranges, perhaps in his honour, and these served as backgrounds for his paintings.

Jeanne seems to have been incapable of looking after their baby; it was decided to find her a wet-nurse to look after it in the country. In Paris, little Giovanna was cared for by Lunia who says that Modigliani often came to peer at his child at night. Sometimes, totally drunk, he would appear with Utrillo and ask to see her, then Lunia would say that she was asleep and that they must be quiet, and Modigliani would sit in the street just to be near his daughter. When he made too much of a fuss, Zborowski would switch all the lights off in the Joseph Bara apartment to pretend they were out or asleep, but Lunia says that her heart went out for Modigliani and, had she been alone, she would have opened the door to him. Modigliani was aware of Jeanne's limitations when he entrusted the upbringing of Giovanna to his family in Italy; of the two, he was more of a parent. The question of marriage loomed large, as a document shows that he pledges to marry 'Jane [sic] Hébuterne'; although he was a notoriously bad speller, one imagines that had he cared about her just a little more, he might have spelt his prospective wife's name right.

And Jeanne was pregnant, which may explain the attempted rush to the altar. The portraits show her more submissive than ever, a kind of sacrificial animal. Modigliani paints her with a kind of vengeful cruelty, rejecting her on canvas.

When he paints her as beautiful, it is less for her own sake than for the symbol of maternity which he has come to respect. There is one magnificently lyrical portrait of Jeanne at a fairly advanced stage of pregnancy, where she wears a vivid striped sash which accentuates her shape; the pose is frontal and she tilts her head to one side; it is painted in tones of apricot and auburn, line and colour merge in a harmonious ensemble, and Jeanne attains the gravity and grandeur of a Venetian Madonna. Their life-style did not change from the time when they were living in hotels. Jeanne never was much of a housewife, and a visitor noted the thick layer of dust and cigarette ash on the floor of the studio; when the latter offered to sweep it up, Modigliani refused. Towards the end he could not bear even the slightest disturbance in his environment. He carried on eating in small restaurants, Rosalie's or late-night snack-bars. He would put mounds of salt and pepper on his plate because otherwise he could not taste the food; he smoked more

142

146

140

143 Self-portrait, 1919

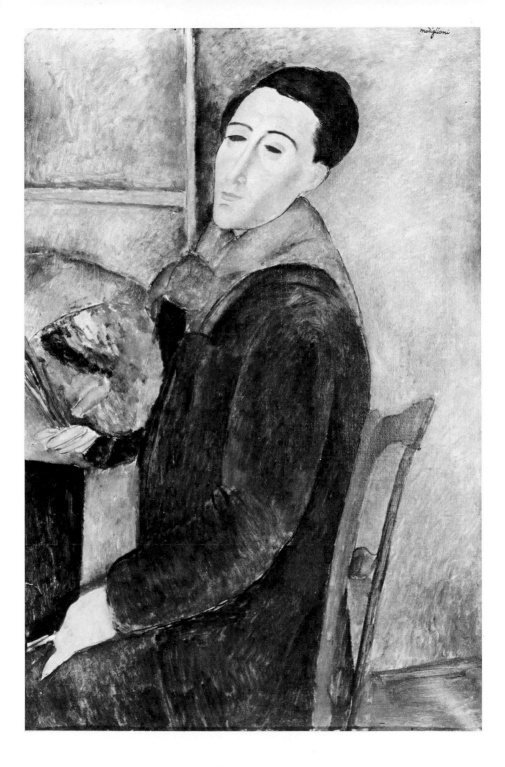

144 Jeanne Hébuterne, *Modigliani Reading in Bed,* 1919

and more and would make himself cough, especially in public places: he had an impressive consumptive cough, the Romantic death-cry *par excellence.*

143 His one and only self-portrait, painted in 1919, is probably the most negative statement about himself he could possibly make, in that it does not express anything at all, not even his talent. His thin face is a hollow mask with blank eyes, his inner concentration has gone; it has the phosphorescent beauty of death, in that his youthful good looks have reappeared, but pale and lifeless; a kind of Dorian Gray in reverse. He sits huddled in a rust jacket, a blue shawl knotted round his neck, it is winter. The palette is a tiny abstract painting in its own right, showing a whirlwind of yellows, ochres, white and black. There are no surviving painted portraits of Modigliani by other artists; the documents we have are mainly very posed photographs, showing him as a swagger Bohemian; a kind of superstitious fear stopped him from posing for them, lest they paint the haggard brutal reality. All his life, he kept tight control over his public image and would not have welcomed visual reminders of how transparent it had become. Jeanne's drawings of him

144 resemble the authorized photographs: she had chosen to love the heroic Bohemian, and the greater part of the Modigliani legend has grown out of her vision of him.

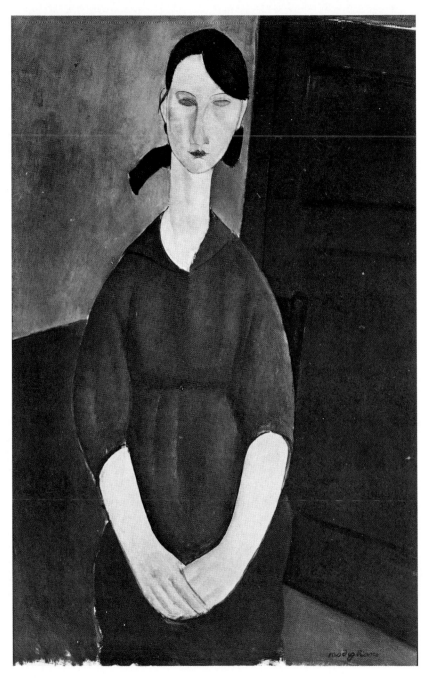

145 *Paulette Jourdain*, 1919

The style of the very last paintings is hermetic; the sitters appear to be immovable, monumental in their stillness, whereas the curved, often cylindrical space in which they are compressed flows from either side. This was the style that so influenced the Art Deco painters.

Paulette Jourdain was the fourteen-year-old maid of the Zborowskis; in later years, she was to bear Zbo's child. Modigliani was gentle, even considerate to her. Yet now Modigliani is no longer interested in painting the nascent womanhood of the sitter – in fact the finished result resembles more her appearance of a few years later. She appears to be lit from within, the ivory starkness of her face and arm is contrasted with her black dress and the red and orange background; she glows with the strength and self-sufficiency of a mysterious idol. All the very last portraits have this quality.

In the portraits of Mario Varvogli and the very last one of Jeanne he poses his sitters in a S shape which relieves the severity of the frontal pose. The last portrait of Jeanne shows unique understanding of her helplessness; she is dressed in pastel tones a little like an eighteenth-century shepherdess; she appears oblivious to everything outside their relationship, even the child which is about to be born. For once Modigliani has painted her with immense tenderness, verging on pity.

Varvogli was a Greek musician who was Modigliani's last drinking companion on New Year's Eve 1919; he was probably someone who did not know him well enough to realize he was dying and to attempt to curb his drinking – which may be one reason why Modigliani appreciated his company; his initial drawings show him experimenting with the pose and even making a separate study of the hands. He has depicted him as a tired libertine, resting a little wearily, still in his evening clothes, his bow-tie drooping, features strained, early morning stubble. Unusually for this period, Modigliani has given him the attributes of perception: one blank eye looking inwards, the other looking straight out. Maybe after all Varvogli understood exactly what was happening and also knew that nothing could be done to stop Modigliani following to the end the course he had chosen.

At the end of his career Modigliani was painting symbols of humanity, just as he had at the very beginning, but in a strong classicizing style of his own, which was to be vulgarized throughout the 1920s. Now Modigliani's attentiveness to his sitters had finally gone; his unique ability to capture their individuality and to translate this intuitive understanding into paint had finally disappeared. Because of the innumerable rebuffs he had received in his life and his ever increasing use of narcotics and alcohol, he had progressively distanced himself from his fellow human beings, even Soutine. He now lived out his relationships from within, on a mythical level, without really attempting a two-way communication; as Lunia points out, he had an

145

147, 148

146

148

147

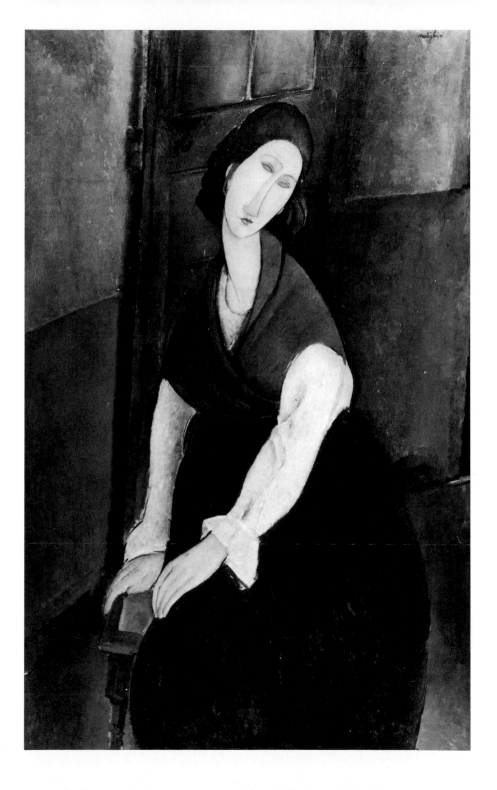

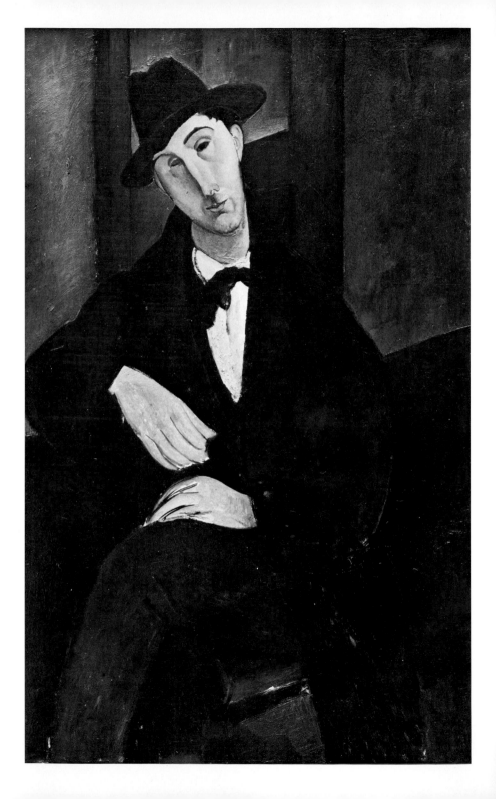

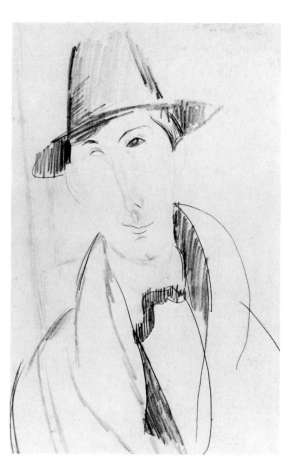

147 *Mario Varvogli*, 1920

148 *Mario Varvogli*, 1920

incessant need to talk about himself (and at the same time demanded full attention), and this self-absorption is indicated by the monotony of his portraits: if the sitters look alike, it is precisely that their differences no longer matter, except very occasionally. It is what they have in common as human types that he portrays at the end of his life: their grace, their fragility, their silence, their essential absurdity. No criticism, no derision. The human being has become the motif, the challenge is no longer the sitter but the painting. Modigliani has become the victim of his genial facility of stylization which he applies now in a uniform manner, and this may be why the late paintings are so popular – they are so recognizably 'Modigliani'. The idiosyncrasies, used judiciously before, appear together like the unavoidable components of a fixed formula; it is not altogether surprising that forgers prefer to exercise their talents on the late works.

There must have been a moment when Modigliani saw with great clarity the dead-end his art was heading for, and this must have terrified him. He may have predicted this years before, which would explain his slow suicide. With a precise knowledge of his inner desiccation, he could not take any risks, especially that of abstaining from drugs and drink, as if he were afraid that without them he might not repeat the miracle of producing pictures. It is not that he could paint only under their influence: he was afraid that any change in his internal chemistry would disrupt the delicate mechanism that made him create art works, now that the essential impetus had come from himself and infinitely less than before from the sitter – and his portraits are as a result depersonalized. He maintained his internal balance with hashish, gin, cocaine, brandy, but this is not, despite all that has been said, the real tragedy of his life. The tragedy resides in the lack of recognition in his own lifetime and his pitiful need for it more than anything else.

149

Modigliani's health was becoming distinctly worse; his instinct for survival had manifested itself in the autumn by a short letter to his mother, where he appeared to be thinking of coming to Italy for a time; but now he no longer wrote home, and his general behaviour could now only precipitate his end. He would stay the whole night at La Rotonde, drinking continuously, wander about in the icy cold in his shirtsleeves, refusing to wear a coat, as if to defy fate. When Zbo timidly suggested he look after himself, Modigliani would turn on him as if he were his worst enemy and demand sharply that he stop moralizing. But he would never complain. About ten days before his death, Modigliani was stricken with violent pains in the kidneys and took to his bed; Zbo was ill and could not visit him. A few days later, Ortiz de Zárate, who had been away, decided to call on him with Kisling, and there, horrified, they discovered Modigliani dying, delirious in bed, complaining of extreme headache. Jeanne was sitting beside him silently, just watching; she had not thought of sending for the doctor. The mattress was littered with empty bottles and half-opened tins of sardines dripping with oil. He was coughing up blood and the studio was freezing; on the easel, the still damp portrait of Varvogli. When the doctor arrived, he declared that Modigliani was dying of tubercular meningitis. Ortiz de Zárate carried him downstairs, and he was taken to hospital where he became unconscious. He died at 8.50 on Saturday evening, 24 January 1920, without regaining consciousness.

While he still had a fraction of his wits about him, he is said to have uttered either: 'I only have a fragment of my brain left' or 'Cara cara Italia' (Beloved beloved Italy) or (referring to Jeanne) 'we have made an eternal pact' or 'I leave you Soutine'. Writers, depending on whether they are friends, Italians, romantics or Soutine researchers, quote one or other of these last phrases. All

149 The last known photograph of Modigliani, *c.* 1919–20

are relevant as they throw different light on the Modigliani legend, which grew to gigantic proportions (as did the prices of his paintings) exactly two days after his death.

On the Sunday, Jeanne went to see the body; she gazed at it for a long time and walked out backwards, in silence, to keep this last image of him forever. The next day her parents took her home, and banished her to a maid's room on the fifth floor. Her brother André stayed with her all night, because she was afraid of being left alone, afraid of carrying out a resolution she had made a long time before; but she still kept a knife under her pillow. She was, after all, nine months pregnant. When, towards morning, André dozed off, she found her courage and, driven finally perhaps by her parents' hostility, threw herself out

of the window. André's first thought was that the tiny corpse, hideously mutilated, would alarm his mother and he begged a workman to wheel it to Modigliani's studio, where it remained all morning because the concierge of their own house refused it entrance. When the studio was cleared up, drawings by Jeanne were found, in which she depicts herself with long braids, piercing her breast with a dagger.

'Bury him like a Prince', Emanuele telegraphed. The procession was enormous; the policemen who had arrested him so many times on charges of disorderly conduct took their hats off to him as it passed; the funeral hearse was covered with a mound of flowers; it was solemnly followed by nearly every artist in Paris, including Picasso, Soutine, Léger, Kisling, Ortiz de Zárate, Lipchitz, Derain, Survage, Severini, Foujita, Utrillo, Valadon, Vlaminck, as well as the poets, Jacob, Salmon, and his close friends (not Lunia, who was away). A rabbi said prayers over his grave. Modigliani's death shook everyone, especially the artists for whom it was a personal tragedy: the struggle for survival in a savage unpoetic society or the luck to be in a position to fight back; each one was burying a fragment of their struggles at Père Lachaise that day, resolved perhaps never to let this happen to them.

Jeanne was hurriedly buried by her family in a forlorn cemetery near Bagneux. Zborowski, Salmon, Chana Orloff, and Kisling accompanied them in taxis. It was only five years later that her family relented and allowed Emanuele to rebury her beside Modigliani at Père Lachaise, and he inscribed on their tomb 'Finally they sleep together'.

Modigliani's paintings, drawings and sculptures had an extraordinary fate in terms of influence, speculation and legend-making. The speculators rejoiced. Right at the end of his life, Modigliani's paintings averaged 150 francs; ten years later the prices soared to around 500,000 francs, and everyone who had ever met him was busily engaged on writing their memoirs; many others tore their hair out as they remembered the paintings and drawings they had destroyed or despised (not least Rosalie); as many of the drawings were unsigned anyway, Modigliani's official dealers actually authorized an able forger to imitate his signature on the drawings they handled, because the prices they fetched were then much higher.

How Modigliani would have scorned this! One day at La Rotonde, he drew the portrait of an American lady; she insisted that he sign it, because she had heard somewhere that signed works were much more valuable. Modigliani looked her straight in the eye, then took his pencil and wrote his name on the drawing in huge capital letters, like an advertisement, right across her face.

206

Bibliography

List of illustrations

Index

Bibliography

I have selected some of the works that have been most useful to me and that would best help a student researching the period, together with those referred to in the text.

1 CATALOGUES OF MODIGLIANI'S WORK

Ambrogio Ceroni, *Modigliani*, London and New York 1959.
Jacques Lanthemann, *Catalogue raisonné de l'œuvre de Modigliani*, Barcelona 1970.

2 BIOGRAPHIES AND STUDIES

Giovanni Scheiwiller, *Modigliani*, Milan 1927.
Jacques Lipchitz, *Modigliani*, New York 1952, London 1953.
Gotthard Jedlicka, *Modigliani*, Zürich 1953.
André Salmon, *La Vie passionnée de Modigliani*, Paris 1957; trs. as *Modigliani, a Memoir*, London and New York 1961.
Jeanne Modigliani, *Modigliani: Man and Myth*, London and New York 1959.
Alfred Werner, *Modigliani the Sculptor*, New York 1962.
Anna Akhmatova, *The Flight of Time*, Moscow 1965 (includes her study on Modigliani).
Pierre Sichel, *Modigliani*, London and New York 1967.
William Fifield, *Modigliani: the Biography*, New York 1976, London 1978.

3 BACKGROUND READING

Charles Pierre Baudelaire, *Les Paradis artificiels*, Paris 1860.
Comte de Lautréamont, *Les Chants de Maldoror*, Paris 1869; trs. in *Maldoror and Poems*, London and New York 1978.
André Warnod, *Les Berceaux de la jeune peinture: Montmartre-Montparnasse*, Paris 1925.
Adolphe Basler, *L'Art chez les peuples primitifs*, Paris 1929.
Nina Hamnett, *Laughing Torso*, London and New York 1932.
Fernande Olivier, *Picasso et ses amis*, Paris 1933; trs. as *Picasso and his Friends*, London 1964.
Berthe Weill, *Pan dans l'œil!*, Paris 1933.
Charles Douglas, *Artists' Quarter: Reminiscences of Montmartre and Montparnasse in the First Two Decades of the Twentieth Century*, London 1941.
Gino Severini, *Tutta la vita di un pittore*, Milan 1946.
Augustus John, *Fragments of an Autobiography*, London 1952.
Michel Georges-Michel, *De Renoir à Picasso*, Paris 1954; trs. as *From Renoir to Picasso: Artists I Have Known*, London and Boston 1957.
André Level, *Souvenirs d'un collectionneur*, Paris 1959.
Gabriel Fournier, *Cors de chasse 1912–54*, Geneva 1957.
John Golding, *Cubism, a History and an Analysis 1907–1914*, London 1959, New York 1972.
Ilya Ehrenburg, *People and Life 1891–1921*, London 1961, New York 1962.
Jean-Pierre Crespelle, *Montparnasse vivant*, Paris 1962.
Barbara Tuchman, *The Proud Tower: A Portrait of the World Before the War 1890–1914*, London and New York 1966.
Ossip Zadkine, *Le Maillet et le ciseau, souvenirs de ma vie*, Paris 1968.
John Berger, *The Moment of Cubism and Other Essays*, London 1969.
Maria (Marevna) Voroböv, *Life with the Painters of La Ruche*, London 1972.
A. E. Elsen, *Origins of Modern Sculpture*, London and New York 1974.

4 CONTEMPORARY WRITINGS

Guillaume Apollinaire, *Alcools*, Paris 1913; English trs., London and Atlantic Highlands 1975; *Zone* trs. separately by Samuel Beckett, London 1972.

——*Apollinaire on Art: Essays and Reviews 1902–1918*, London and New York 1972.

Blaise Cendrars, *Prose du Transsibérien et de la petite Jeanne de France*, Paris 1914.

——, *Le Panama ou les aventures de mes sept oncles*, Paris 1914; trs. as *Panama, or The Adventures of my Seven Uncles*, London and New York 1931.

Beatrice Hastings, articles from *The New Age*, London 1914, 1915.

Max Jacob, *Le Cornet à dés*, Paris 1916.

——, *La Défense de Tartufe*, Paris 1919.

Edward F. Fry, *Cubism*, London and New York 1966 (includes Cubist manifestos).

Filippo Marinetti, *Selected Writings* (ed. R.W. Flint), London and New York 1971.

List of illustrations

23 *Paul Alexandre*, 1909. Pencil, $13\frac{3}{8} \times 10\frac{1}{4}$ (34×26). Private Collection

24 *Portrait of Paul Alexandre on a Brown Background*, 1909. Oil on canvas, $39\frac{3}{8} \times 31\frac{7}{8}$ (100×81). Private Collection

25 *Portrait of Paul Alexandre on a Green Background*, 1909. Oil on canvas, $39\frac{3}{8} \times 31\frac{7}{8}$ (100×81). Private Collection

26 *Paul Alexandre*, 1913. Oil on canvas, $31\frac{1}{2} \times 18$ (80×45.5). Private Collection

27 *Jean Alexandre*, 1909. Oil on canvas, $31\frac{7}{8} \times 23\frac{5}{8}$ (81×60). Private Collection

28 *L'Amazone*, 1909. Oil on canvas, $36\frac{1}{4} \times 25\frac{1}{2}$ (92×65). Alexander Lewyt Collection

29 *The Beggar of Livorno*, 1909. Oil on canvas, $26 \times 23\frac{1}{4}$ (66×59). Private Collection

30 *Study for The Cellist*, 1909. Oil on canvas, $29\frac{1}{8} \times 23\frac{5}{8}$ (74×60). Private Collection

31 CONSTANTIN BRANCUSI 1876–1957 *Head*, 1908. Plaster cast, ht $11\frac{3}{4}$ (29.8). Musée National d'Art Moderne, Paris. Photo Réunion des Musées Nationaux, Paris

32 *Brancusi* (reverse of ill. 30), 1909. Oil sketch, $29\frac{1}{8} \times 23\frac{5}{8}$ (74×60). Private Collection

33 *Head*, 1910–11. Limestone, ht 18 (46). Musée National d'Art Moderne, Paris. Photo Réunion des Musées Nationaux, Paris

34 *Head*, 1911. Limestone, ht 24 (61). Tate Gallery, London

35 *Head*, 1912. Stone, ht $25\frac{1}{2}$ (65). National Gallery of Art, Washington D.C.

36 *Head*, 1913–14. Marble, ht $20\frac{1}{2}$ (52.5) Private Collection

37 WILLIAM LEHMBRUCK 1881–1919 *Fallen Youth*, 1915–16. Cement. Lehmbruck Museum, Duisburg

38 CONSTANTIN BRANCUSI 1876–1957 *The Kiss*, 1911. Stone, ht 23 (58.5). Philadelphia Museum of Art, Louise and Walter Arensberg Collection

39 Modigliani with Adolphe Basler at the Dôme, *c.* 1919. Photograph. Photo Museo Civico Giovanni Fattori, Livorno

40 Mask from the Ivory Coast. Wood. Formerly in the Paul Guillaume Collection. From Adolphe Basler, *L'Art Chez les Peuples Primitifs*, 1926

41 *Nude with African Statue*, *c.* 1913. Pencil, $10\frac{1}{2} \times 8\frac{1}{4}$ (26.7×21). Private Collection

42 *Head with an Abacus*, 1911–12. Pencil, $17 \times 10\frac{1}{4}$ (43×26). Private Collection

43 *Head with a Plinth*, *c.* 1910. Charcoal, $13\frac{3}{8} \times 10\frac{3}{8}$ (33.8×26.3). Kupferstichkabinett, Basle

44 *Standing Woman (African Drawing)*, 1910–11. Pencil and charcoal, $17 \times 10\frac{1}{4}$ (43×26). Private Collection

45 *Standing Caryatid*, 1911–12. Oil sketch on board, $32\frac{5}{8} \times 18\frac{7}{8}$ (83×48). Private Collection

46 *Standing Caryatid*, 1912. Stone, ht 63 (160). Private Collection

47 *Crouching Caryatid* (preliminary drawing for ill. 50), 1910–11. Pencil and charcoal, $13 \times 10\frac{1}{4}$ (33×26). Private Collection

48 *Caryatid*, *c.* 1913. Watercolour, $20\frac{7}{8} \times 16\frac{1}{2}$ (53×42). Private Collection

49 *Caryatid*, *c.* 1913–15. Pastel and crayon with wash. $20\frac{7}{8} \times 19$ (53×48.2). Musée d'Art Moderne de la Ville de Paris. Photo Giraudon

50 *Crouching Caryatid*, 1913. Limestone, ht $36\frac{1}{4}$ (92). The Museum of Modern Art, New York, Mrs Simon Guggenheim Fund

51 CONSTANTIN BRANCUSI 1876–1957 *Prometheus*, 1911. Gilded bronze, l. 7 (17.6). Private Collection. Photo Solomon R. Guggenheim Museum, New York

52 CONSTANTIN BRANCUSI 1876–1957 *Portrait of a Woman*, *c.* 1918. Oil on paper laid on canvas, $24\frac{1}{8} \times 15\frac{1}{2}$ (61.2×39.3). Courtesy David Grob, London

53 *Head* (reverse of ill. 54), 1913. Stone, ht 22 (56). Musée National d'Art Moderne, Paris. Photo courtesy the author

54 *Head*, 1913. Stone, ht 22 (56). Musée National d'Art Moderne, Paris. Photo Réunion des Musées Nationaux, Paris

55 *Head*, 1912–13. Limestone, ht 28 (71). Private Collection

56 GABRIEL FOURNIER *At La Rotonde*, 1916. Pen and ink

57 Advertisements. From *Montparnasse*, 19, 1923. Photo Eileen Tweedy

58 *Guillaume Apollinaire*, 1915. Pencil, $15\frac{3}{8}$ × $10\frac{1}{2}$ (39 × 26·5). Private Collection

59 *Picasso*, 1915. Pencil and paint on paper, $13\frac{3}{4}$ × $10\frac{5}{8}$ (35 × 27). Whereabouts unknown

60 *Frank Burty Haviland*, 1914. Oil on paper, $28\frac{1}{2}$ × $23\frac{1}{2}$ (72·5 × 59·5). Mattioli Collection

61 DIEGO RIVERA 1886–1957 *Self-portrait*, 1918. Pencil, $13\frac{3}{4}$ × $9\frac{1}{2}$ (35 × 24). Private Collection

62 *Diego Rivera* (study for ill. 65), *c.* 1914. Pencil, $13\frac{5}{8}$ × $8\frac{3}{4}$ (34·5 × 22·5). Private Collection

63 *Diego Rivera* (study for ill. 65), *c.* 1914. Pencil and ink, $10\frac{1}{4}$ × 8 (26 × 20). Courtesy the Art Institute of Chicago, gift of Mr and Mrs Wesley M. Dixon Jr, 1967

64 *Diego Rivera* (study for ill. 65), 1914. Oil on canvas, $39\frac{3}{8}$ × $31\frac{1}{8}$ (100 × 79). Museu de Art de São Paulo

65 *Diego Rivera*, 1914. Oil on canvas, $39\frac{3}{8}$ × $31\frac{7}{8}$ (100 × 81). Private Collection

66 *Henri Laurens*, 1915. Oil on canvas, $31\frac{7}{8}$ × $23\frac{5}{8}$ (81 × 60). Private Collection

67 *Jean Cocteau*, 1916. Oil on canvas, $39\frac{3}{8}$ × $31\frac{7}{8}$ (100 × 81). Pearlman Collection

68 *Moïse Kisling*, 1915. Pencil, $15\frac{3}{4}$ × $9\frac{1}{2}$ (40 × 24). Private Collection

69 *Raymond Radiguet*, 1915. Oil on canvas, $14\frac{1}{2}$ × $11\frac{1}{2}$ (37 × 29). Private Collection

70 *Jacques Lipchitz* (preparatory drawing for ill. 73), *c.* 1916. Pencil. Private Collection

71 *Jacques and Bertha Lipchitz* (preparatory drawing for ill. 73), *c.* 1916. Pencil. Private Collection

72 *Bertha Lipchitz* (preparatory drawing for ill. 73), *c.* 1916. Pencil, 9 × $6\frac{1}{4}$ (23 × 16). Private Collection

73 *Jacques and Bertha Lipchitz*, 1917. Oil on canvas, $31\frac{1}{2}$ × 21 (80 × 53·3). Courtesy the Art Institute of Chicago, Helen Birch Bartlett Memorial

74 *Beatrice Hastings (Beata Matrex)*, 1915. Pencil, $21\frac{1}{4}$ × $16\frac{1}{2}$ (54 × 42). Private Collection

75 *Beatrice Hastings as Madam Pompadour*, 1915. Oil on canvas, 24 × $19\frac{7}{8}$ (61 × 50·4). Courtesy the Art Institute of Chicago

76 *Beatrice Hastings*, 1915. Oil on canvas, $31\frac{7}{8}$ × $21\frac{1}{4}$ (81 × 54). Private Collection

77 FRANCESCO PARMIGIANINO 1503–40 *Madonna and Child with Angels (Madonna del Collo Lungo)*, *c.* 1535 (detail). Oil on wood, 85 × 52 (216 × 132). Palazzo Pitti, Florence. Photo Alinari

78 *Beatrice Hastings in an Armchair*, 1915. Pencil, $16\frac{1}{2}$ × $10\frac{1}{4}$ (42 × 26·6). Private Collection

79 *Beatrice Hastings (Beatrice)*, 1915. Pencil, $15\frac{7}{8}$ × 10 (40·3 × 25·4). Private Collection

80 *Paul Guillaume (Novo Pilota)*, 1915. Oil on canvas, $41\frac{3}{8}$ × $29\frac{1}{2}$ (105 × 75). Private Collection. Photo Giraudon

81 *Celso Lagar*, 1915. Oil on canvas, $13\frac{3}{4}$ × $10\frac{5}{8}$ (35 × 27). Private Collection

82 *L'Arlequin* (self-portrait?), 1915. Oil on paper, 17 × $10\frac{5}{8}$ (43 × 27). Statens Museum for Kunst, Copenhagen

83 Advertisement. From *Nord-Sud*, June–July 1917

84 *Chaïm Soutine*, 1917. Pencil. Private Collection

85 *Chaïm Soutine*, 1915. Oil on canvas, 14⅛ × 10⅞ (36 × 27·5). Staatsgalerie, Stuttgart

86 *Max Jacob*, 1916. Oil on canvas, 28¾ × 23⅝ (73 × 60). Kunstsammlung Nordrhein-Westfalen, Düsseldorf

87 *The Bride and Groom*, 1915. Oil on canvas, 21¾ × 18¼ (55·2 × 46·3). The Museum of Modern Art, New York, gift of Frederick Clay Bartlett

88 *Monk (L'Estatico)*, 1916. Pencil, 17⅛ × 10¼ (43·5 × 26). Private Collection

89 *Crucifixion (Christos)*, 1916. Pencil, 16½ × 10⅝ (42 × 27). Private Collection

90 *Kneeling Woman (Dies Irae, Dies Illae)*, 1918. Pencil. Private Collection

91 MAX JACOB 1876–1944 Poem from *Le Laboratoire central*, 1921.

92 *Max Jacob*, 1915. Pencil, 15⅛ × 10⅞ (38·5 × 27·5). Private Collection

93 *Reclining Nude (Almaïsa)* (preparatory drawing for ill. 94), 1916. Pencil, 11¾ × 18⅛ (30 × 46). Private Collection

94 *Reclining Nude (Almaïsa)*, 1916. Oil on canvas, 31⅞ × 45⅝ (81 × 116). Private Collection. Photo courtesy Acquavella Galleries Inc., New York

95 *Life Study*, c. 1917. Pencil, 16½ × 10¼ (42 × 26). Private Collection

96 PABLO PICASSO 1881–1973 *Study for the Bathers*, 1918. Pencil, 9½ × 12¼ (24 × 31). Courtesy the Fogg Art Museum, Harvard University, bequest of Meta and Paul J. Sachs

97 *Life Study*, 1917. Pencil, 17⅛ × 11 (43·5 × 28). Private Collection

98 Theda Bara in *Cleopatra*, 1918. Photo

99 Mary Pickford, c. 1918. Photo

100 TITIAN 1487/90–1576 *Venus with the Organ-player*, c. 1548 (detail). Oil on canvas, 54⅛ × 85⅜ (148 × 217). Prado, Madrid. Photo Mas

101 *Reclining Nude*, 1917. Oil on canvas, 23⅝ × 36¼ (60 × 92). Staatsgalerie, Stuttgart

102 *Seated Nude*, 1917. Oil on canvas, 39¾ × 25½ (100 × 65). Private Collection

103 *Reclining Nude*, 1917. Oil on canvas, 28½ × 45⅞ (72·4 × 116·5). Museum of Modern Art, New York, Mrs Simon Guggenheim Fund

104 *Reclining Nude*, 1917. Oil on canvas, 23⅝ × 36¼ (60 × 92). Mattioli Collection

105 *Seated Nude*, 1917. Oil on canvas, 44⅞ × 29⅛ (114 × 74). Koninklijk Museum voor Schone Kunsten, Antwerp

106 PIERRE-AUGUSTE RENOIR 1841–1919 *Reclining Nude*, c. 1918. Oil on canvas. Private Collection

107 Exhibition catalogue, 1917

108 *Standing Nude (Le Nu blond)*, 1917. Oil on canvas, 36¼ × 25½ (92 × 65). Private Collection

109 *Blaise Cendrars*, 1916. Pencil, 16½ × 10¼ (42 × 26). Private Collection

110 Nijinsky, 1912. Photograph by Adolphe de Meyer

111 *Dancer*, 1916. Pencil and pen, 16⅝ × 10¼ (42·2 × 26). The Art Museum, Princeton University, Dan Fellows Platt Collection

112 KEES VAN DONGEN 1887–1968 *Tableau (Le Châle espagnol)*, 1913. Oil on canvas, 76¾ × 51¼ (195 × 130). Courtesy Dolly van Dongen

113 French postcard, 1915. Courtesy Graham Ovenden

114 FRANÇOIS BOUCHER 1703–70 *Mlle O'Murphy*, 1751. Oil on canvas, 23⅜ × 28¾ (60·3 × 73). Wallraf Richartz Museum, Cologne

115 EDOÚARD MANET 1832–83 *Olympia*, 1863 (detail). Oil on canvas, 51 × 74¾ (130 × 190). Musée du Jeu de Paume, Paris. Photo Giraudon

116 MOÏSE KISLING 1891–1953 *Reclining Nude*, 1917. Oil on canvas, 23⅝ × 28¾ (60 × 73). Musée du Petit Palais, Geneva

117 *Reclining Nude*, 1917. Oil on canvas, 25½ × 39¾ (65 × 100). Private Collection

118 *Léopold Zborowski*, 1918. Oil on canvas, 18⅛ × 10⅝ (46 × 27). Private Collection

119 *Hanka Zborowska*, 1917. Oil on canvas, 21⅝ × 13 (55 × 33). Galleria Nazionale d'Arte Moderna, Rome

120 *Lunia Czechowska*, 1917. Oil on canvas, 21⅝ × 18⅛ (55 × 46). Private Collection

121 *Lunia Czechowska (La Vita è un Dono . . .)*, 1918. Pencil, 16½ × 9⅞ (42 × 25). Private Collection

122 *Elena Pawlowski*, 1917. Oil on canvas, 25½ × 18⅛ (65 × 46). Phillips Collection, Washington D.C.

123 *Monsieur Baranowski*, 1918. Oil on canvas, 43¾ × 22 (111 × 56). Courtesy Sir Robert and Lady Sainsbury. Photo John Webb

124 *Jeanne Hébuterne*, 1918. Oil on canvas, 18⅛ × 11⅜ (46 × 29). Private Collection

125 *Jeanne Hébuterne*, 1918. Oil on canvas, 18⅛ × 11½ (46 × 29). Private Collection

126 Jeanne Hébuterne. Photograph

127 *Jeanne Hébuterne, c.* 1919. Pencil, 13½ × 11 (34·2 × 28). Kupferstichkabinett, Basle

128 *Little Girl in Blue*, 1918. Oil on canvas, 45⅝ × 28¾ (116 × 73). Private Collection

129 *Léopold Survage*, 1917/18. Oil on canvas, 24 × 18⅛ (61 × 46). Ateneumin Taidemuseo, Helsinki

130 *Jeanne Hébuterne*, 1919. Oil on canvas, 39⅝ × 25½ (100 × 65). Private Collection

131 Modigliani with Paul Guillaume in Nice, *c.* 1919. Photo Museo Civico Giovanni Fattori, Livorno

132 *Jeanne Hébuterne, c.* 1919. Pencil, 13 × 9⅞ (33 × 25). Private Collection

133 *Landscape at Cagnes*, 1919. Oil on canvas, 23⅝ × 17¾ (60 × 45). Dewey Collection

134 CHAÏM SOUTINE 1894–1943. *Road to Cagnes*, 1919. Oil on canvas, 32 × 25¼ (81·2 × 64·7). Private Collection

135 Rachèle Osterlind. Photograph

136 *The Shopkeeper*, 1918. Oil on canvas, 39⅝ × 25½ (100 × 65). Private Collection. Photo Giraudon

137 *The Little Peasant*, 1919. Oil on canvas, 39⅜ × 25½ (100 × 65). The Tate Gallery, London

138 *Lunia Czechowska*, 1919. Oil on canvas, 81¼ × 13 (46 × 33). Private Collection. Photo Giraudon

139 *Hanka Zborowska*, 1919. Oil on canvas, 39¾ × 25½ (100 × 65). Private Collection. Photo Giraudon

140 *Jeanne Hébuterne with Sash*. Oil on canvas, 36¼ × 23⅝ (92 × 60). Private Collection

141 *Lunia Czechowska with Fan*, 1919. Oil on canvas, 39⅜ × 25½ (100 × 65). Musée National d'Art Moderne, Paris. Photo Giraudon

142 *Jeanne Hébuterne*, 1919. Oil on canvas, 21⅝ × 15 (55 × 38)

143 *Self-portrait*, 1919. Oil on canvas, 39⅜ × 25½ (100 × 65). Private Collection. Photo Giraudon

144 JEANNE HÉBUTERNE 1898–1920. *Modigliani Reading in Bed*, 1919. Pencil. Private Collection

145 *Paulette Jourdain*, 1919. Oil on canvas, 39¾ × 25½ (100 × 65). Private Collection

146 *Jeanne Hébuterne*, 1919. Oil on canvas, 51¼ × 31⅞ (130 × 81). Private Collection. Photo courtesy Sotheby Parke Bernet

147 *Mario Varvogli*, 1920. Oil on canvas, 45⅝ × 28¾ (116 × 73). Private Collection

148 *Mario Varvogli*, 1920. Pencil, 19¼ × 12 (48 × 30). Museum of Modern Art, New York, gift of Abby Aldrich Rockefeller

149 Modigliani, *c.* 1919–20. Photograph. Jeanne Modigliani Collection

We wish to thank the Archivio Ceroni for kindly supplying many of the photographs.

Index